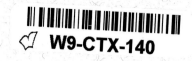

HISTORIC PHOTOS OF
CHICAGO

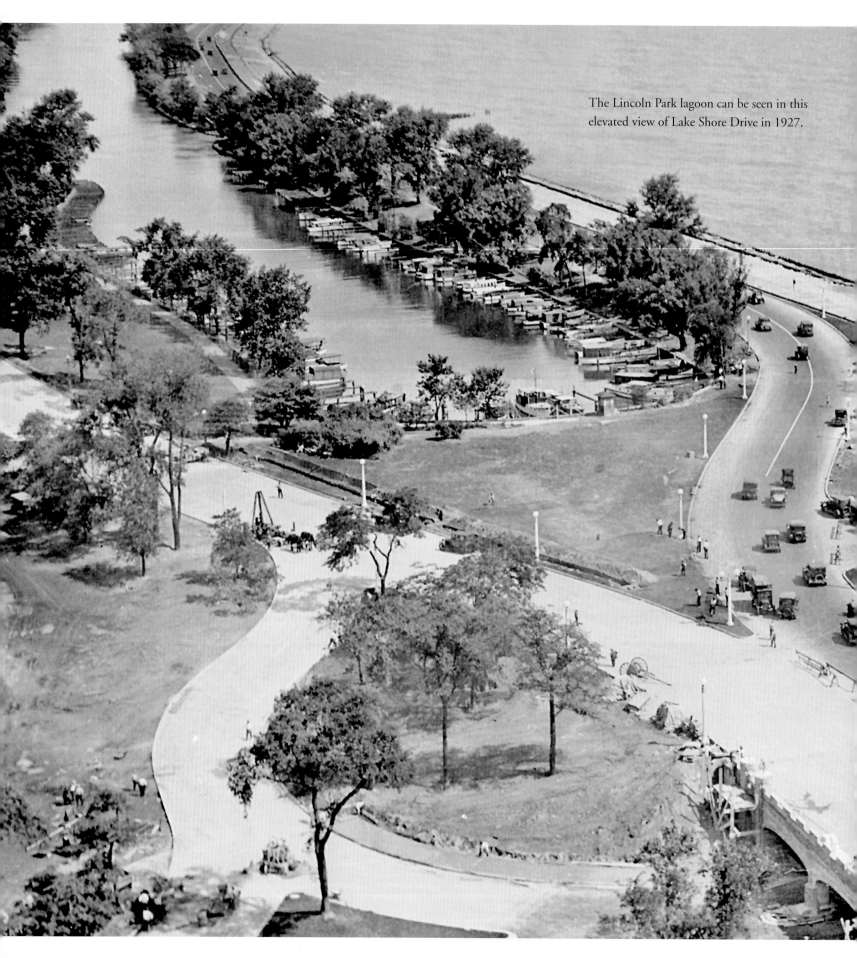

The Lincoln Park lagoon can be seen in this elevated view of Lake Shore Drive in 1927.

HISTORIC PHOTOS OF
CHICAGO

TEXT AND CAPTIONS BY RUSSELL LEWIS
OF THE CHICAGO HISTORY MUSEUM

Turner Publishing Company
200 4th Avenue North • Suite 950 412 Broadway • P.O. Box 3101
Nashville, Tennessee 37219 Paducah, Kentucky 42002-3101
(615) 255-2665 (270) 443-0121

www.turnerpublishing.com

Library of Congress Control Number: 2006905289

ISBN: 1-59652-255-0

Printed in the United States of America

0 9 8 7 6 5 4 3 2 1

CONTENTS

Potter Palmer's mansion, shown here in 1914, sparked development on the Gold Coast when he and his family moved here in 1885. Before that, Prairie Avenue, south of the business district, was the most desirable address in Chicago. The Palmer mansion was demolished in 1950.

ACKNOWLEDGMENTS

This book and the partnership between Turner Publishing Company (TPC) and the Chicago History Museum (CHM) were conceived by Todd Bottorff, president of TPC, and Gary Johnson, president of the CHM. Their enthusiasm for this book project was an ongoing source of support, and I am grateful for all of their encouragement.

Lesley Martin of CHM brought both research and editing skills to the book. She did a remarkable job of fact checking and editing the captions, and she conducted crucial research of the Museum's collection for additional images. I am grateful for her professionalism and high standards.

Rob Medina, also of CHM, facilitated making digital files of these images for production in record time, and I appreciate all of his hard work to meet a challenging schedule. CHM photographers Jay Crawford and John Alderson performed their magic on these vintage images, ensuring they are presented in their best light while retaining their historic integrity as visual artifacts.

We would also like to thank the organizations and corporations that provided support for this work. They include Chicago Architecture Foundation, Turtle Wax, and others. Their interest in Chicago history has helped preserve a vital part of the city's past.

Through the efforts of all of these people and institutions, we are pleased to present *Historic Photos of Chicago.*

PREFACE

Chicago has many thousands of historic photographs that reside in archives, both locally and nationally. The collections of the Chicago History Museum represent a most extraordinary resource for those who seek to understand Chicago's history and culture. This book began with the observation that, while those photographs are of great interest to many, they are not widely accessible. During a time when Chicago is looking ahead and evaluating its future course, many people are asking how do we treat the past? These decisions affect every aspect of the city—architecture, public spaces, commerce and infrastructure—and these, in turn, affect the way that people live their lives. This book seeks to provide easy access to a valuable, objective look into the history of Chicago.

The power of photographs is that they are less subjective in their treatment of history. Although the photographer can make decisions regarding what subject matter to capture and some limited variation in its presentation, photographs do not provide the breadth of interpretation that text does. For this reason, they offer an original, untainted perspective that allows the viewer to interpret and observe.

This project represents countless hours of review and research. The researchers and authors have reviewed thousands of photographs in numerous archives. We greatly appreciate the generous assistance of the archivists listed in the acknowledgments of this work, without whom this project could not have been completed.

The goal in publishing this work is to provide broader access to this set of extraordinary photographs that seek to inspire, provide perspective and evoke insight that might assist people who are responsible for determining Chicago's future. In addition, the book seeks to preserve the past with adequate respect and reverence.

With the exception of touching up imperfections caused by the damage of time, no other changes have been made. The focus and clarity of many images is limited to the technology and the ability of the photographer at the time they were taken.

The work is divided into eras. Beginning with some of the earliest known photographs of Chicago, the first section records photographs from pre–Civil War through 1871. The second section covers the devastation of the Great Fire and the reconstruction that culminated in the Columbian Exposition. The third section spans the beginning of the twentieth century through World War I. Section four moves from World War I to World War II. The last section covers World War II to the 1970's.

In each of these sections we have made an effort to capture various aspects of life through our selection of photographs. People, commerce, transportation, infrastructure, religious institutions, and educational institutions have been included to provide a broad perspective.

We encourage readers to reflect as they go walking in Chicago, stroll along the lakefront or explore one of the city's neighborhoods. It is the publisher's hope that in utilizing this work, longtime residents will learn something new and that new residents will gain a perspective on where Chicago has been, so that each can contribute to its future.

Todd Bottorff, Publisher

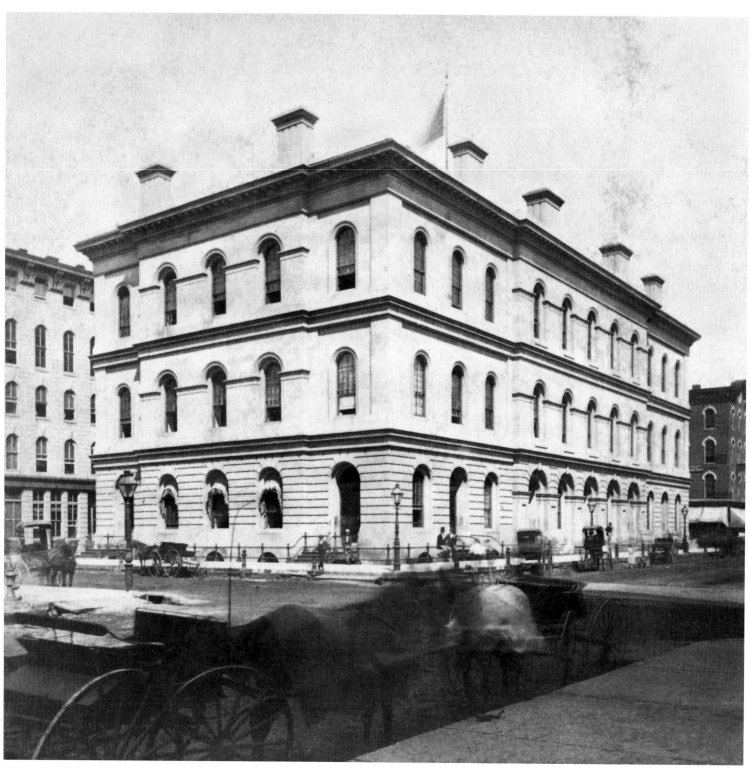

The Post Office and Custom House complex was located at the northwest corner of Dearborn and Monroe.

BEFORE THE FIRE

1840–1871

Between 1840 and 1871, the dynamic interplay between industrialization and urbanization that transformed Chicago into a city was set in motion. Eighteen forty-eight was a watershed year for Chicago. The Illinois & Michigan Canal, which stretched ninety-six miles from Chicago to LaSalle, opened for business after twelve years of construction. Eager to take advantage of the Canal's promise for new commerce, businessmen founded the Chicago Board of Trade that same year. The arrival of the *Pioneer,* the first locomotive, which extended the reach of the Galena & Chicago Union Railroad, signaled the rise of a burgeoning urban community and a new kind of city that would dominate the region. Indeed, by mid-century, a critical mass of people, innovative ideas, money, and transportation networks converged along Lake Michigan and launched Chicago as the fastest-growing city in the world.

Chicago's population grew from a mere 350 citizens when it was incorporated as a town in 1833 to 4,000 by 1840. Over the next decade it increased eightfold (29,963) and more than tripled in 1860 (112,172). By 1870, Chicago boasted a population of 298,977, the fourth largest city in America. During the 1830's Irish immigrants flooded into Chicago to work on the canal, and thousands of Germans began their steady immigration in 1850. Joined by English, Scots, Welsh, Norwegians, Swedes, and Danes, Chicago's immigrants accounted for nearly half the city's population in 1870. The scale of the city expanded from a single square mile in 1833 to nine square miles in 1850 to thirty-five square miles by 1870.

The city thrived as a national processing and distribution center for grain, lumber, and meat, and business innovations such as the McCormick Reaper Works and the Union Stock Yard further stimulated economic growth and urban transformation. Chicago also fostered the cultural trappings of an urban society such as the Chicago Historical Society (1856). Chicagoans struggled with muddy streets and outbreaks of cholera and typhoid, but a new sewer system in 1852, raised street grades in 1856, and street railways in 1859 contributed to an urban infrastructure that made the city more livable.

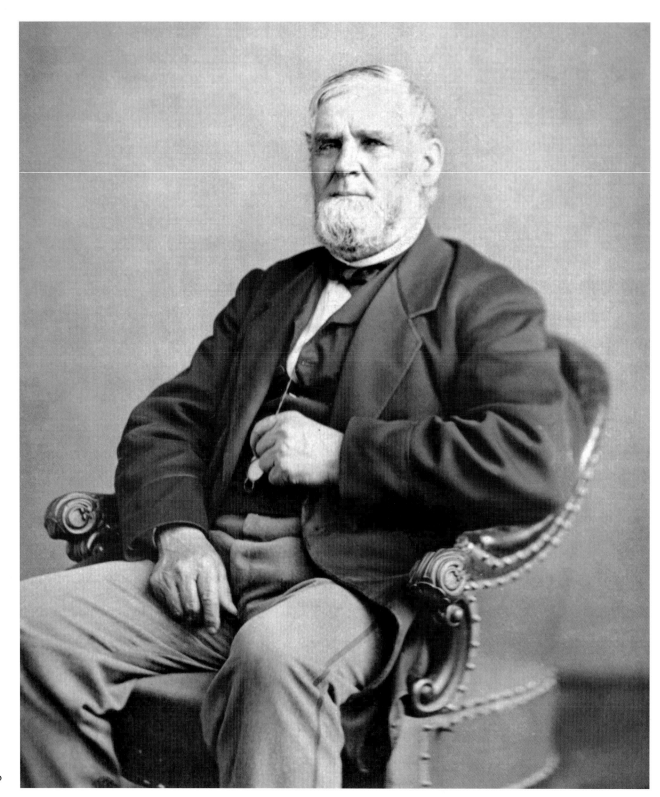

William Ogden
Butler, the first
Mayor of Chicago

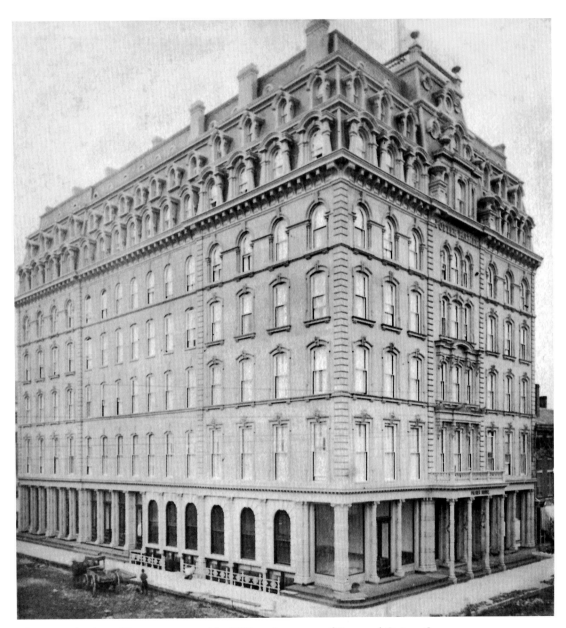

The original Palmer House was erected in 1851 at the corner of State and Quincy Streets.

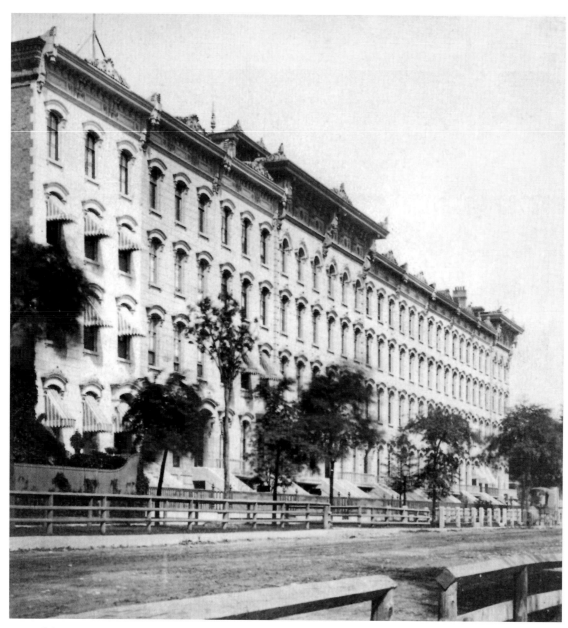

One of the earliest examples of luxury housing on the lakefront, Terrace Row was completed in 1856 along Michigan Avenue south of Van Buren Street. W.W. Boyington designed these Italianate townhouses of "Athens Marble" (the term for limestone from Lemont, Illinois). They were sold for prices ranging from $18,000 to $30,000.

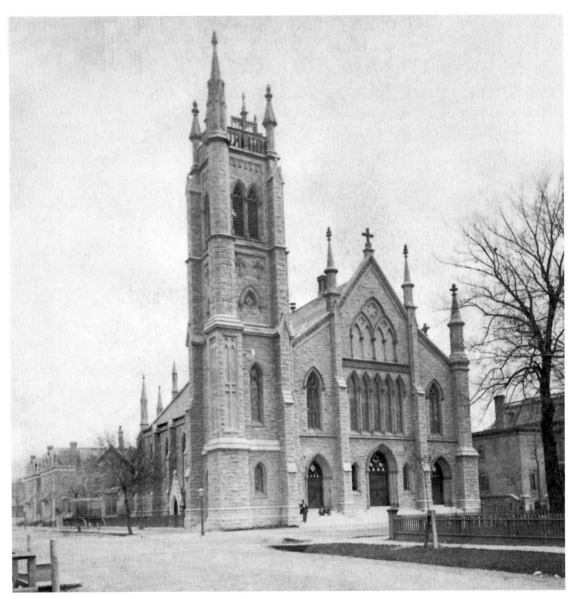

St. James was the first Episcopal church in Chicago. It was originally at Cass (now Wabash) and Illinois Streets. In 1857, the congregation moved to its new (and current) location at the southeast corner of Cass and Huron Streets.

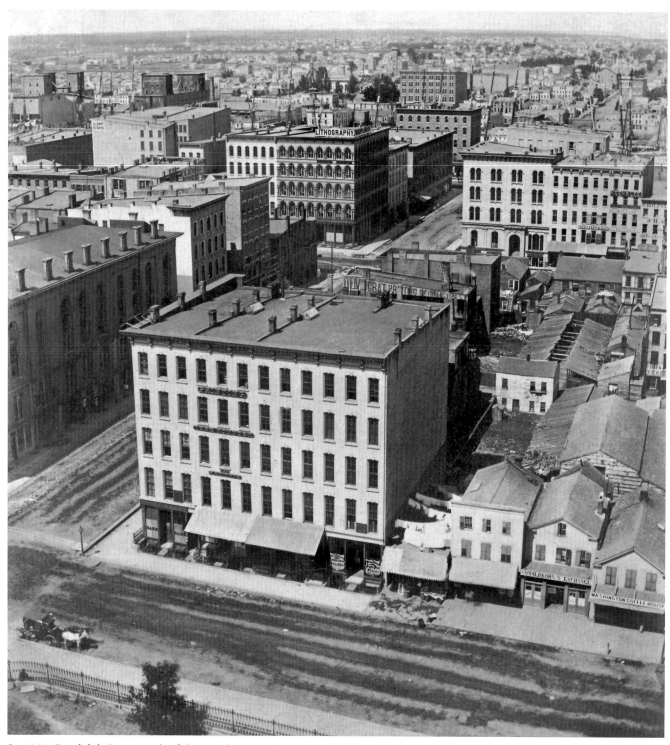

In 1858, Randolph Street north of the courthouse included a mixture of respectable office buildings and tumble down wooden structures. This is the current site of the James R. Thompson Center.

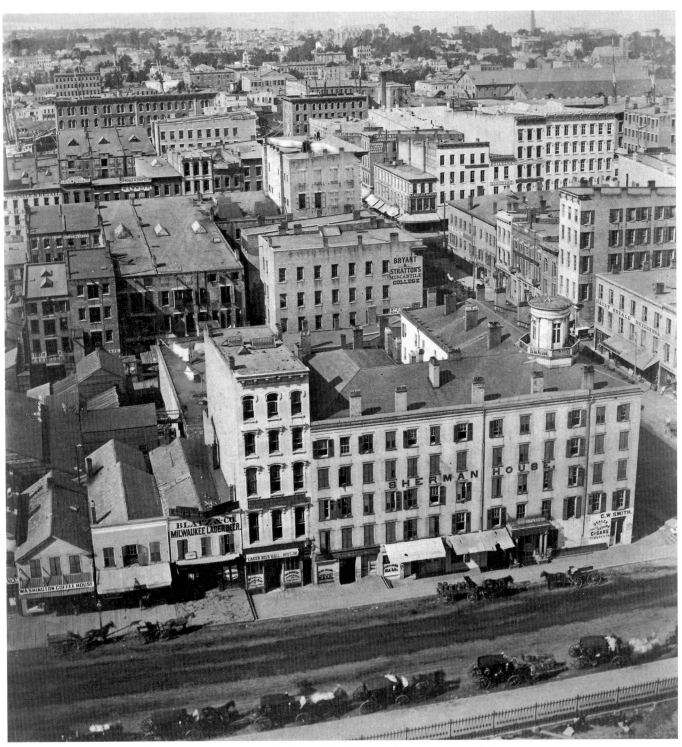

A view of Randolph Street from atop the Courthouse in 1858. The Sherman House was one of the most impressive buildings built in the city during its early years.

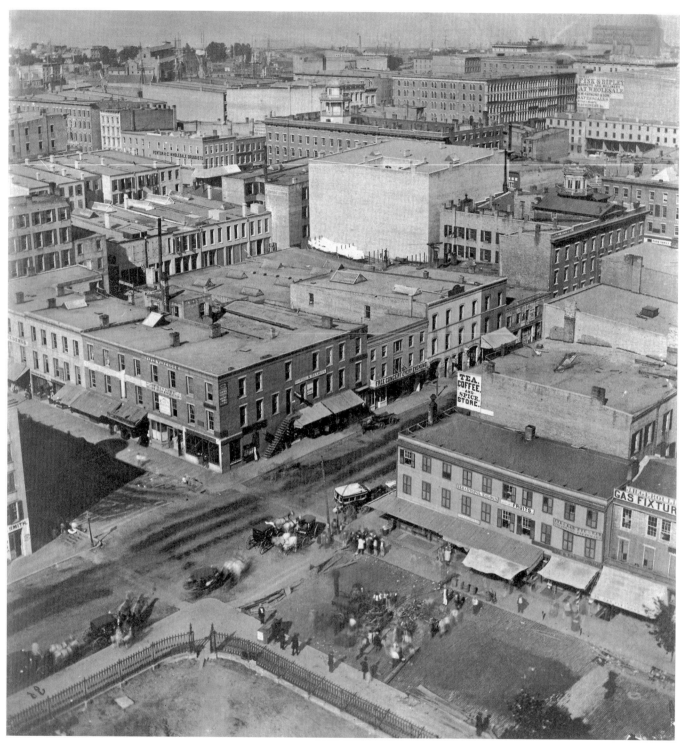

The intersection of Clark and Randolph was busy even in 1858. Lake Michigan is visible in the background.

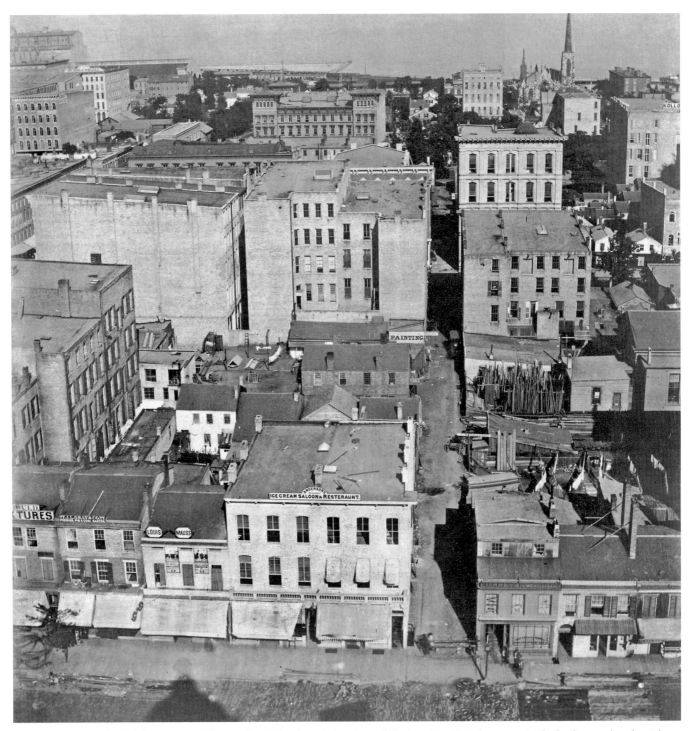

Looking east towards the lake in 1858. The steeple of what is probably Second Presbyterian Church appears in the background to the right. The architect of that church was James Renwick, who also designed St. Patrick's Cathedral in New York City and the Smithsonian Institute in Washington D.C.

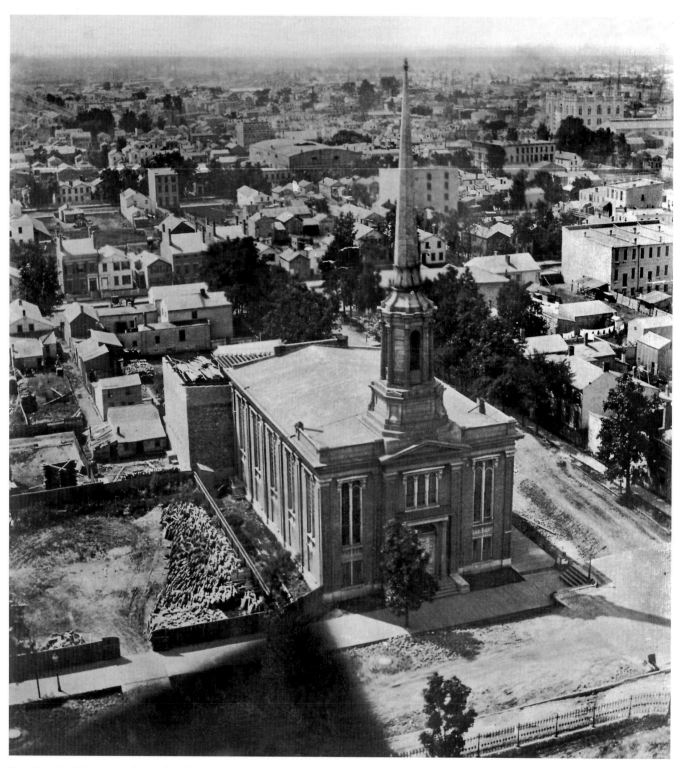

First Baptist Church was located at the corner of Washington and LaSalle in 1858. American National Bank now sits on this site.

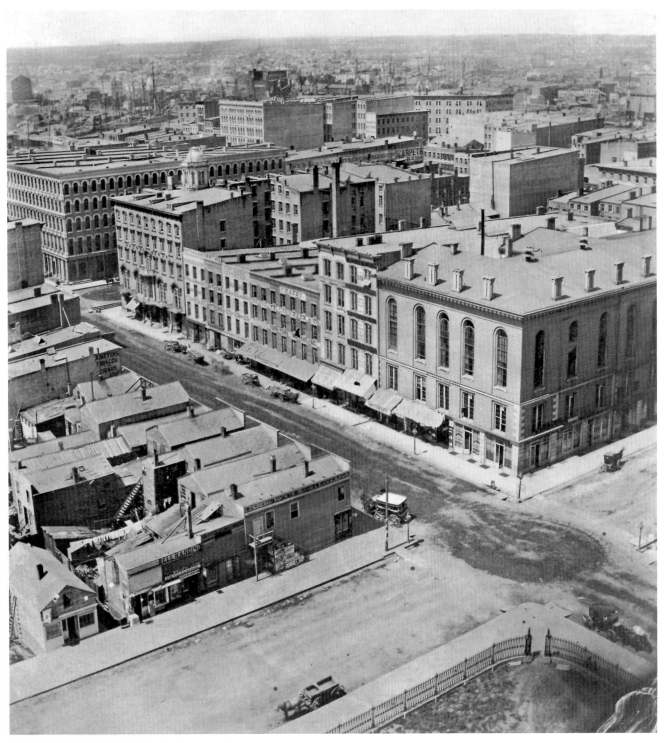

The Bismarck Hotel now stands on the south side of this intersection of LaSalle and Randolph.
In 1858, the Metropolitan Hall stood at this intersection.

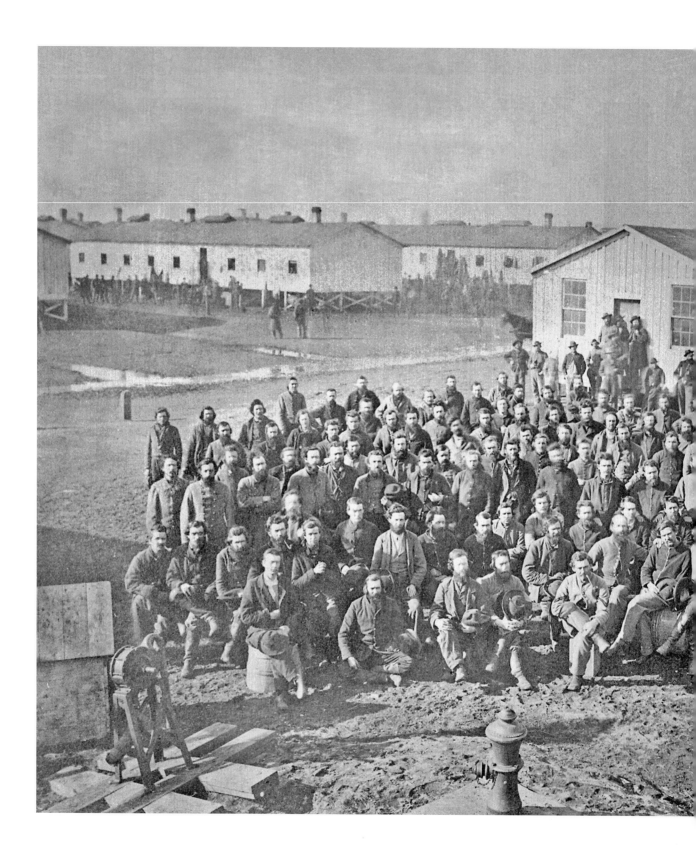

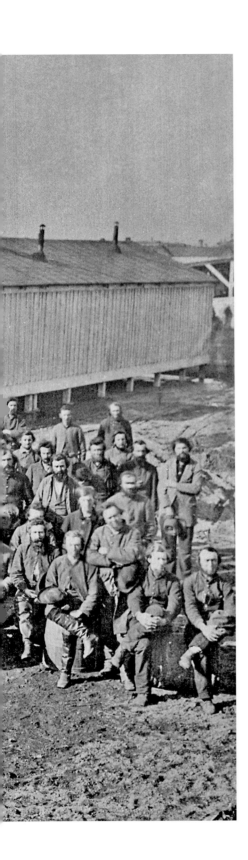

Confederate prisoners of war at Camp Douglas during the Civil War. Located at Thirty-First Street and Cottage Grove Avenue, Camp Douglas housed as many as 26,000 prisoners over the course of the war. Harsh conditions led to the deaths of some 4,000 men, who were buried in unmarked graves in Chicago's City Cemetery. When it closed in 1867, their remains were moved to a mass grave at Oak Woods Cemetery. A monument was erected at the "Confederate Mound" in 1893.

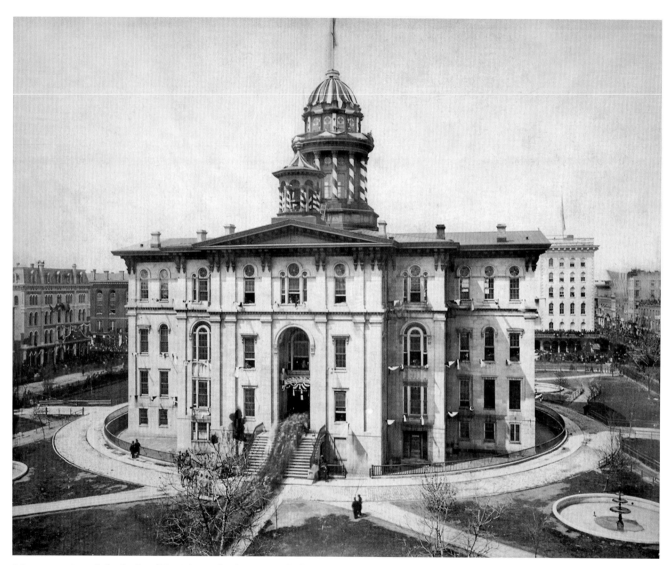

Mourners viewed the body of President Abraham Lincoln lying in state at the courthouse in Chicago, one of the stops on the journey from Washington, D.C. to Springfield, Illinois. In Chicago, Lincoln's remains were transferred to a special train equipped with George Pullman's first "Pioneer" palace car.

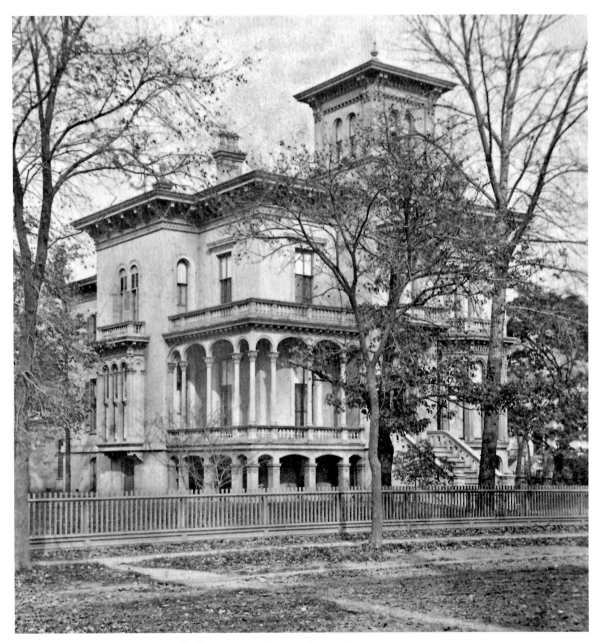

The George Rumsey mansion at Rush and Huron in 1871 before the fire.

Pine Street was the name given to the continuation of Michigan
Avenue north of the river, today known at the "Magnificent Mile".

THE GREAT FIRE
AND RECONSTRUCTION

1871–1900

On the evening of October 9, 1871, a fire broke out on DeKoven Street in the barn of Patrick and Catherine O'Leary. Drought conditions in Chicago had made the wooden city particularly vulnerable, and small fires had erupted over several months. But this fire was different. Fanned by a brisk northwesterly wind, the fire spread rapidly, and within hours the heart of Chicago was engulfed in flames. The Great Chicago Fire burned for thirty-one hours and left a three-and-a-half-square-mile landscape of urban devastation in the city's core. More than 18,000 buildings were reduced to ashes and blackened ruins, and nearly one-third of the city's 300,000 citizens were homeless; miraculously only 300 people perished.

Much of the industrial and transportation infrastructure, however, went unscathed; the economy recovered quickly, and Chicagoans rebuilt their city. The expansion of regional and national networks of rail lines in the 1870s and 1880s that made Chicago the central transfer point for people and freight throughout the continent fueled an urban juggernaut that transformed the city into a midwestern metropolis. Yet economic expansion and increased immigration brought labor strife that revealed deep class divisions within the city.

By 1890, Chicago was the city of the century. Its population of 1,009,850 made it second only to Philadelphia and represented a thirty-seven-fold increase since 1830. Eastern and southern European immigrants joined the city's established ethnic groups, and the number of African Americans doubled. As a result of large-scale annexations in 1889, Chicago encompassed 182.9 square miles, making it physically the largest city in the world. And it looked different too. The construction of the Home Insurance Building in 1885 with its steel skeletal frame launched the skyscraper, and in 1892 the first elevated railway (the "L") appeared. But the defining moment came in 1893, 23 years after the Great Fire, when Chicago hosted the World's Columbian Exposition on 628 acres in Jackson Park, and twenty-seven million visitors marveled at the beauty and harmony of the White City and the novelty of the first Ferris Wheel. Chicago had exceeded all expectations and inspired a new urban vision.

Patrick and Catherine O'Leary lived with their five children in the rear
of this building at 137 DeKoven Street. They rented out the front two
rooms. The Chicago Fire Academy now stands on this site.

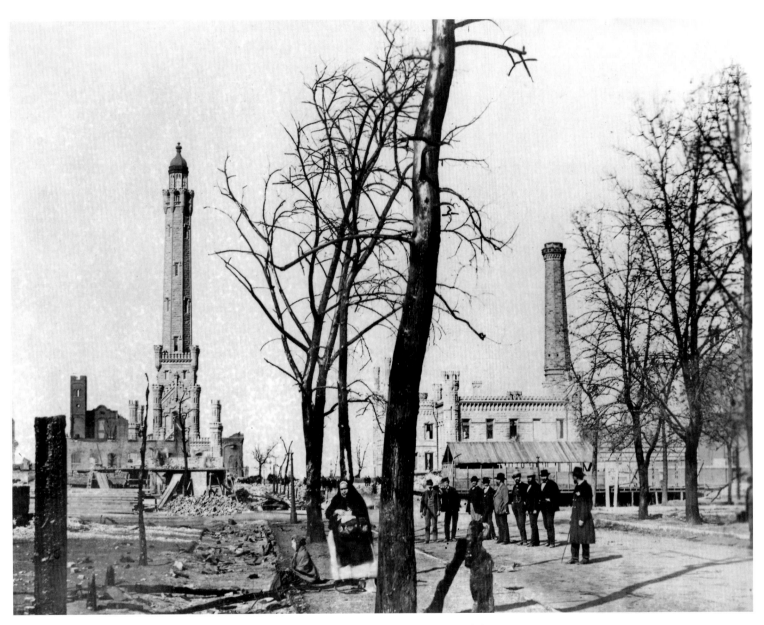

The survival of the Water Works and the Water Tower made these structures vital symbols of the city.

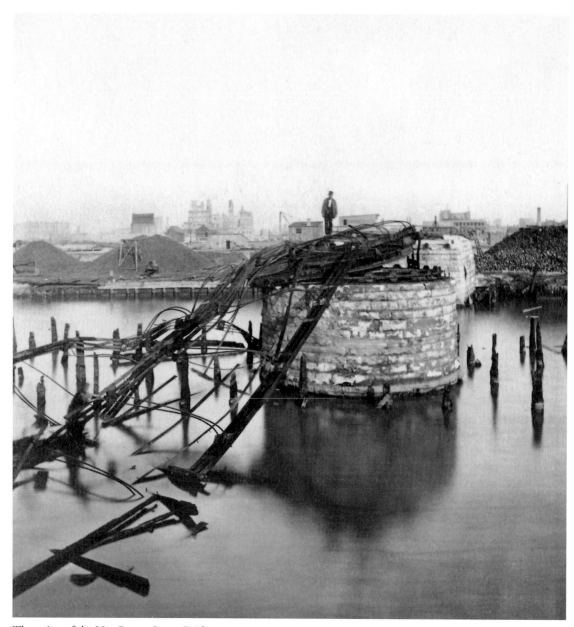

The ruins of the Van Buren Street Bridge.

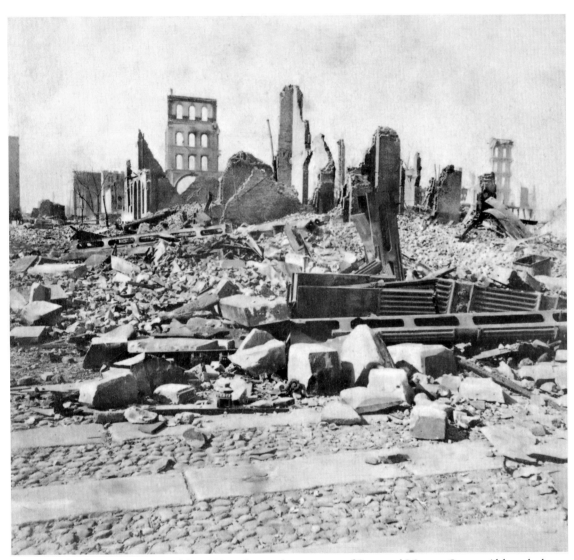

The second Palmer House opened in 1871 at the southeast corner of State and Monroe Streets. Although the building burned, the records of architect J.M. Van Osdel, buried in the basement in a pit covered with sand and clay, came through the fire. This is said to have been the inspiration for clay tile in fireproofing.

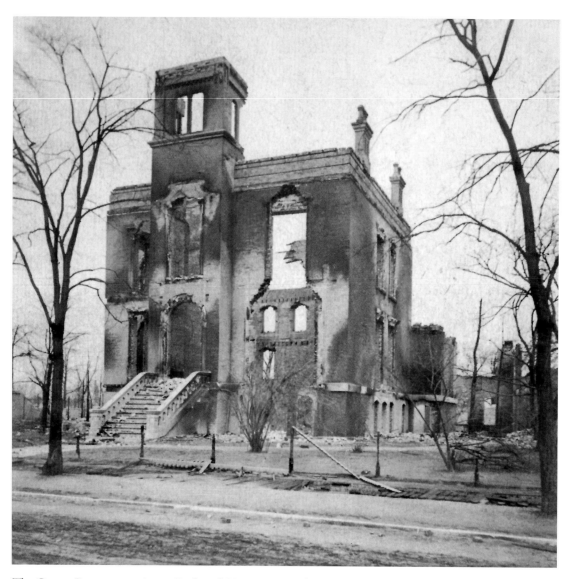

The George Rumsey mansion at Rush and Huron Streets after the fire.

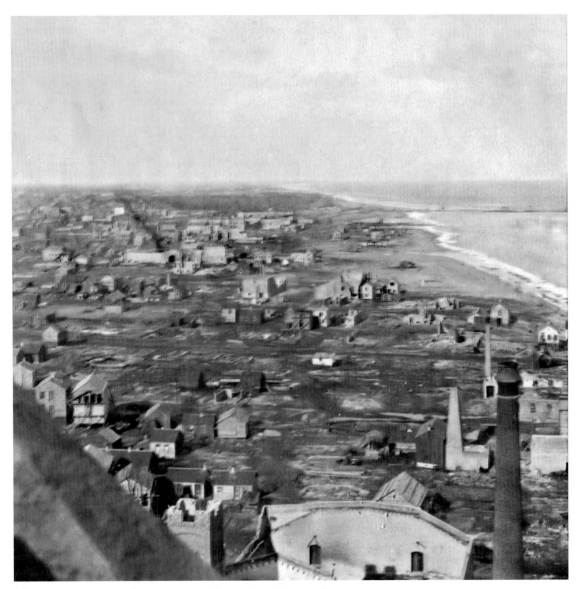

The Water Tower served as a vantage point for this photograph
showing the rebuilding of the city to its north.

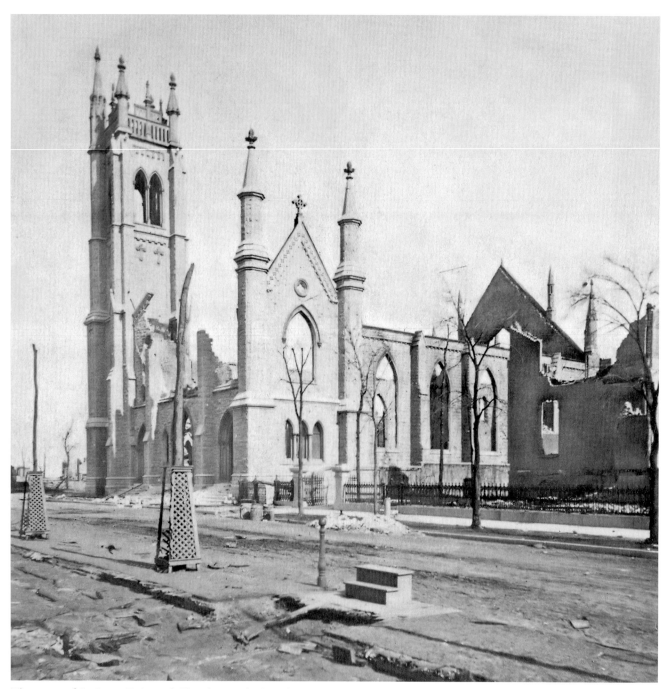

The tower of St. James Episcopal Church at Wabash and Huron withstood the fire, although the main building was destroyed.

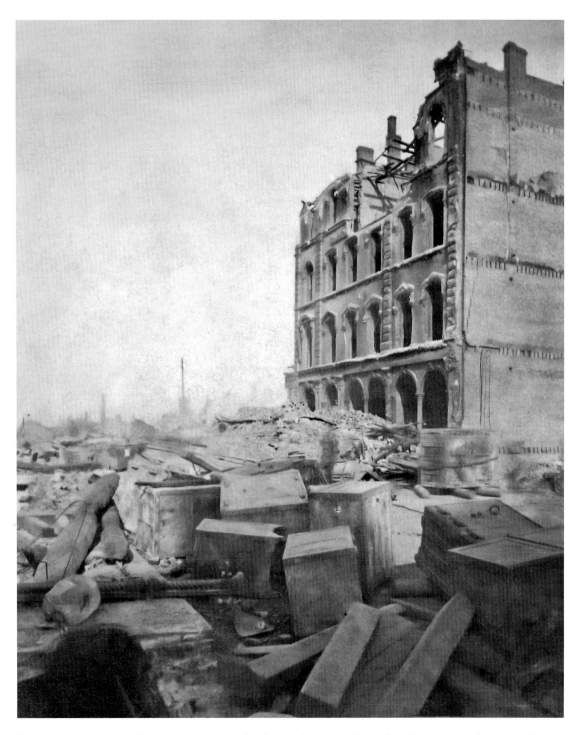

The large objects in the foreground may be safes that made it through the fire. Survivors recalled that safe breaking was a popular industry for a few days following the fire. However, the efforts were usually fruitless, as the rolls of bills often crumbled to dust when the safe doors swung open.

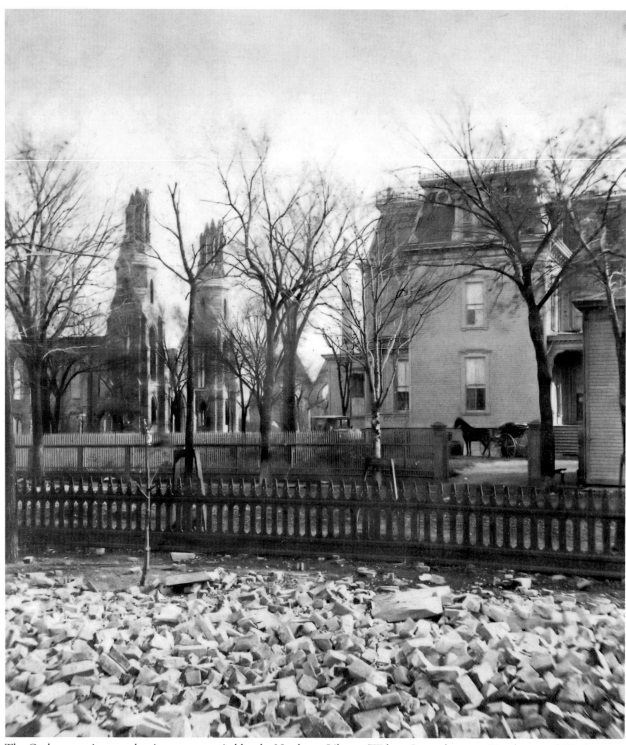

The Ogden mansion, on the site now occupied by the Newberry Library (Walton Street, between Dearborn and Clark Streets), was saved partly by a shift in the wind and partly by covering portions of the building with soaked carpets.

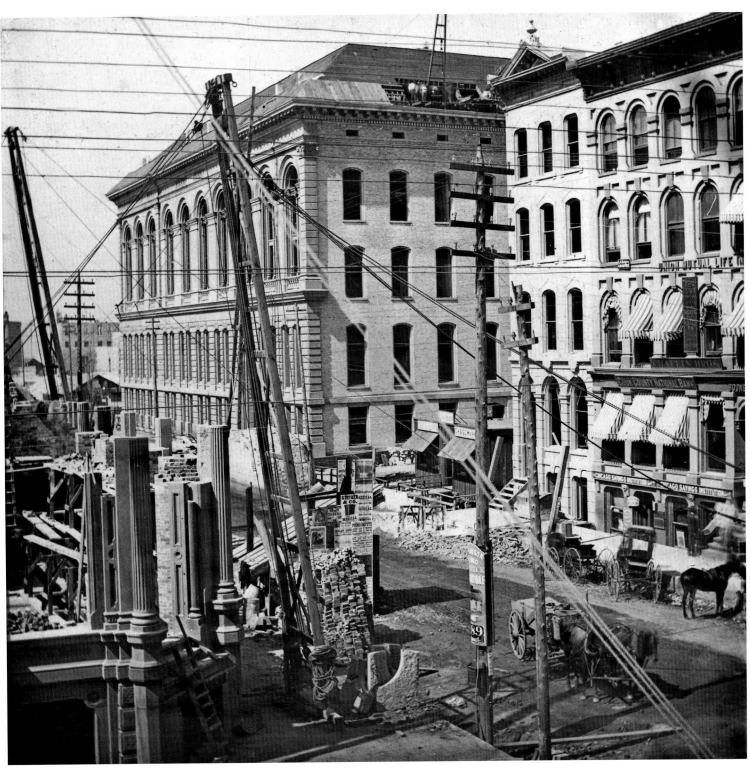

The Chamber of Commerce building was rebuilt on its original site on the southeast corner of LaSalle and Washington.

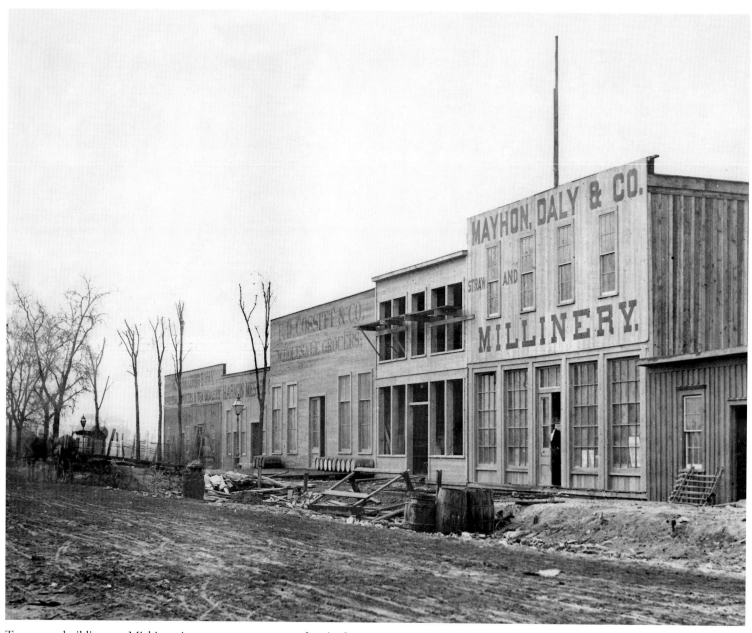

Temporary buildings on Michigan Avenue sprung up soon after the fire.

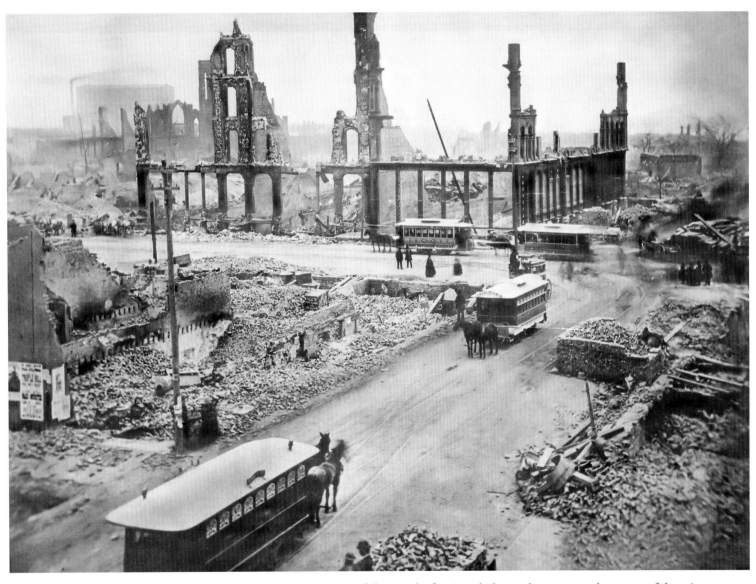

The remains of "the world's busiest intersection," (State and Madison) following the fire. Broadsides can be seen posted on some of the ruins.

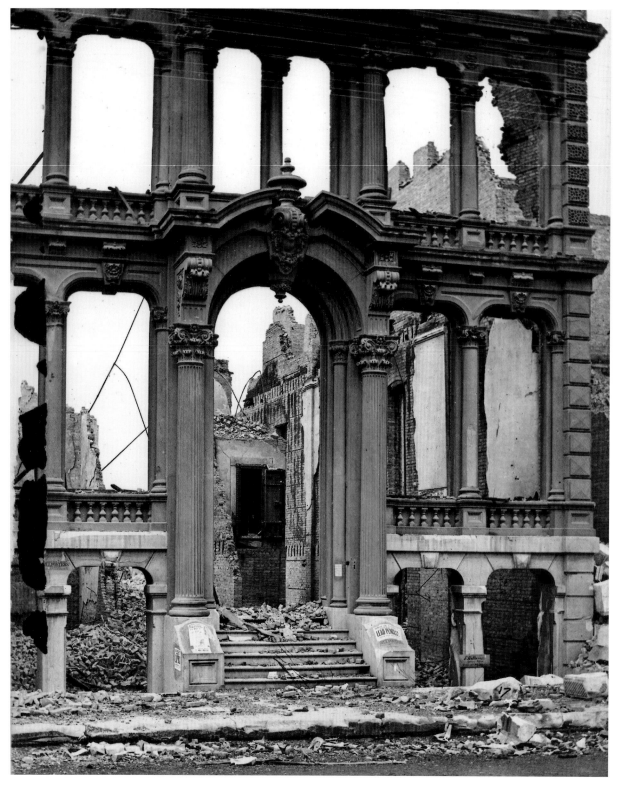

Located at 112-116 Wabash, the Farwell Building was the site of the oldest dry goods firm in the city, John F. Farwell & Company. Owned by brothers John V. and Charles B. Farwell and three other partners, the company would soon rebuild on the northwest corner of Monroe and Franklin Streets.

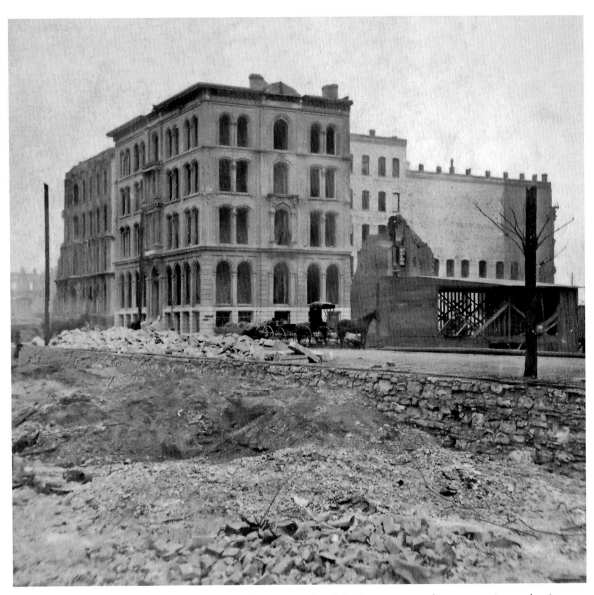

The Nixon Building, at the northeast corner of Monroe and LaSalle Streets, was under construction at the time of the fire. Afterward, an inscription boasted, "This fireproof building is the only one in the city that successfully stood the test of the Great Fire of October 9, 1871."

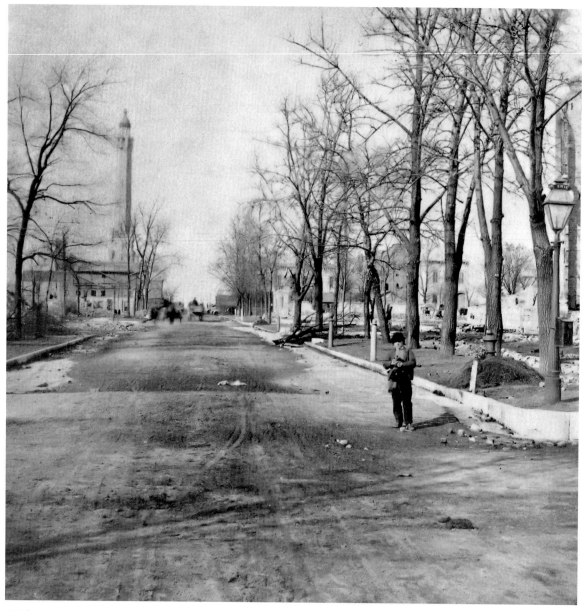

Michigan Avenue north of the Chicago River (then known as Pine Street) as it appeared after the fire.

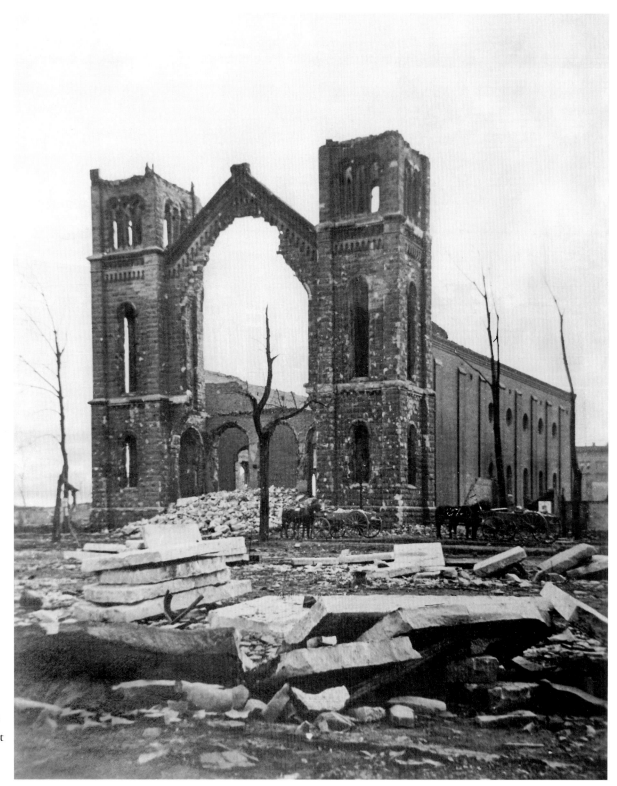

The Trinity Episcopal
Church was located, at
the time of the fire, on the
south side of Jackson Street
between Michigan and
Wabash Avenues

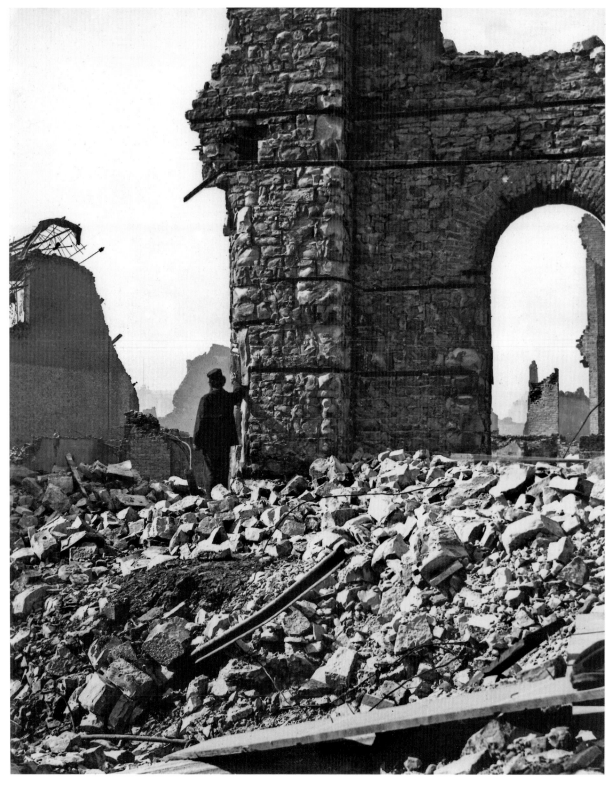

The once-bustling Union Depot on Van Buren Street, reduced to a pile of rubble. After the fire, all railroad trains on the south side stopped at Twenty-second Street, two miles south of their usual terminus.

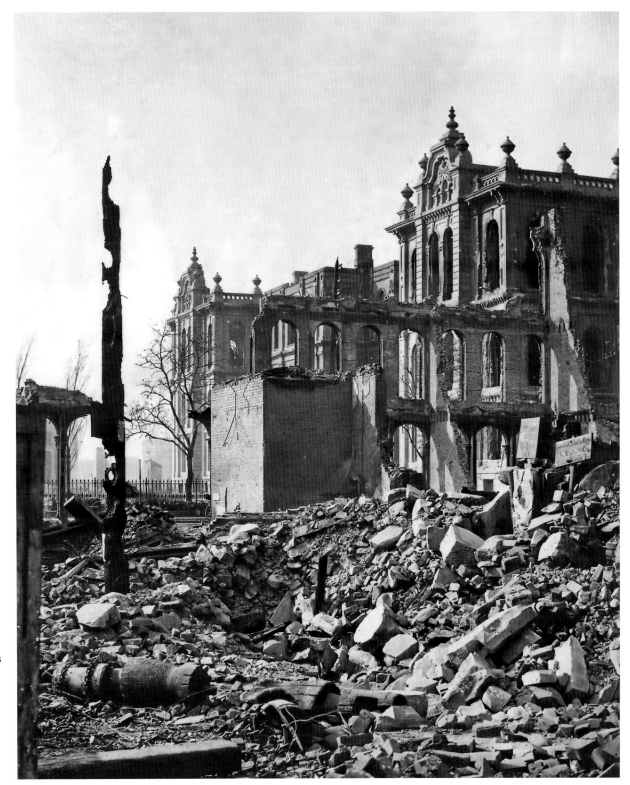

Post Office and Custom House, 1871. Haverley's Theater benefited from the destruction of this building--parts of its ruins were re-used in construction of the theater.

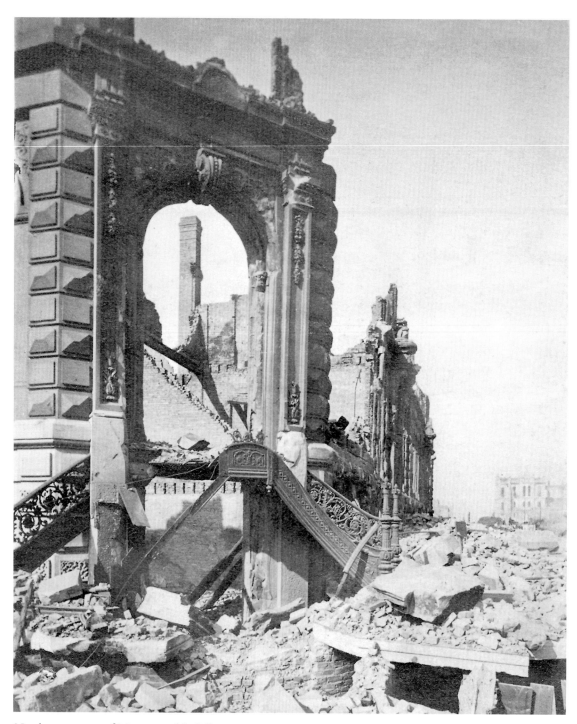

Northwest corner of Monroe and LaSalle

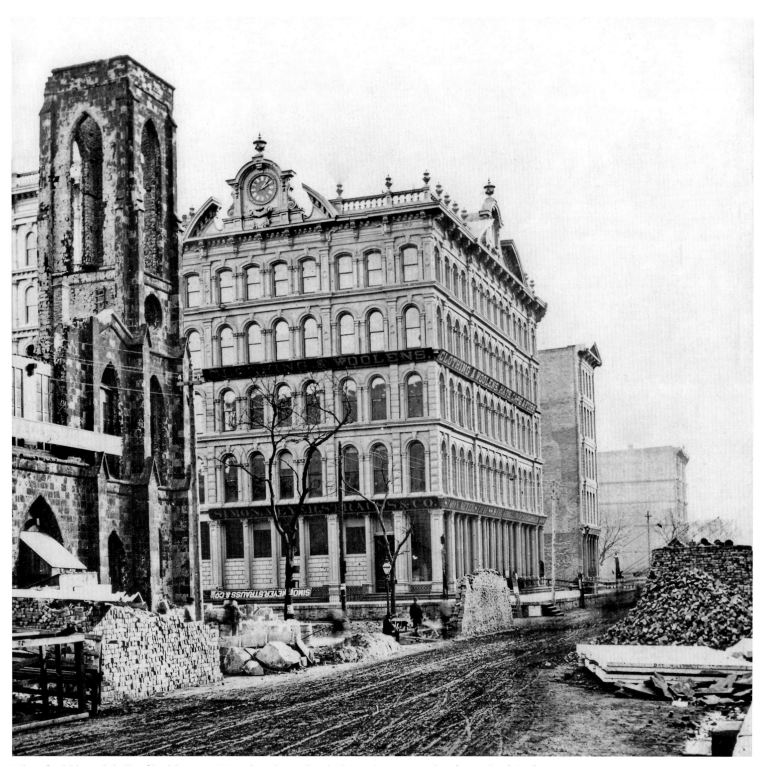

Piles of rubble and shells of buildings awaiting demolition lined Chicago's streets in the aftermath of the fire.

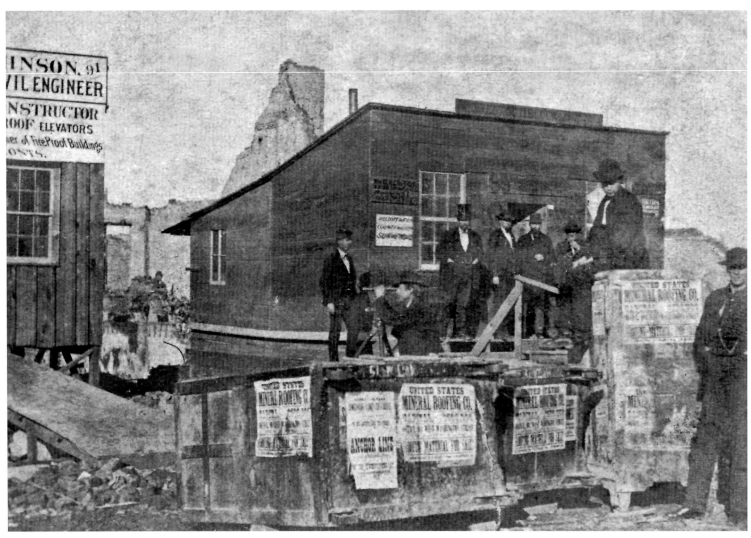

Samuel Kerfoot's famous declaration "All gone but WIFE CHILDREN and ENERGY," appeared the day after the fire on a sign in front of his immediately re-opened real estate business.

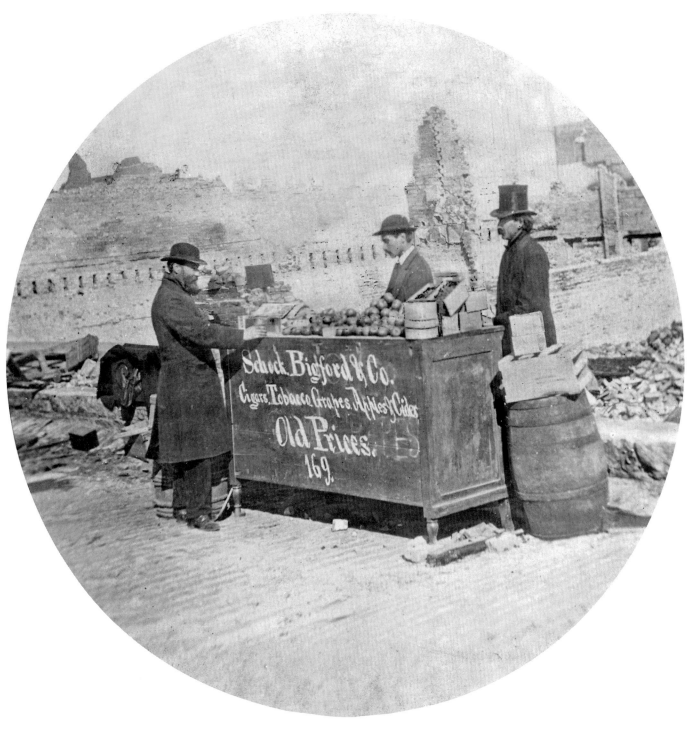

Schock, Bigford & Company, with its stock of cigars, tobacco, grapes, apples, and cider at "Old Prices," is believed to be the first store re-opened in the ruins.

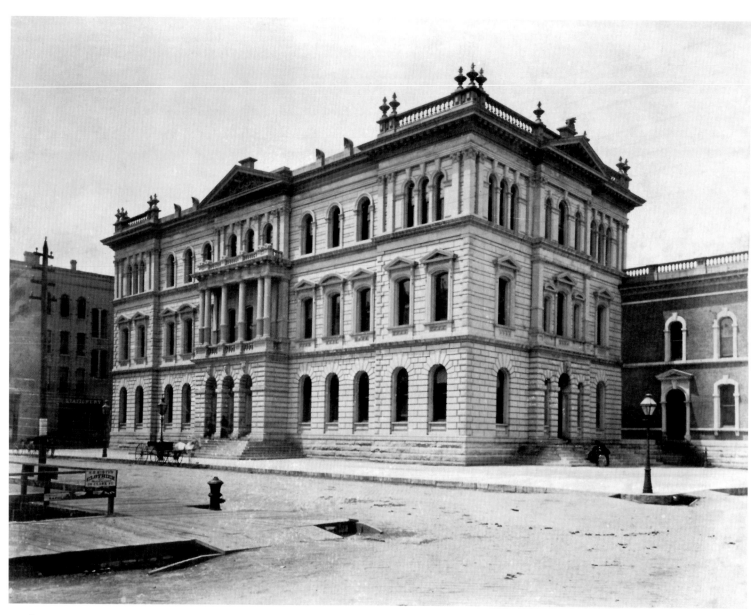

Cook County Criminal Court Building and jail, 1879.

Cyrus Hall McCormick owed his business success in large part to his marketing genius. He sold his reapers with a money back guarantee, a fixed price, and purchases on credit. After his death in 1884, his son took over the company. Labor unrest at his factory in May 3, 1886, led to the deaths of two workers at the hands of police. Outraged workers called for a protest at Haymarket Square the following day.

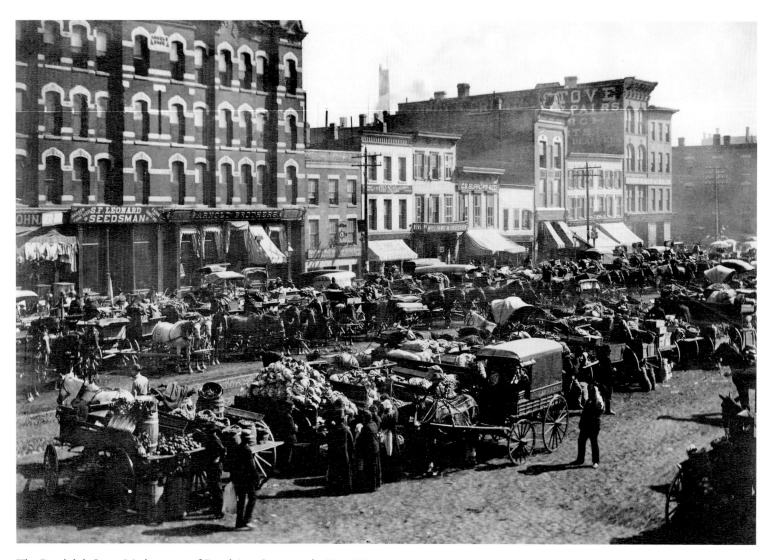

The Randolph Street Market, west of Desplaines Street on the Near West Side, was the site of the Haymarket Riot in 1886. The May 4th rally started so peacefully that Mayor Carter Harrison left early. But when an unknown person threw a bomb into the police line that had formed to disperse the crowd, one officer was killed immediately. Police opened fire on the crowd, injuring and killing both protestors and police.

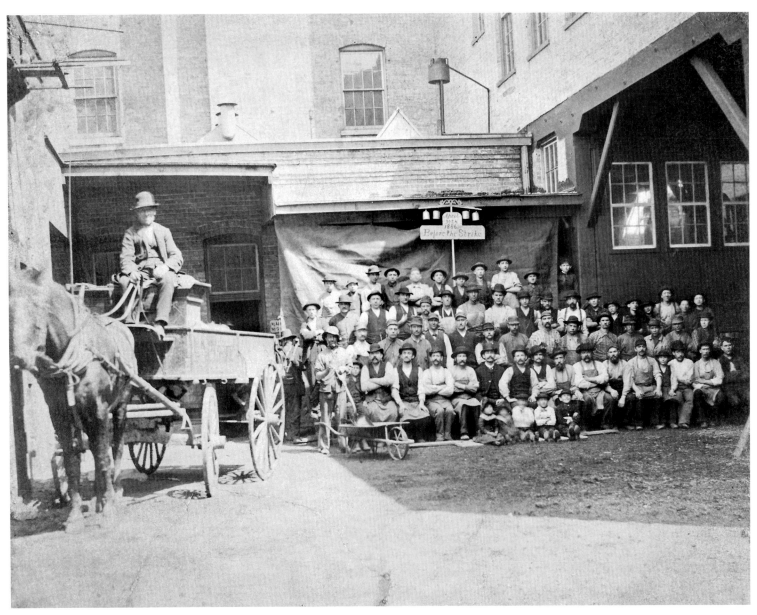

Workers at the Horn Brothers Furniture Company gather for a group portrait on April 30, 1886. The banner in the midst of the workers had the date with the notation "Before the strike." This was a reference to the nationwide one-day labor walkout scheduled on May 1, 1886, in support of an eight-hour work day.

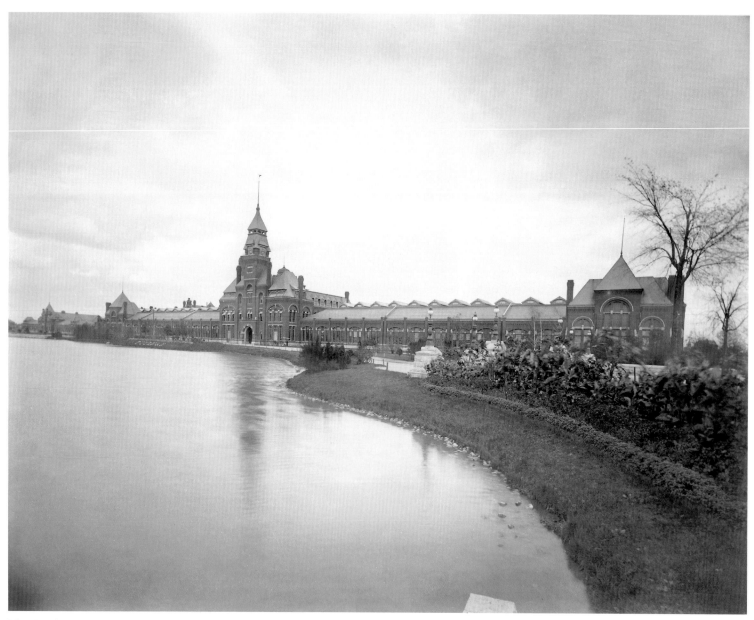

The South Factory wing is seen from across Lake Vista in the 1880's. In keeping with George Pullman's demand for efficiency and self-sufficiency, the manmade Lake Vista served a dual purpose. The exhaust from the giant Corliss engine, which powered the factory, filled Lake Vista. Then workers used the ice from the lake on Pullman cars.

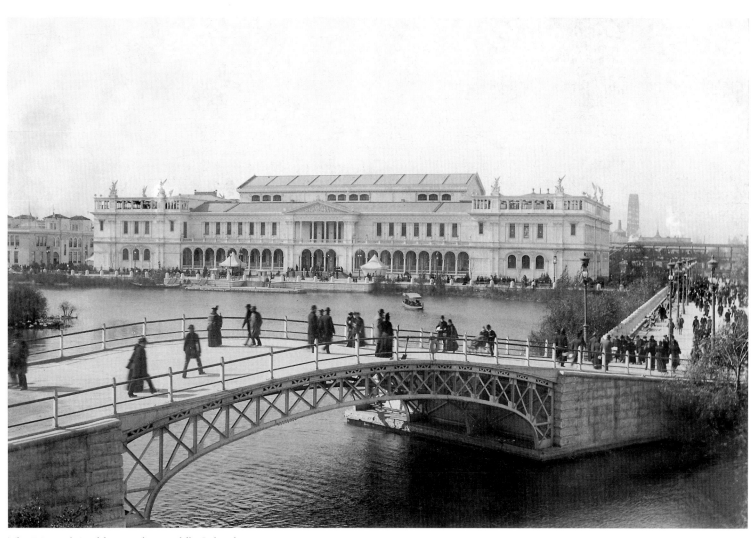

The Woman's Building at the World's Columbian Exposition.

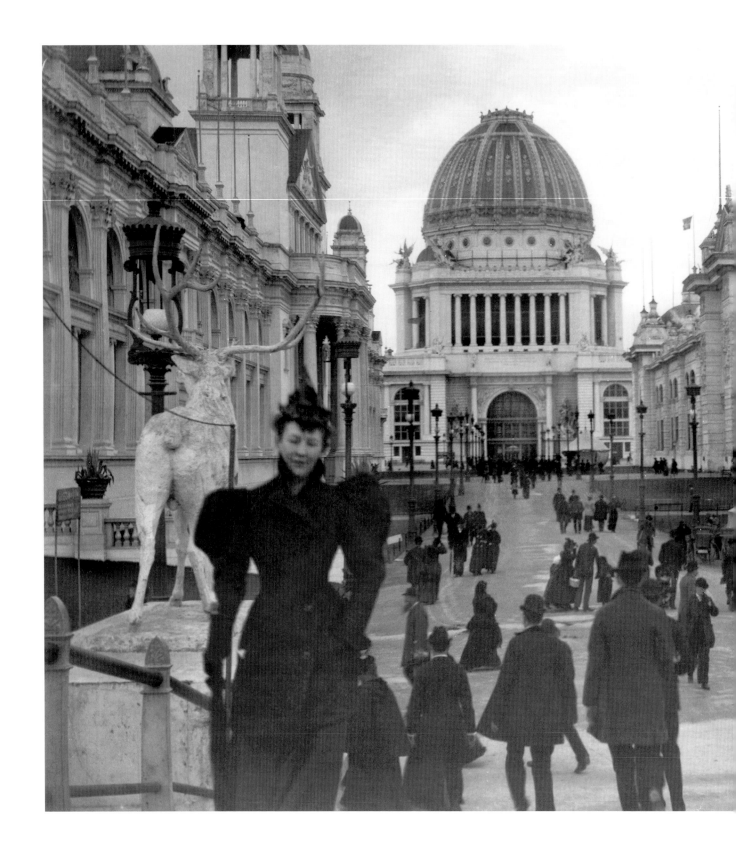

"Chicago Day" at the Columbian Exposition was held
October 9, 1893 on the anniversary of the Great Fire.

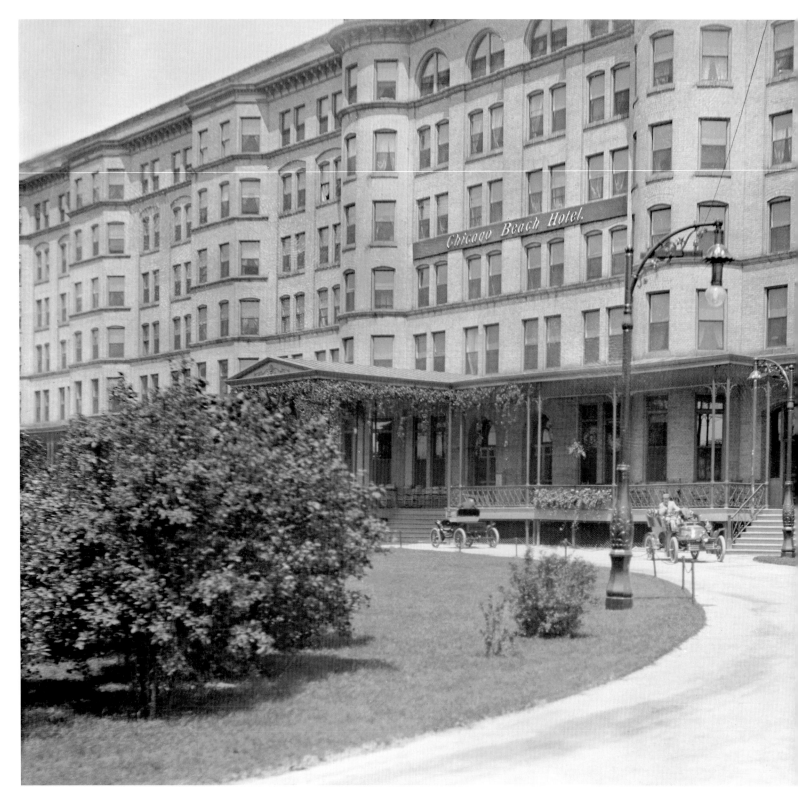

48

Located at Hyde Park Boulevard and 51st Street, the Chicago Beach Hotel was built in 1892.

Many hotels were built in the Hyde Park area in anticipation of crowds for the World's Columbian Exposition of 1893 and later converted to luxury hotels or apartments.

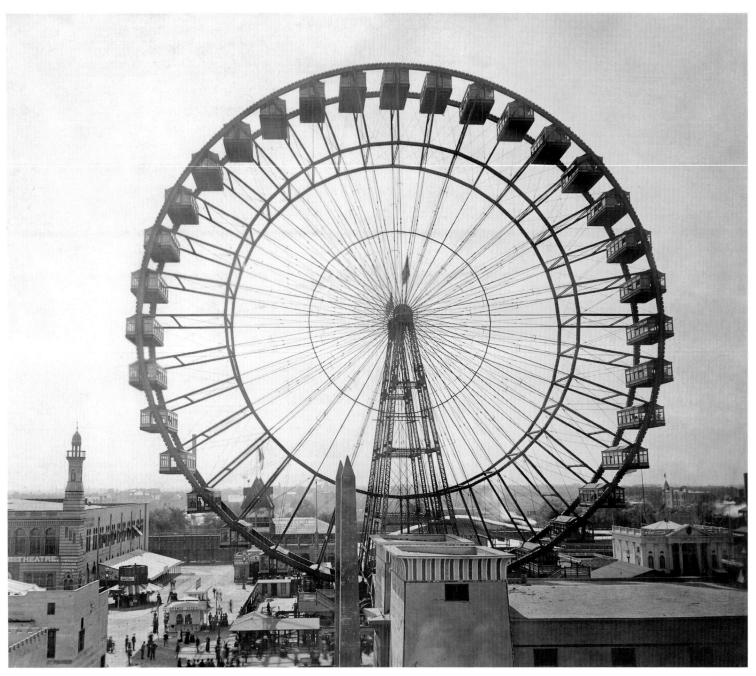

The world's first Ferris Wheel, invented by George Ferris, dominated the Midway at the 1893 World's Columbian Exposition. The 264-foot high structure had 36 cars, each carrying as many as 60 passengers. In 1894, it was dismantled and later rebuilt at North Clark Street and Wrightwood Avenue. It remained there until 1903 when it was again dismantled, to be moved to St. Louis for the Louisiana Purchase Exposition.

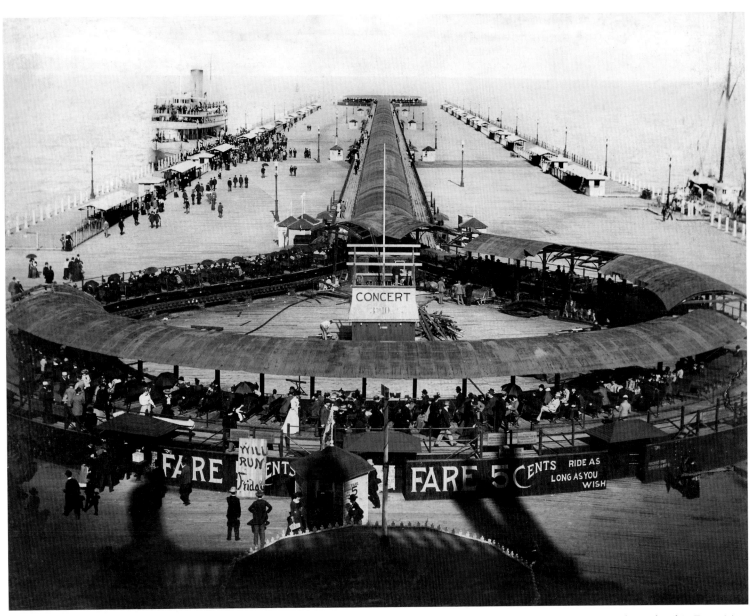

Fairgoers could arrive by boat, get off at the pier and take this movable sidewalk to the entrance to the Court of Honor. The Columbia Exposition occupied 630 acres in Jackson Park and the Midway Plaisance. The main exposition site was bounded by Stony Island Avenue on the west, 67th Street on the south, Lake Michigan on the east, and 56th Street on the north, with the Midway Plaisance extending west between 59th and 60th streets to Cottage Grove.

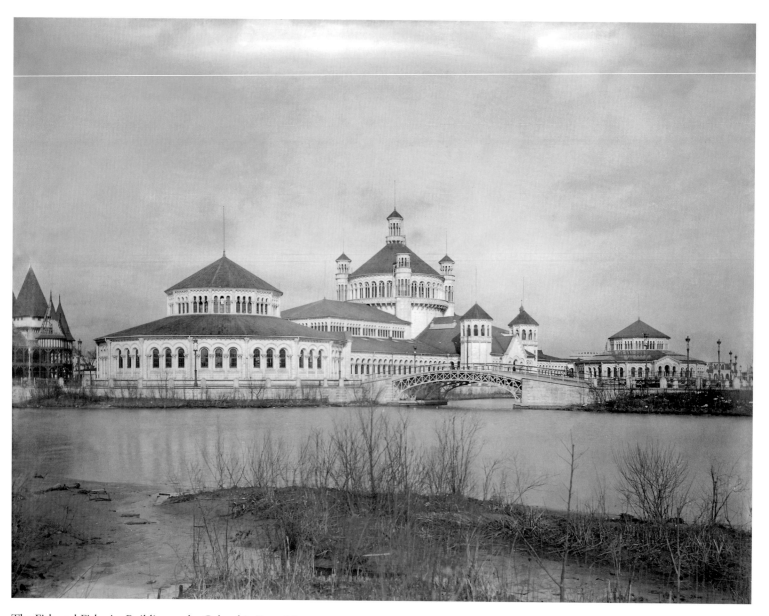

The Fish and Fisheries Building at the Columbia Exposition.

PLANS FOR A GREAT CITY

1900–1917

The opening of the 28-mile-long Sanitary and Ship Canal in 1900 was the realization of multiple efforts over many years by Chicago to permanently reverse the flow of the Chicago River and send the city's waste south, thus ensuring a clean and plentiful supply of drinking water drawn from Lake Michigan for its citizens. But the canal also signaled a new municipal will devoted to making Chicago more livable. The fullest expression of this civic reform movement was the publication in 1909 of the *Plan of Chicago* by Daniel Burnham and Edward Bennett. Reflecting the tenets of the city beautiful movement, which had been inspired by Chicago's White City in 1893, and a progressive activism aimed at the modern city and urban society, the *Plan* envisioned Chicago as a rationally planned city where capitalism, beauty, and social order mutually reinforced each other. From a practical perspective, the *Plan* provided a metropolitan solution to Chicago's regional rail and traffic congestion; the city was literally choking on its success.

Chicago industries, such as meatpacking and breweries, continued to dominate the region and supply national markets, and labor strife intensified in 1904 when packinghouse owners brought in African Americans as strikebreakers. But beginning in 1916, Chicago industries opened their doors to African Americans to meet war-related labor shortages. Encouraged by the *Chicago Defender,* the city's first African American newspaper founded by Robert Sengstacke Abbott in 1905, and direct rail lines from the rural South to the city, thousands of Southern blacks sojourned north to begin a new life in Chicago.

Tragedy gripped the city in 1903 when 603 victims died in the Iroquois Theater Fire and again in 1915, when the Great Lakes steamer *Eastland* capsized in the Chicago River and 844 passengers perished. White City and Riverview amusement parks brought affordable thrills to Chicagoans, and Comiskey Park (1910) and Weeghman Field (1914, later Cubs Park and Wrigley Field) ensured the popularity of baseball as an urban sport. Chicagoans cheered world champions White Sox (1906) and Cubs (1907-8), and in 1910, Rube Foster formed the American Giants, a black baseball team.

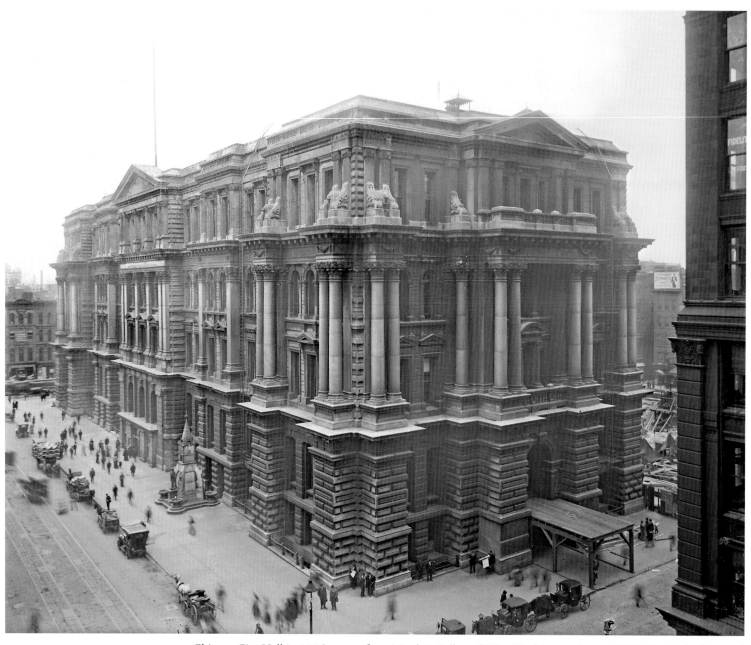

Chicago City Hall in 1906 as seen from North LaSalle and West Washington Streets. Visible in the background is the rubble left after the demolition of the formerly adjacent County Building.

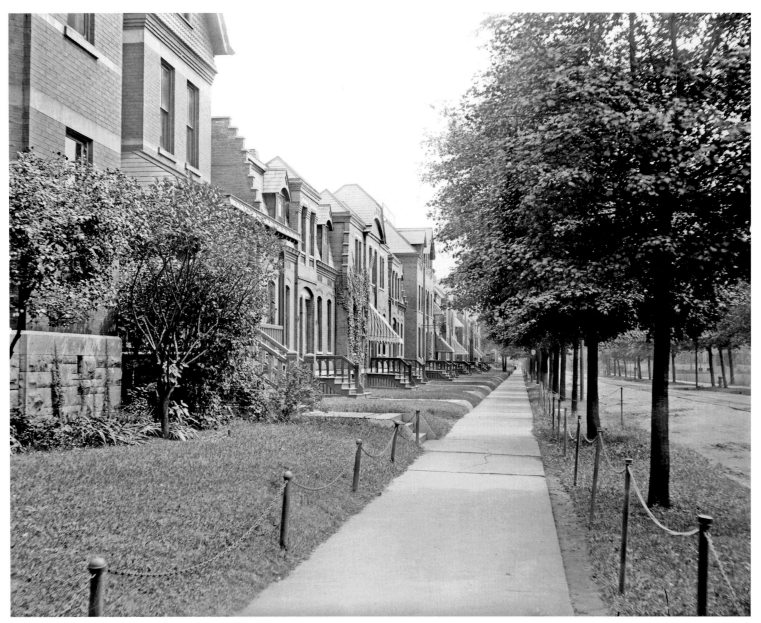

This row of townhouses at St. Lawrence Avenue and 111th Street was part of the "world's most perfect town" created by George Pullman in an attempt to both house workers in his Pullman Palace Car Company and bring in a six percent profit for the company. In addition to homes, Pullman built shops, a church, schools, and a library in the neighborhood surrounding the factory.

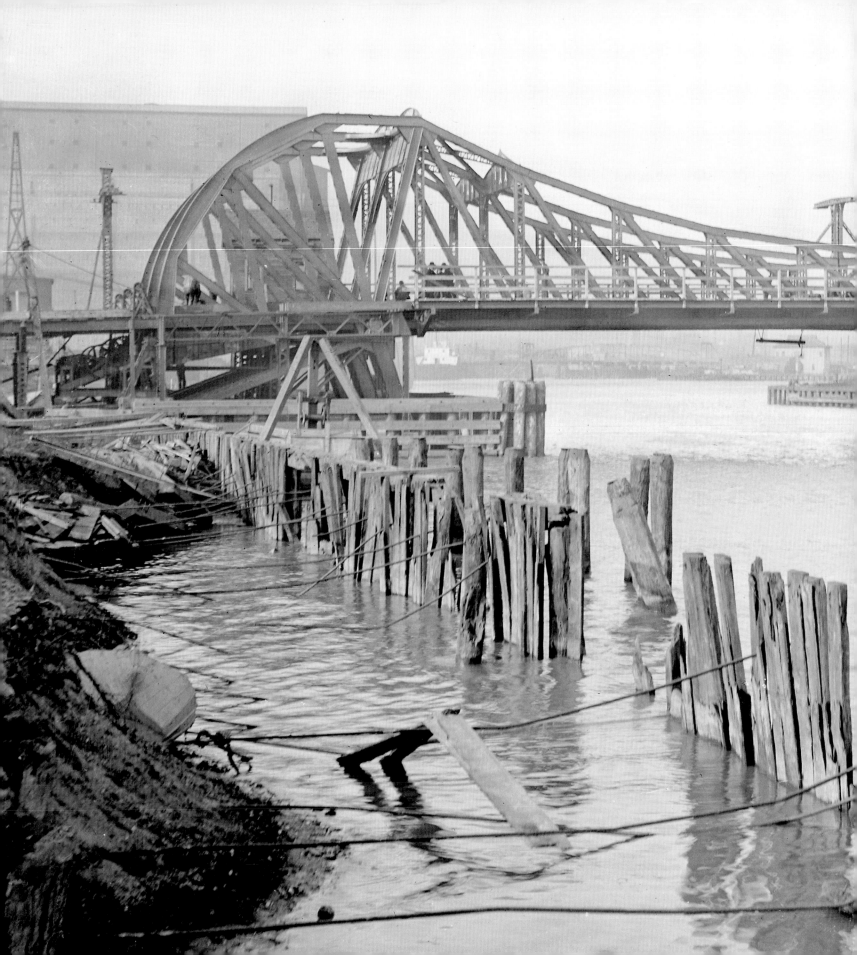

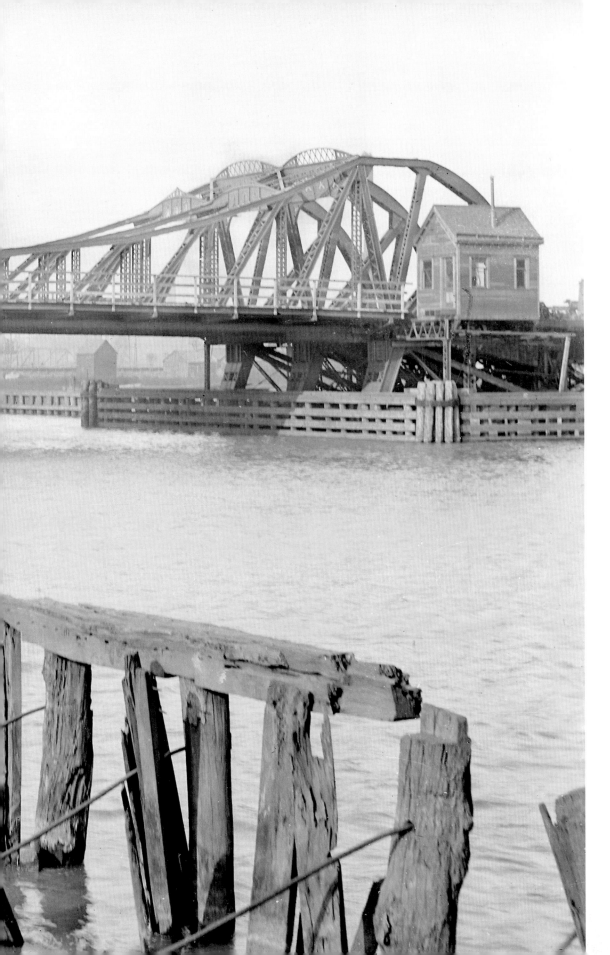

The 95th Street Bridge was a drawbridge to allow boat traffic along the Calumet River, Industrial development in this area started in 1869 when Congress appropriated money for a harbor in South Chicago. In 1903, when this picture was taken, the Calumet area was home to industry giants such as U.S. Steel South Works and the Pullman Works.

In 1870, Potter Palmer married Bertha Honore. Fifteen years later, they moved into a castle-like residence at 1350 North Lake Shore Drive. A portion of the Palmers' extensive art collection can be seen hung gallery-style on the walls in this image, taken in 1907. In the 1860's Potter Palmer started a dry goods business with Marshall Field and Levi Leiter, but soon left that business, going on to develop real estate on State Street.

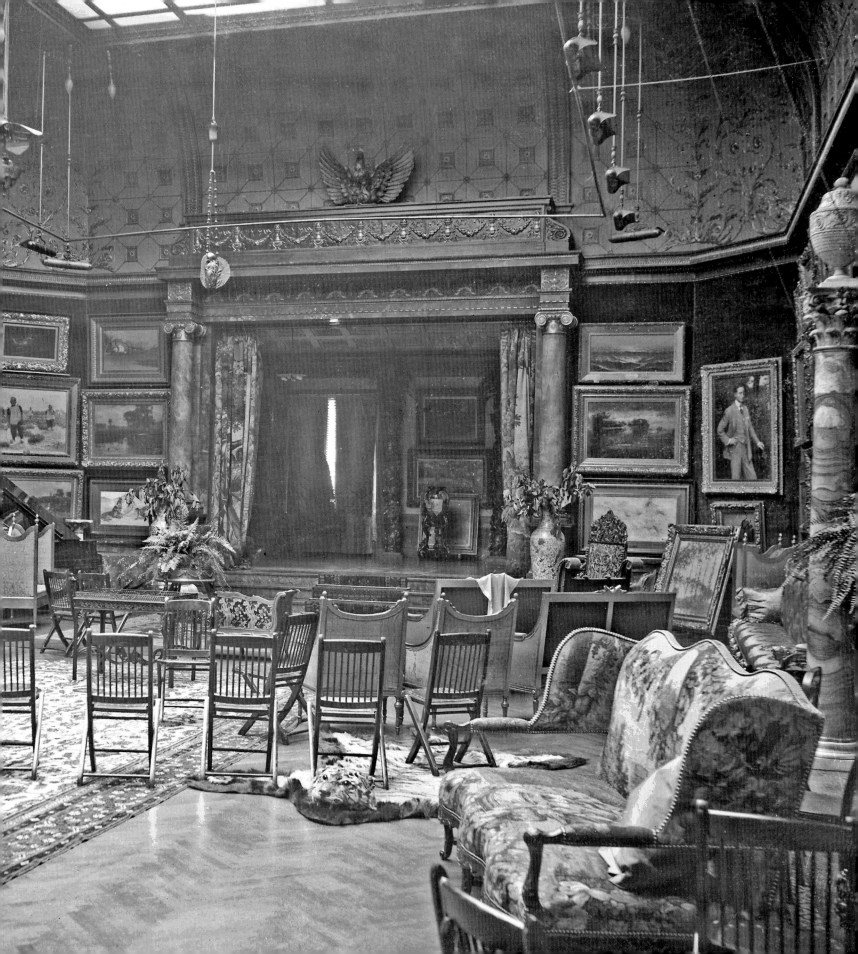

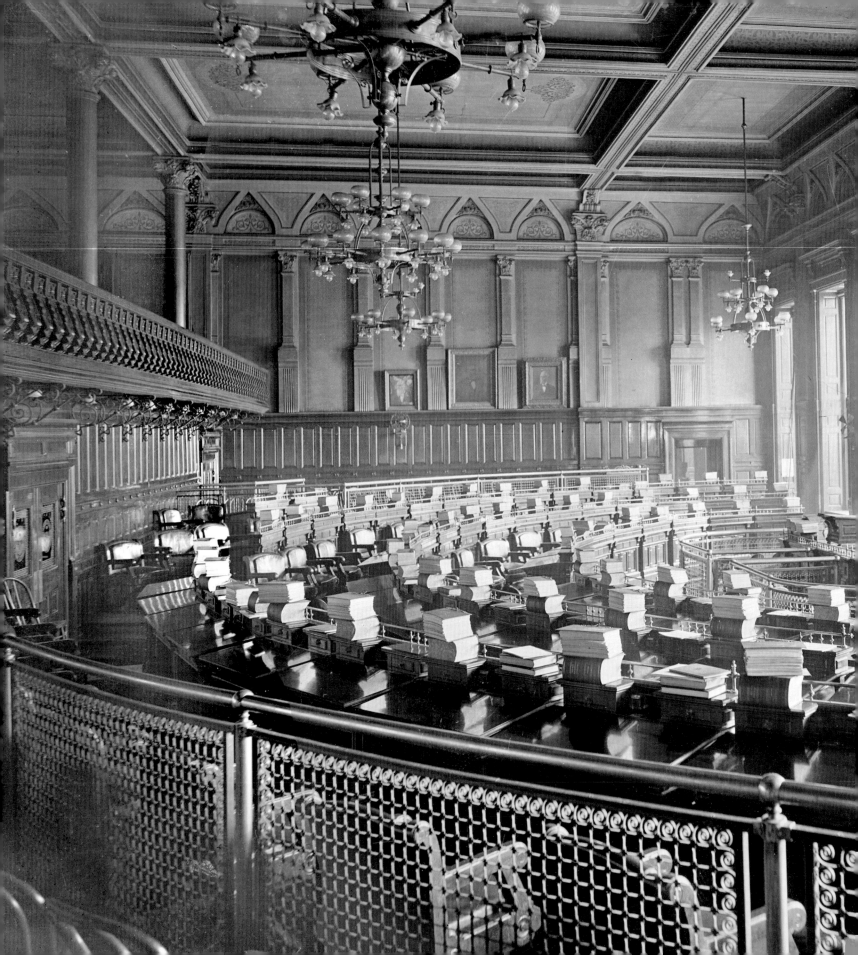

The speaker's rostrum, pictured in 1903, from behind the seating area of the City Council Chamber. This combined City Hall and County Building was completed in 1885, but did not survive long. Demolition to make way for the current city-county building began in 1906.

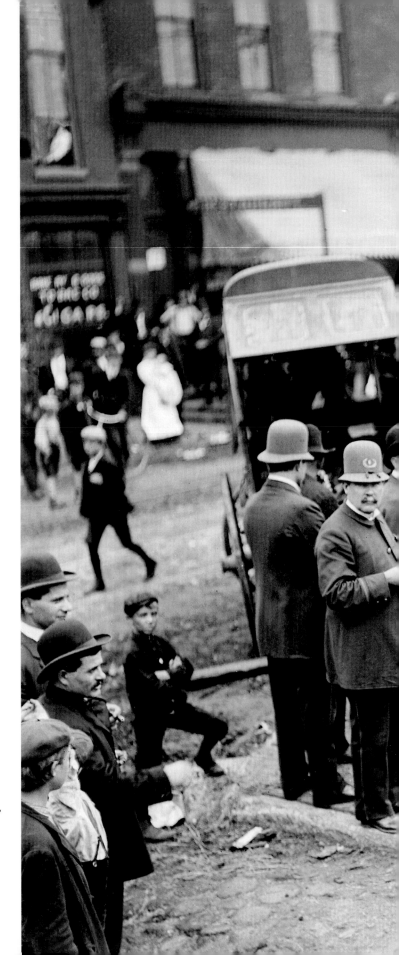

Workers struck the Union Stock Yard for the second time in 1904. Working conditions at the stockyards were very bad. However, an attempt by the Amalgamated Meat Cutters and Butcher Workmen's (AMC) to unionize failed, partially because of an inability to join people of various ethnic groups into a unified group.

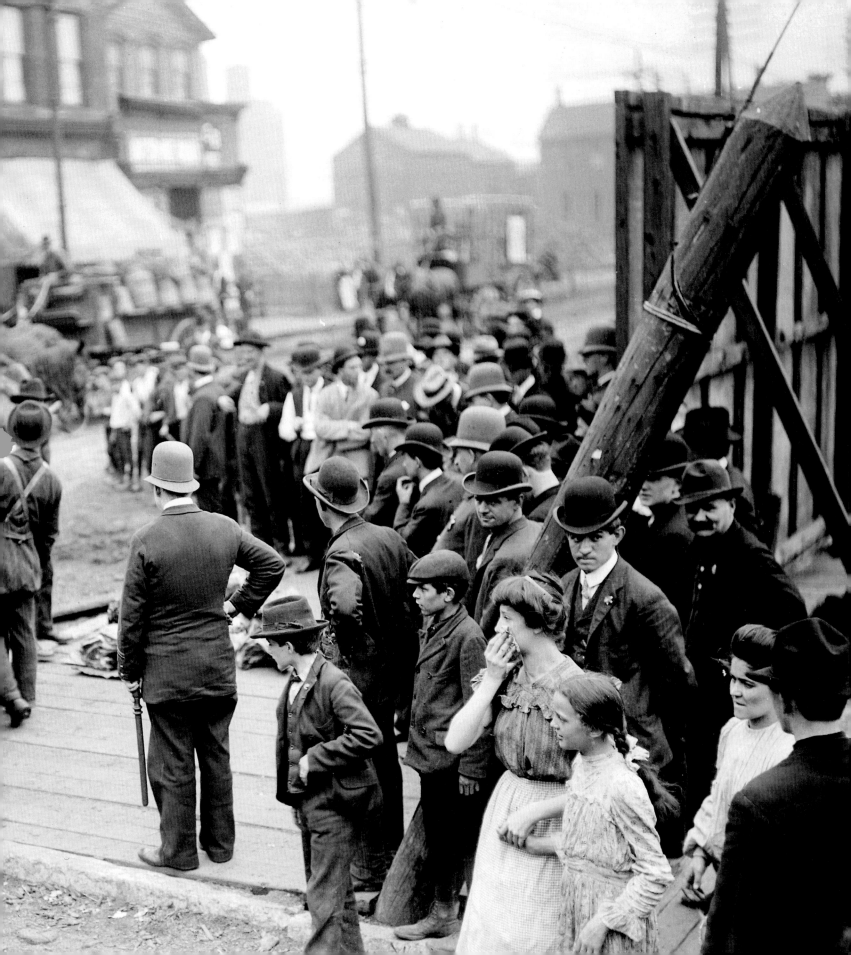

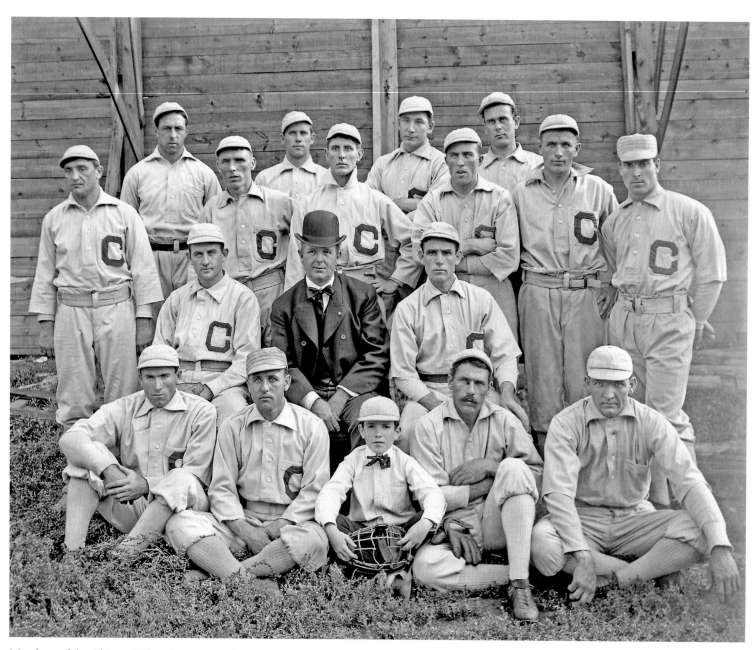

Members of the Chicago White Sox pose with owner Charles Comiskey in 1903. When Comiskey moved his White Stockings from St. Paul in 1900, headline editors began to shorten the team's name, and the team soon officially changed its name.

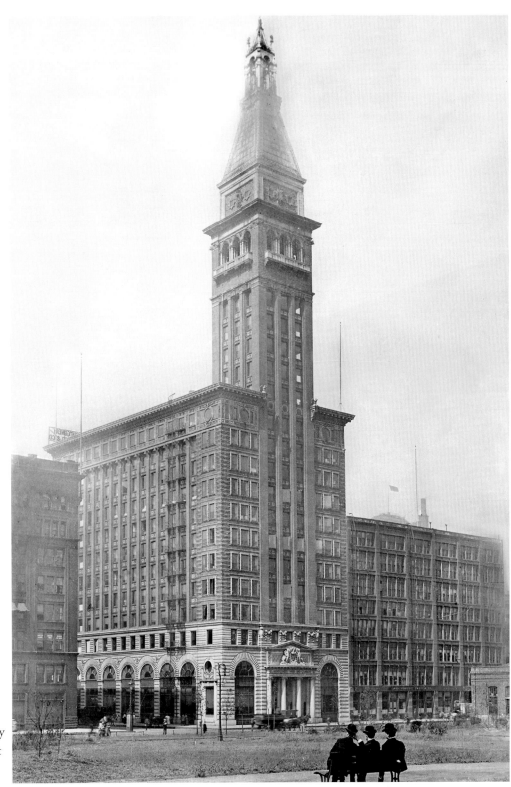

The Montgomery Ward and Company Administration building was erected at 6 North Michigan Avenue in 1899. Pictured here in 1903, the elaborate building was designed to evoke trust in the mail order business begun in 1872 by Aaron Montgomery Ward. At 394 feet tall, it was among the tallest buildings in the city when completed.

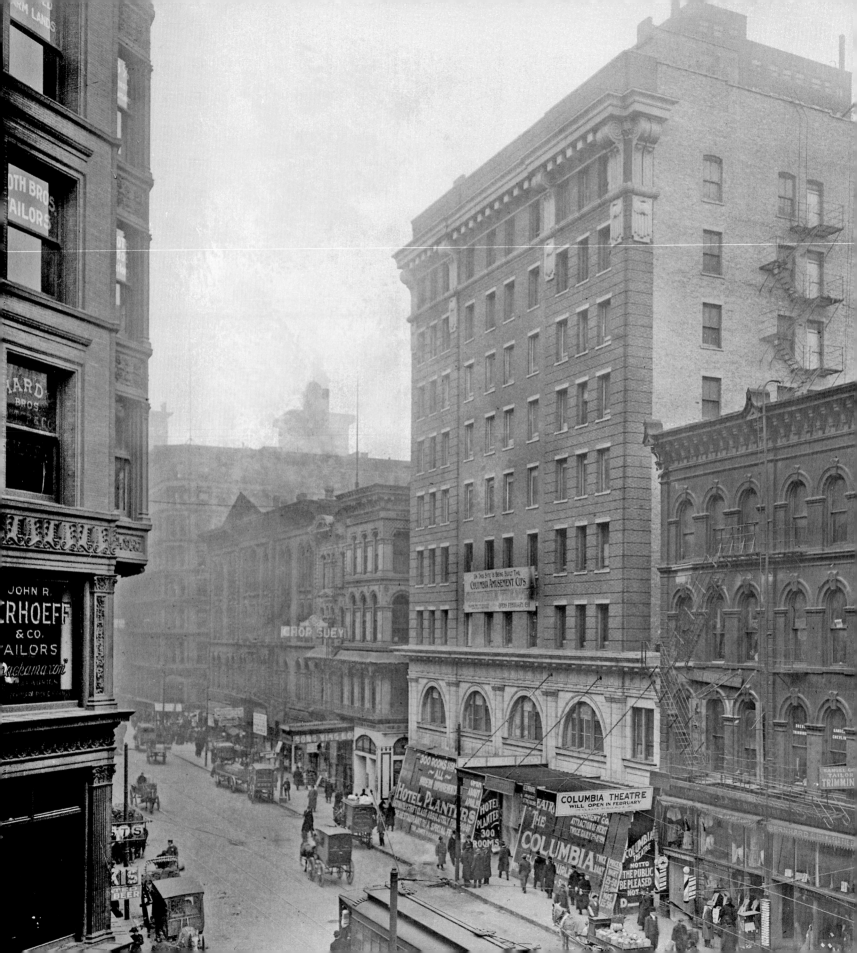

The corner of Clark and Adams. Berghoff's Restaurant is visible in the foreground. Herman Berghoff began selling his Dortmunder beer at this location in the 1890s. A Chicago institution, the restaurant closed in 2006. Carlyn Berghoff, daughter of the last owner, re-opened in the same space with a cafe and catering business.

One of the University of Chicago's main quadrangles, Hutchinson Court, was named in honor of Charles L. Hutchinson, one of the university's original benefactors. Buildings along the court were (from left to right): Hutchinson Hall, John J. Mitchell Tower, the Reynolds Club and Mandel Hall. The quadrangle is pictured shortly after it was built in 1903.

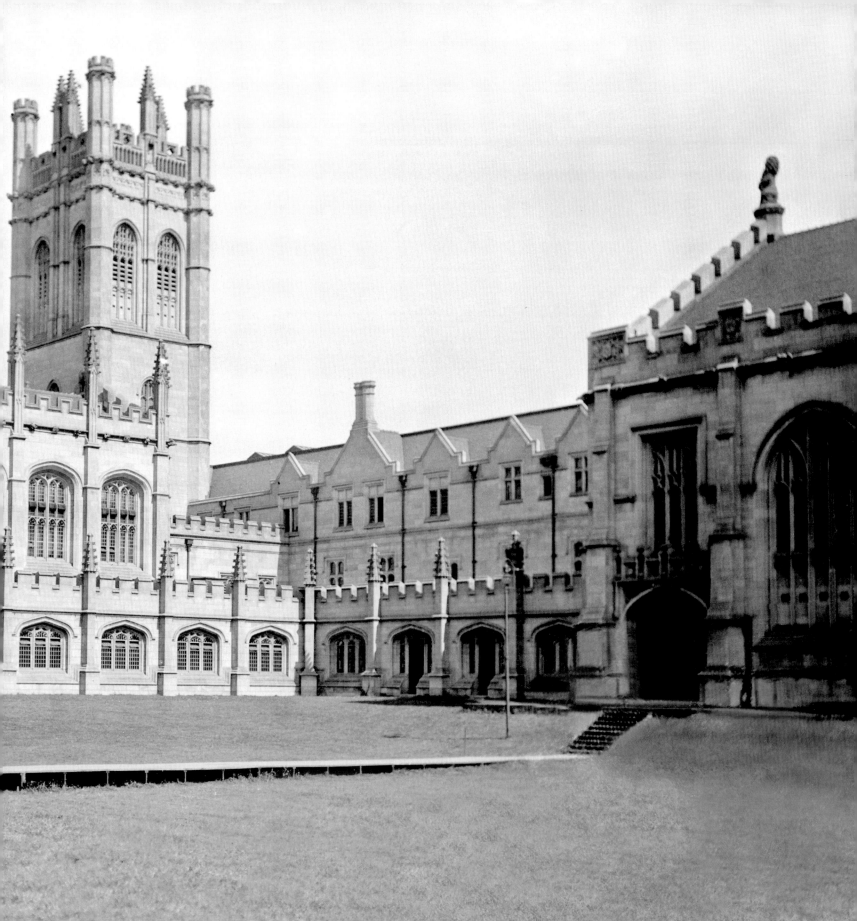

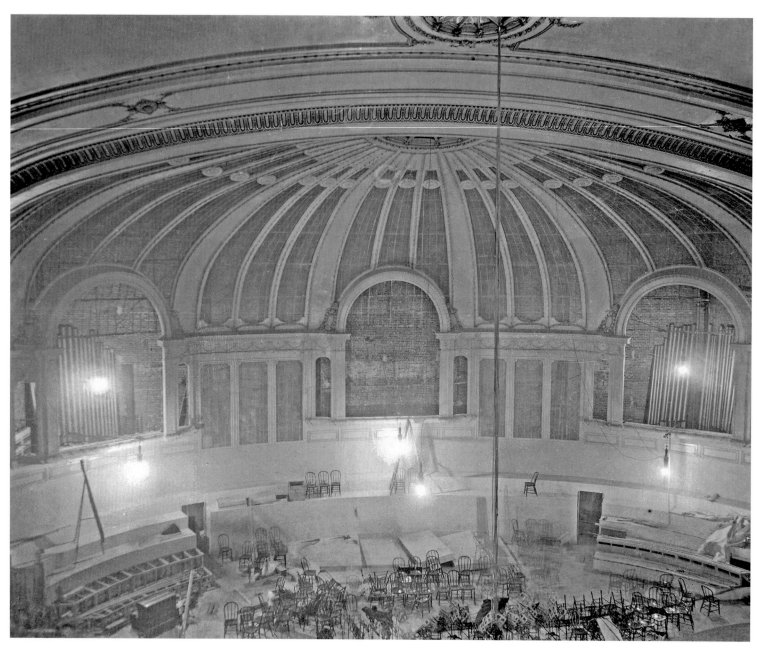

In 1904, Orchestra Hall, 220 South Michigan Avenue, was near completion. The stage, shown in this view, was still piled with chairs and building materials. The hall, designed by architect Daniel Burnham, was built to house the Chicago Orchestra. The Chicago Symphony Orchestra, as it would later be known, is one of the oldest symphonies in the United States.

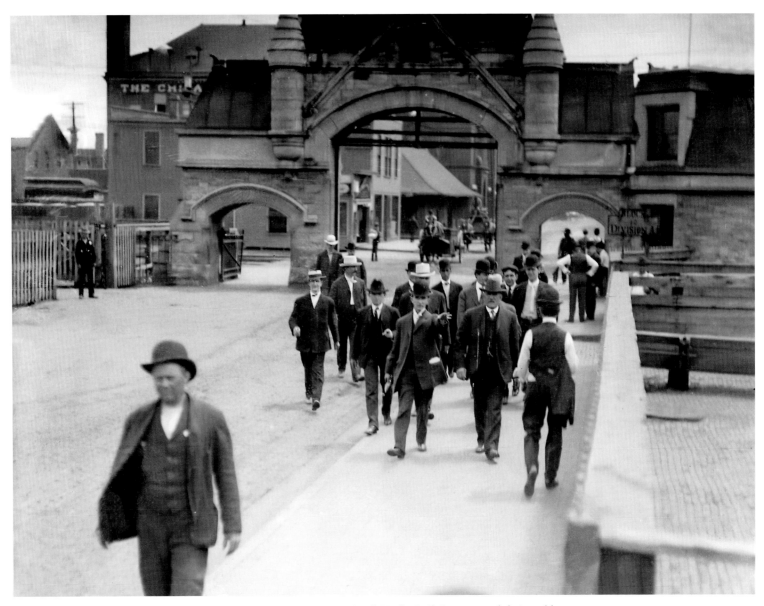

The arched gate, pictured here in 1906, was the entrance to Union Stock Yards. Built in 1879 and designed by architects Daniel Burnham and John Root, it still stands at Exchange Ave and Peoria St. A limestone steer head over the central arch (facing opposite entrance) is traditionally thought to represent "Sherman," a prize-winning bull named after John B. Sherman, one of the founders of the Union Stock Yard and Transit Company.

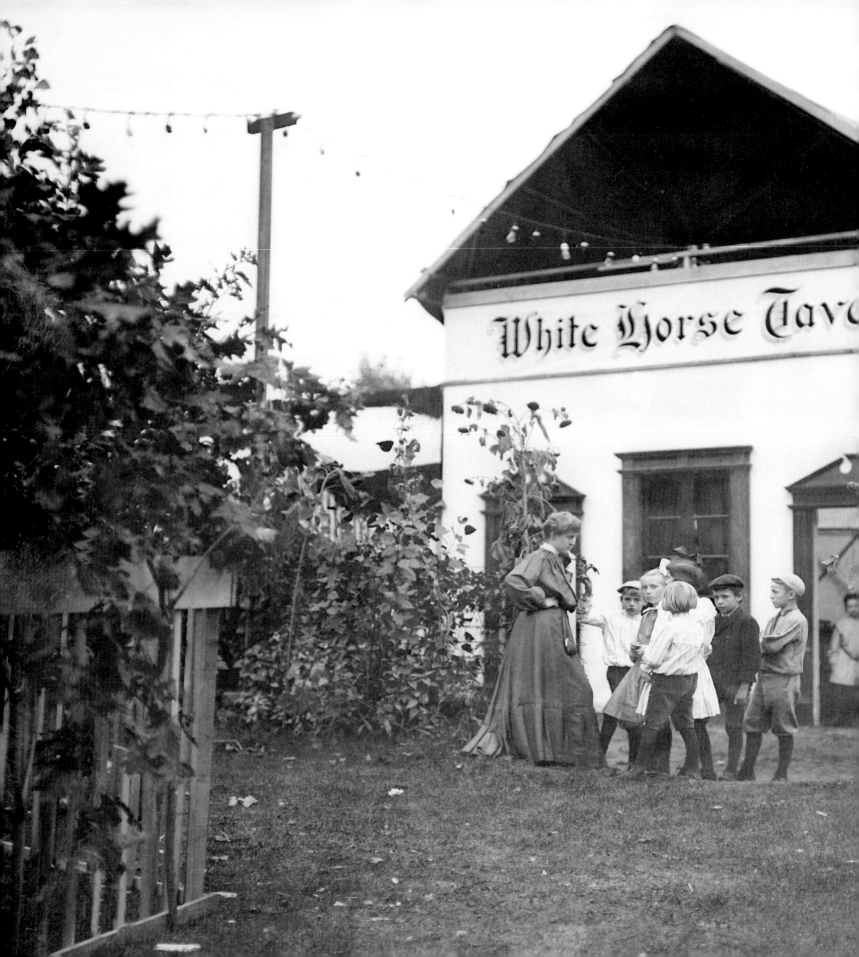

Women and children stand at The White Horse Tavern at White City Amusement Park in 1905. At its heyday, White City, located between 63rd Street and South Park Avenue (now Martin Luther King Drive), advertised itself as the largest of its kind in the nation. It closed in 1933.

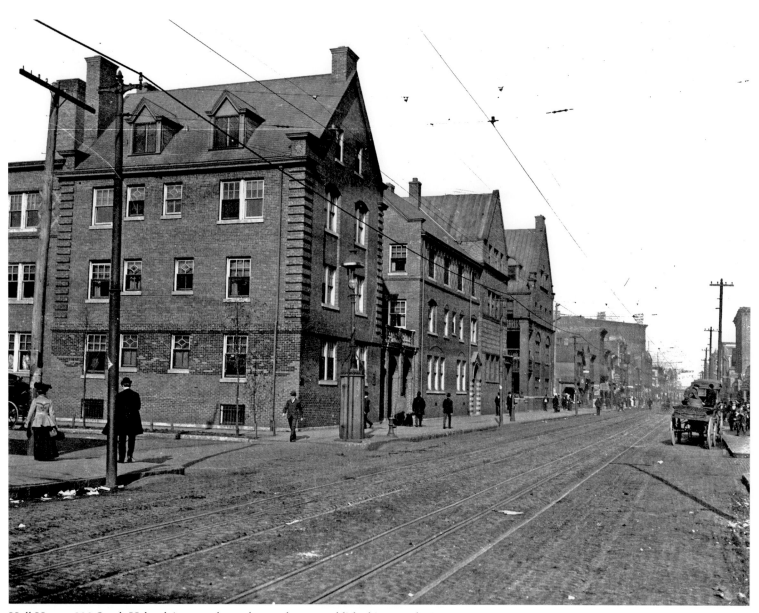

Hull House, 800 South Halsted Avenue, the settlement house established in 1889 by Jane Addams and Ellen Gates Starr. The settlement house began in a dilapidated mansion built by real-estate developer Charles J. Hull in 1856. When the neighborhood began to decline, then-owner Miss Helen Culver rented the Hull Mansion to Addams and Starr. By 1907, the settlement had grown into the 13-building complex seen here.

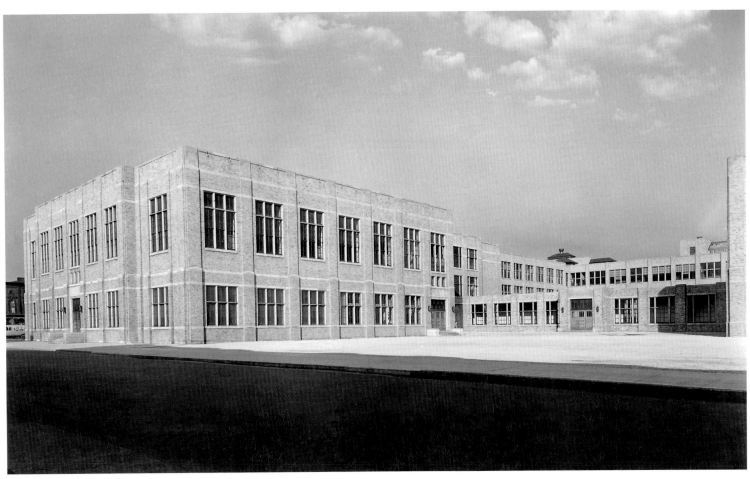

Wendell Phillips High School, 244 East Pershing Road, is the namesake of the nineteenth century abolitionist. Built in 1904, it had a racially mixed student body during its early history, becoming predominantly African-American by 1920. The school has many notable graduates including the nucleus of the Harlem Globetrotters basketball team, entertainers Nat "King" Cole and Dinah Washington, businessmen John H. Johnson and George E. Johnson, and Alonzo S. Parham, the first African-American to attend West Point.

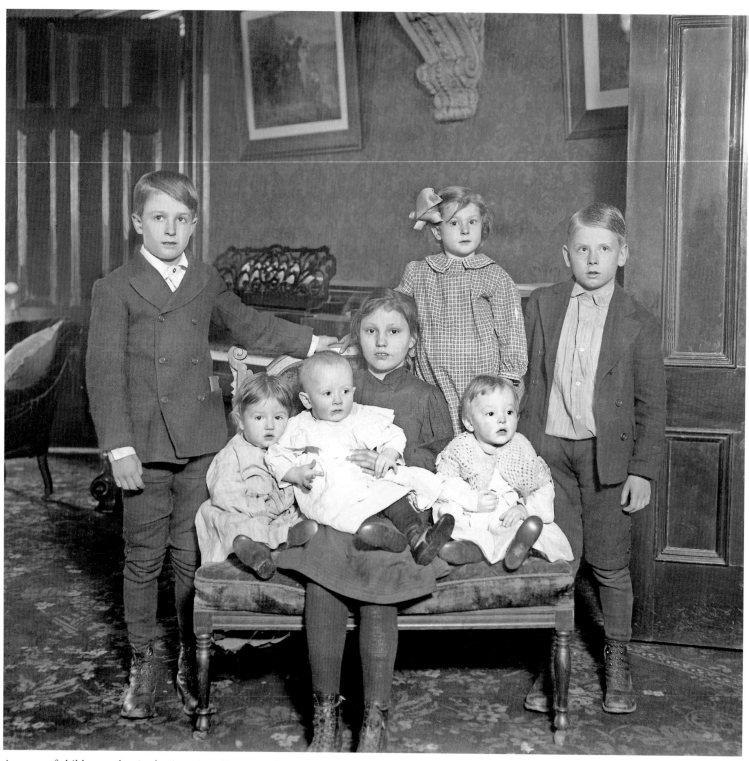

A group of children gather in the American Home Finding Association at 619 West 37th Street (now 307 W. 37th Street) in Bridgeport in 1907.

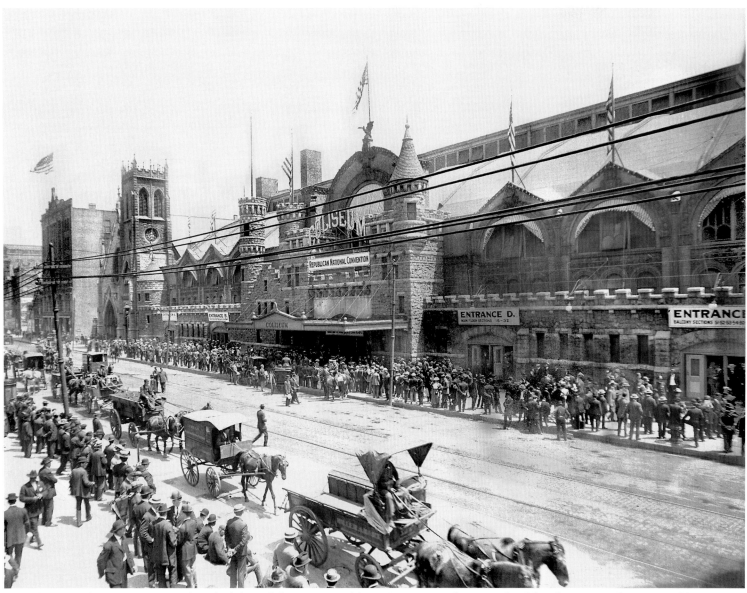

The Chicago Coliseum at 1513 South Wabash hosted the 1908 Republican Convention where President Theodore Roosevelt nominated his successor, William Howard Taft of Ohio. Altogether, the Democratic and Republican parties have picked Chicago as the site for a total of twenty-five political conventions between 1860 and 1996.

Coach Amos Alonzo Stagg (in white hat) stands on Marshall Field (later renamed Stagg Field) in 1905. Stagg was coach at University of Chicago for 40 years, coaching basketball and football. Stagg gained national recognition for his accomplishments as a player and coach: he was a member of the 1951 charter class of the College Football Hall of fame and one of the first groups of inductees into the Basketball Hall of Fame in 1959.

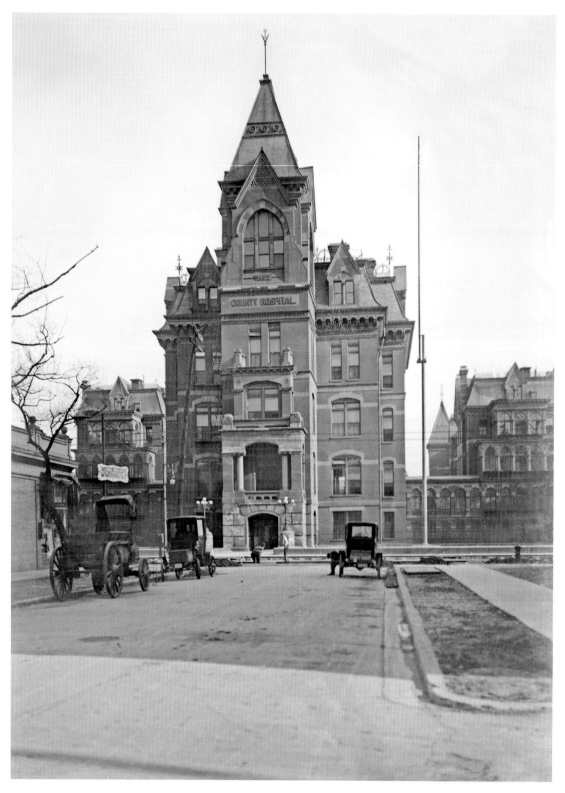

Cook County Hospital moved to Harrison Street on the Near West Side in 1876, following several other attempts by the county to serve those too poor to pay for medical help. In 1916, a new hospital was completed to replace the facility pictured here.

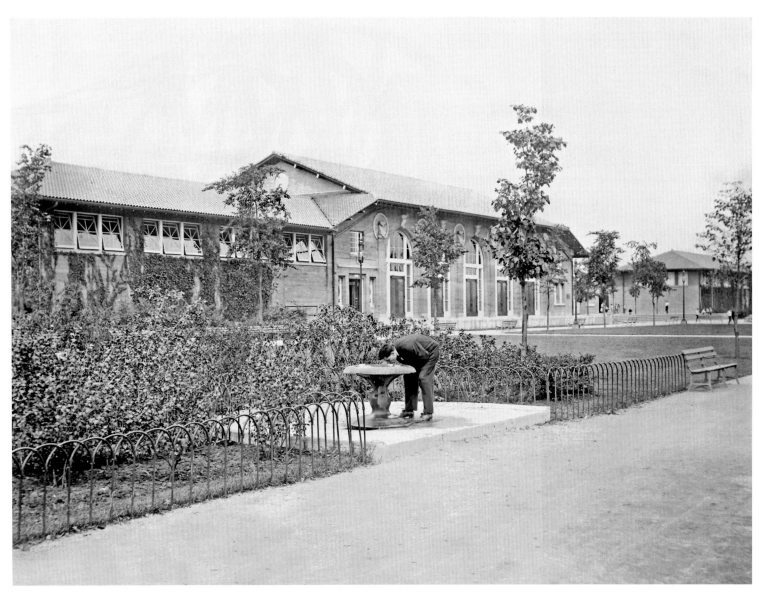

Palmer Park was part of a ten-park system that opened in 1905 to provide breathing space to residents in Chicago's crowded tenement district. The park was named in recognition of Potter Palmer, who served on the South Park Commission. Located at 111th Street and South King Drive, Palmer Park is in the Roseland community.

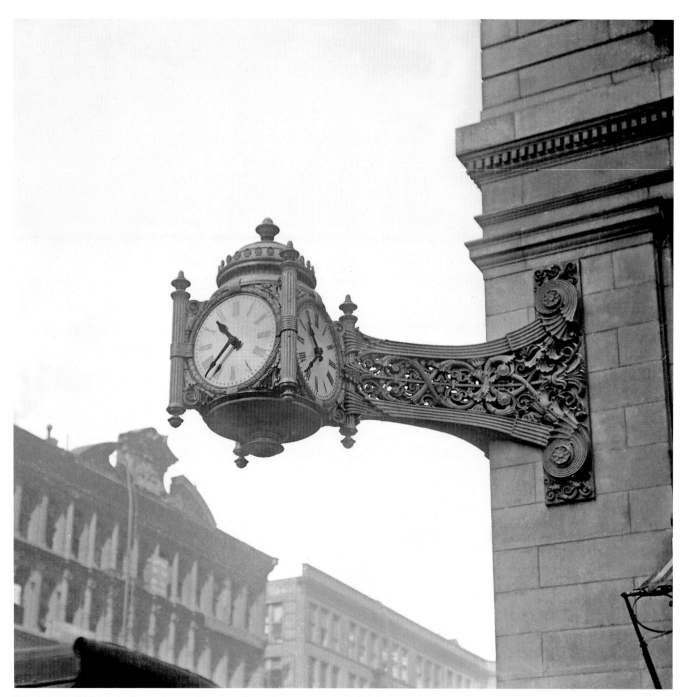

The Marshall Field clocks at the northwest and southwest corners of the department store building are well-known landmarks in downtown Chicago. By the time this picture was taken in 1907, the 12-story granite building, designed primarily by Daniel Burnham and Co., occupied the entire block bordered by State, Washington, and Randolph Streets and Wabash Avenue in Chicago's Loop.

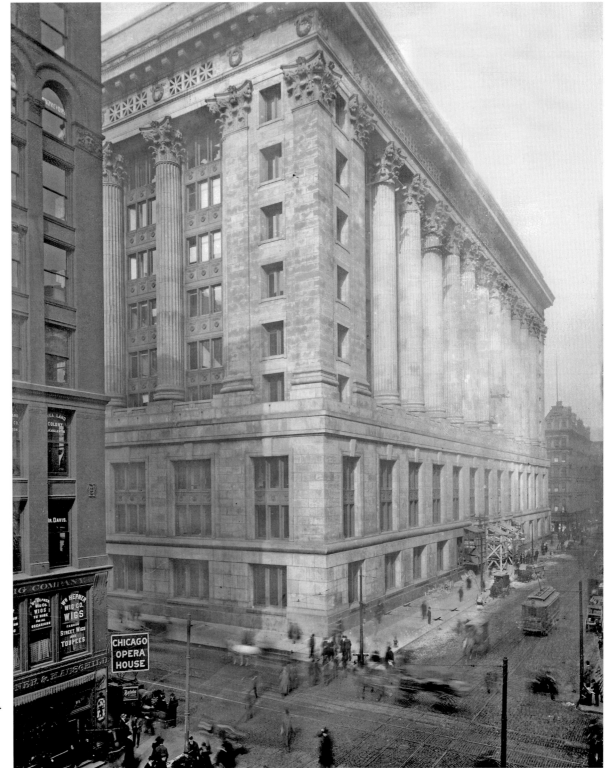

The county portion of the City Hall and County Building was completed first. The southeast corner, at North Clark and West Washington Streets, was photographed here in 1907. Construction on the city half of the complex began in 1909.

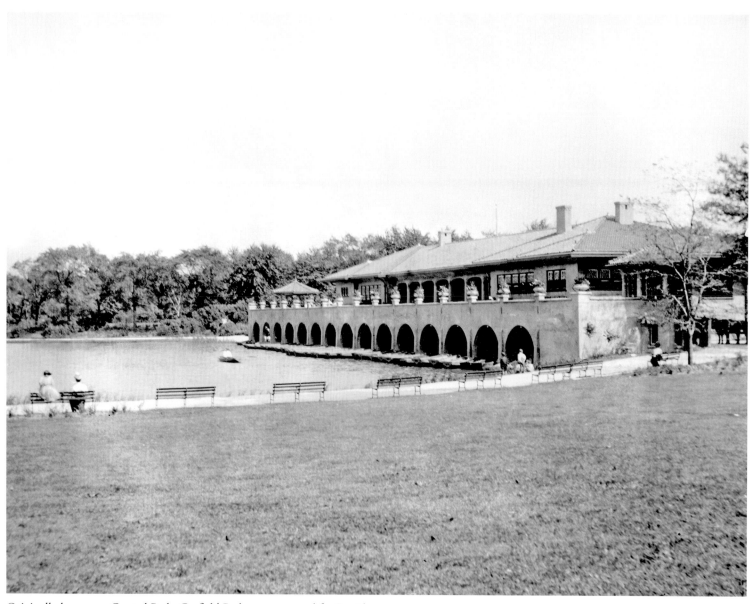

Originally known as Central Park, Garfield Park was re-named for President
James A. Garfield after his assassination in 1881. The 185-acre park included a
pavilion and lagoon, pictured here in 1908.

Prince Nicholas W. Engalitcheff of Russia resided at 526 Deming Place in Lincoln Park in 1909.

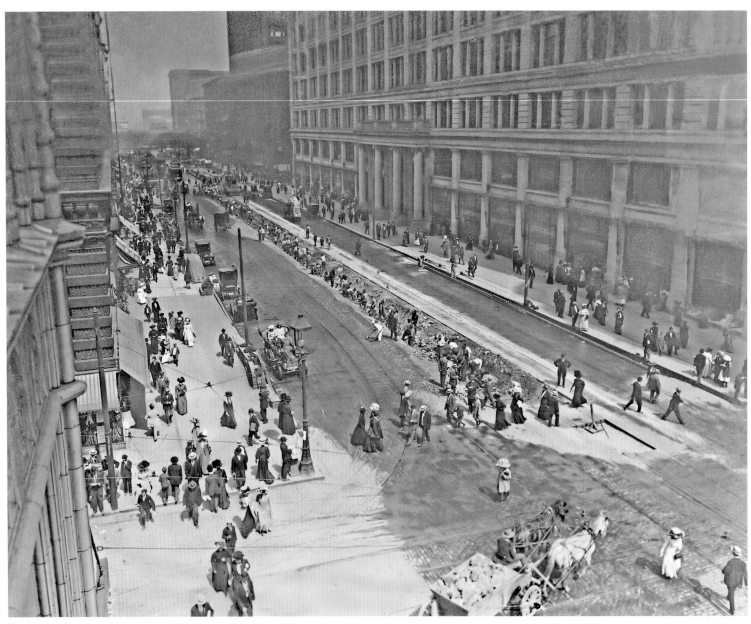

Men dig new streetcar tracks in State Street in the Loop in 1909. The entrance to
Marshall Field's Department Store is visible to the right.

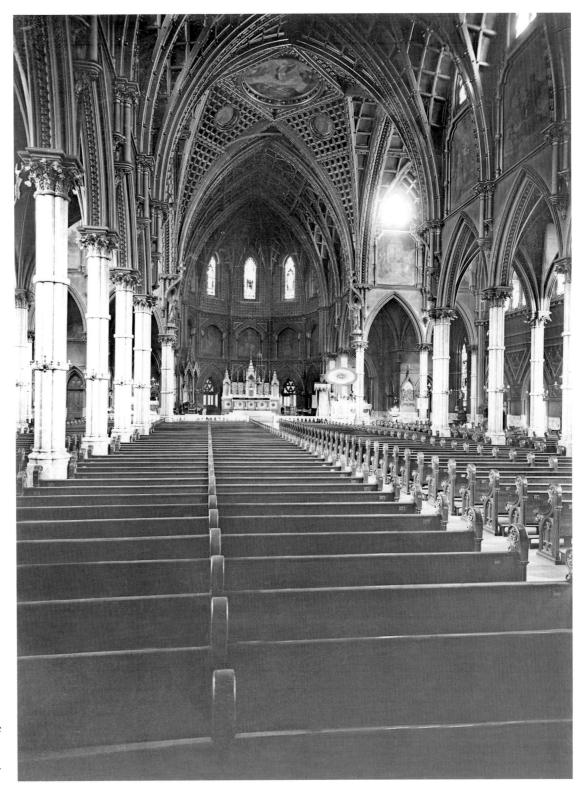

An interior view of Holy Name Cathedral, 735 North State Street in 1909. The Sanctuary Panels of the Holy Name are above the cathedra or bishop's throne. These five bronze panels by Attilio Selva represent the Holy Name of Jesus.

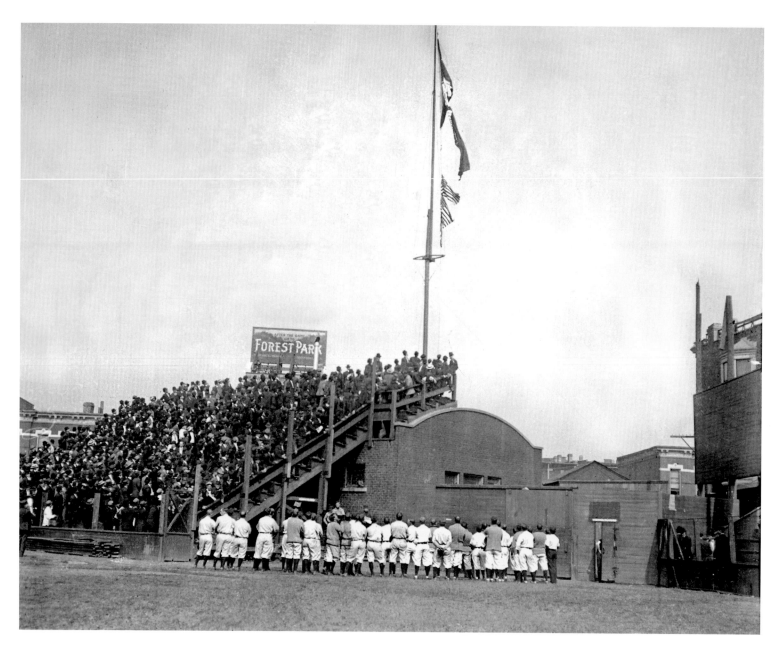

Members of the Chicago Cubs baseball team stand at the flagpole at West Side Grounds during a pennant-raising ceremony in 1909. The park was located between West Polk Street, South Wolcott Avenue, West Taylor Street, and South Wood Street in the Near West Side. The Cubs won the World Series in 1907 and in 1908, but the team has not won the Series again since that year.

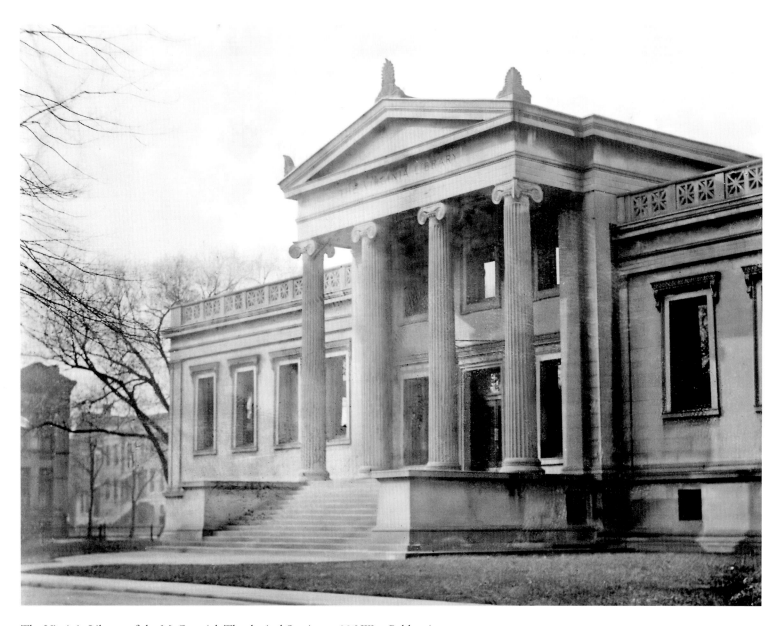

The Virginia Library of the McCormick Theological Seminary, 826 West Belden Avenue, as it appeared in 1909. Cyrus H. McCormick, a zealous Presbyterian, played a key role in moving the Presbyterian Theological Seminary of the Northwest to Chicago from Indiana. After Cyrus's death in 1884, the institution was renamed in his honor. The library, completed in 1895, was the gift of his wife and named in honor of their daughter.

The Auditorium Hotel, 430 South Michigan Avenue, is decorated with United States flags for the arrival of Theodore Roosevelt on June 17, 1912. Roosevelt was in Chicago for the Republican National Convention, where he hoped to recapture the nomination of his party from incumbent President William Howard Taft. He failed in this attempt, but won the nomination of the Progressive Party two months later.

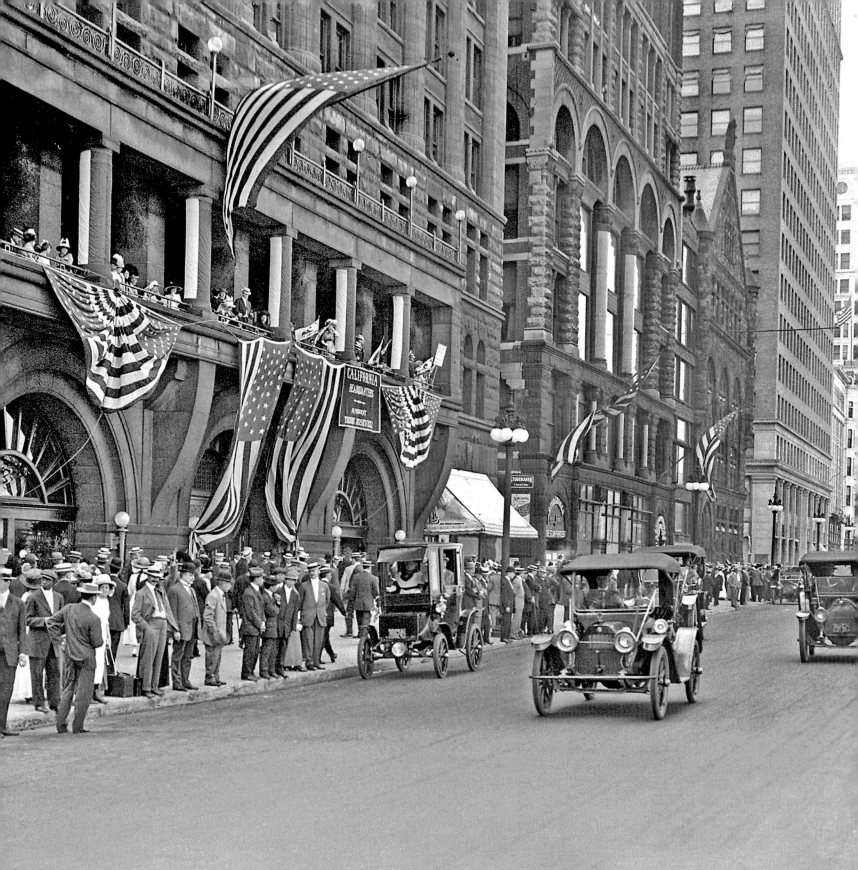

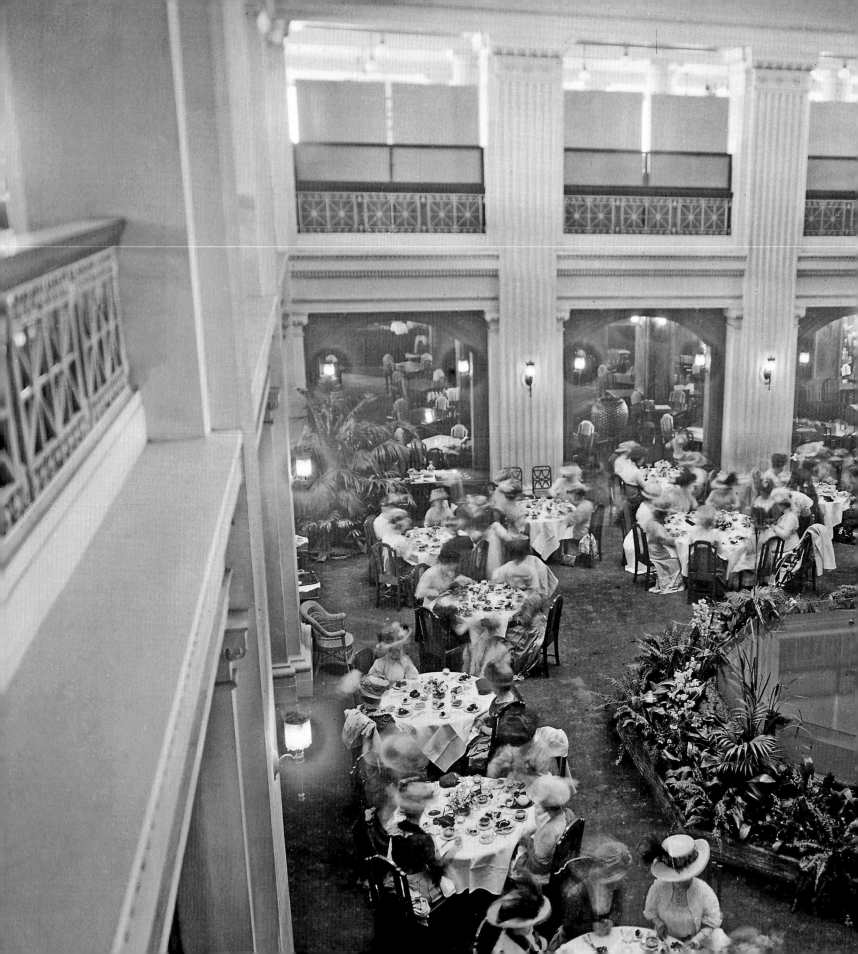

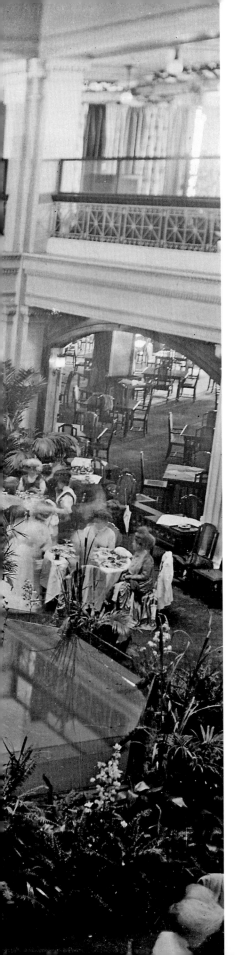

An innovator among American retailers, Marshall Field had many "firsts" to its credit. Its Walnut Room was the first dining room in an American retail store. Here, shoppers enjoy a meal in 1909.

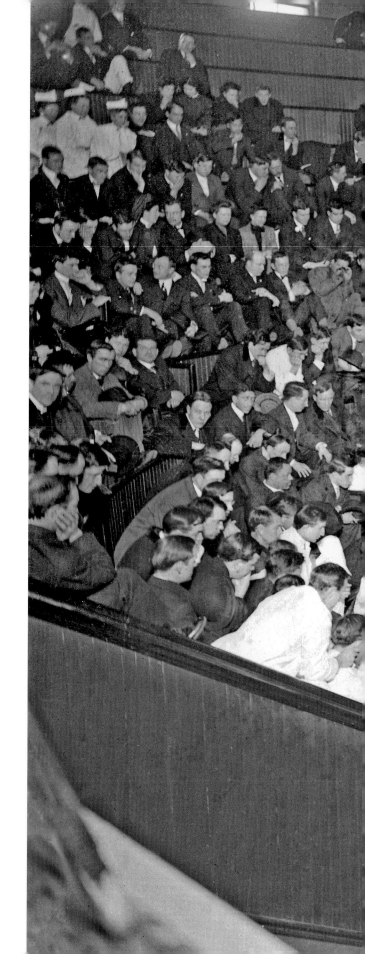

Dr. Thomas Johnnesco performs an operation in the surgical theater at Cook County hospital in 1910. Cook County Hospital has long been a leader in medical education. The hospital began the first internship program in the United States in 1866. Interns, who worked without pay, were chosen by competitive examination.

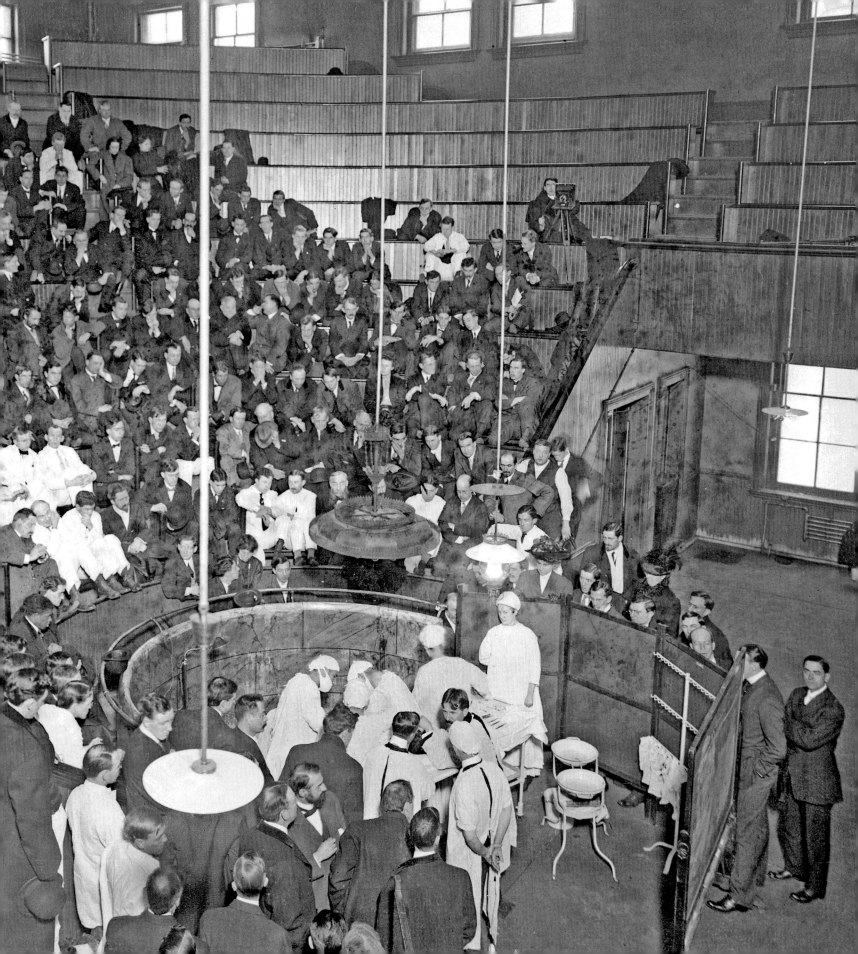

Gas streetlights lined West Fullerton Parkway in 1911 in the Lincoln Park community on the Near North Side. Although the Chicago Fire destroyed many homes south of Fullerton, post-fire construction brought new residents to the area. Growth continued in the new century.

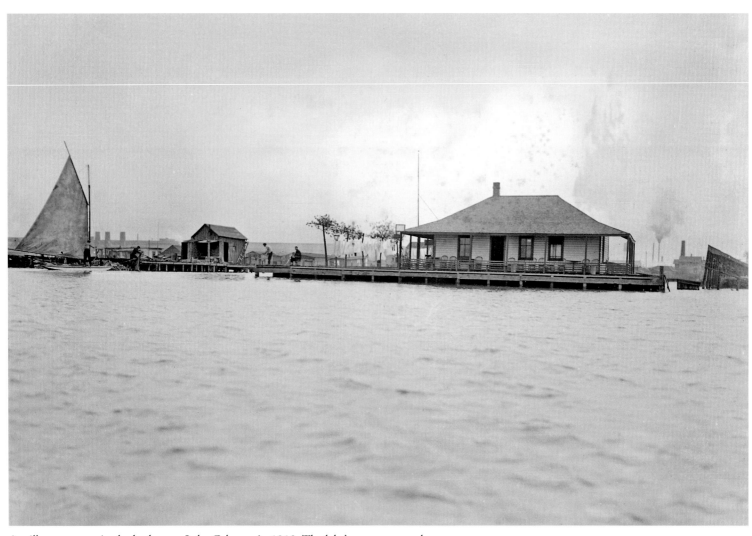

A sailboat appears in the harbor on Lake Calumet in 1913. The lake's swampy marsh was filled and developed by industry in the 1880's. The Pullman Car Company was located on Lake Calumet's western edge.

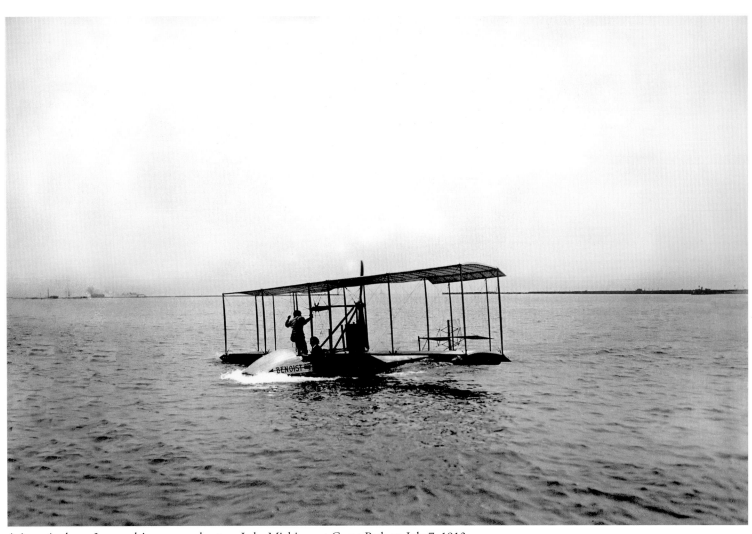

Aviator Anthony Jannus drives an aeroboat on Lake Michigan at Grant Park on July 7, 1913.

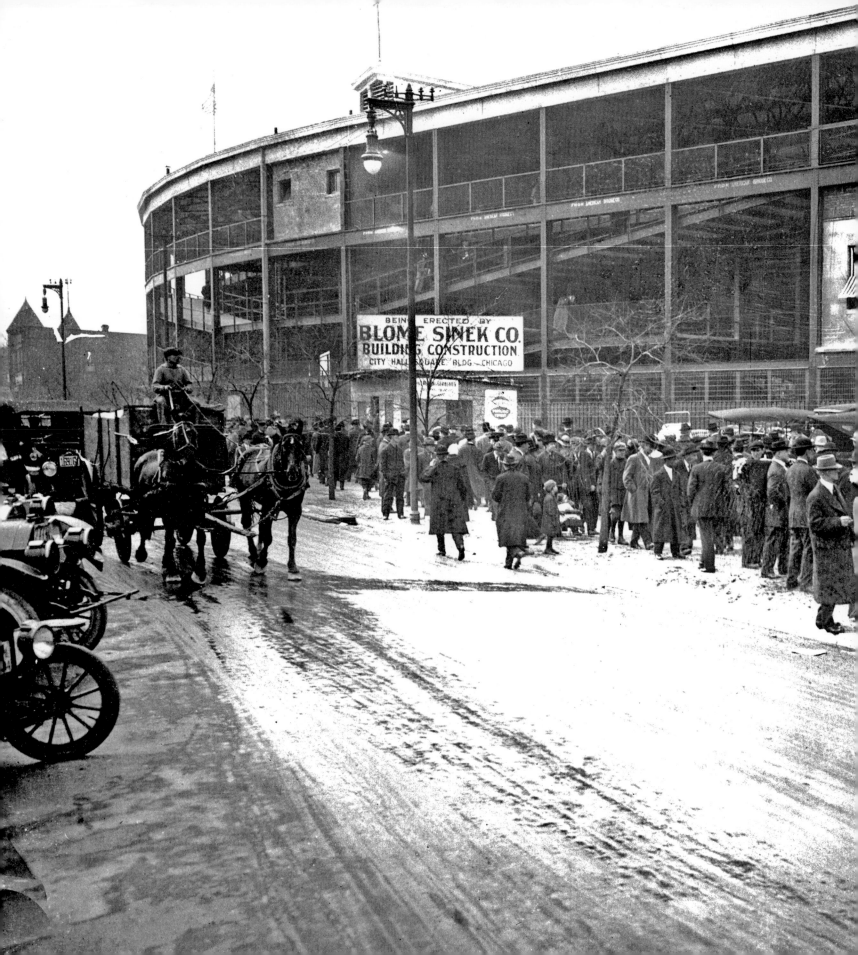

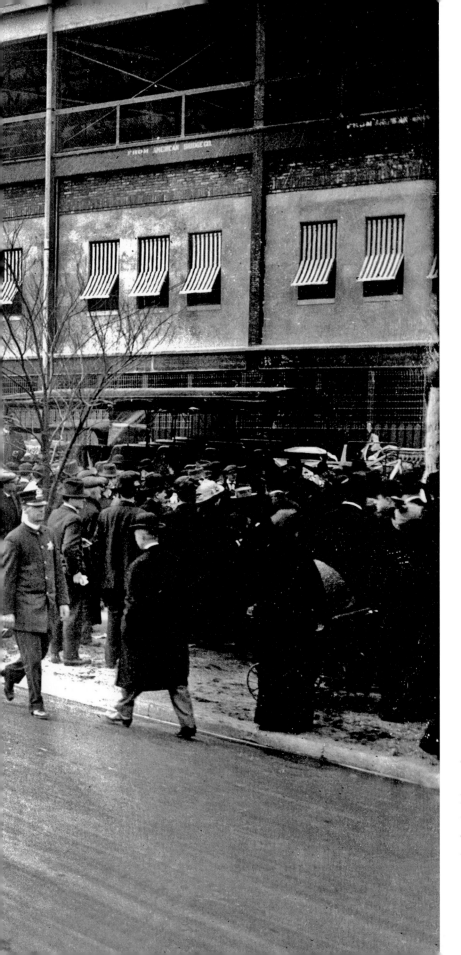

Crowds line up outside the newly built Weeghman Park on May 14, 1914. The ballpark was home to Charlie Weeghman's Federal League team, the Chicago Whales. When the Federal League folded two years later, Weeghman purchased the National League Cubs. Cubs Park was renamed Wrigley Field in 1926 in honor of the team's owner since 1920, William Wrigley, Jr.

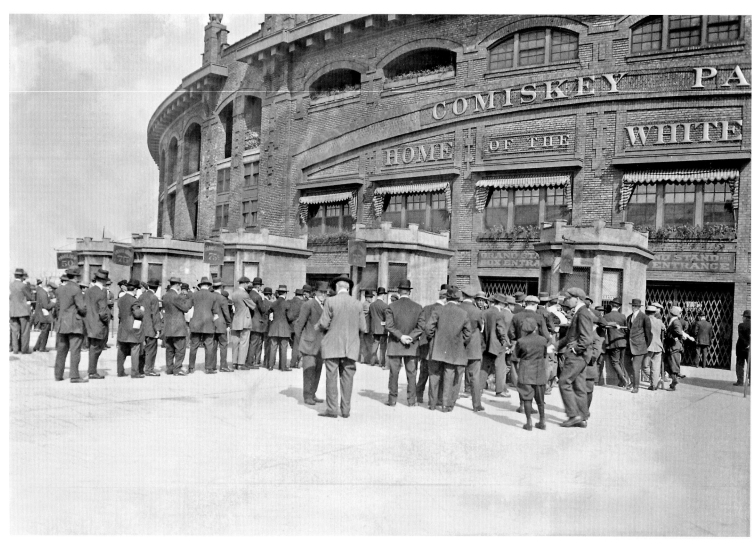

Fans line up at Comiskey Park, at West 34th and Shields Avenues, waiting for tickets to the 1914 Chicago City Series. The White Sox and Cubs have met only once in a World Series, which the White Sox won in 1906. Since then, the teams have occasionally played a City Series for "bragging rights" only. This park was the home of the White Sox from 1910 until 1990, when a new park was built across the street.

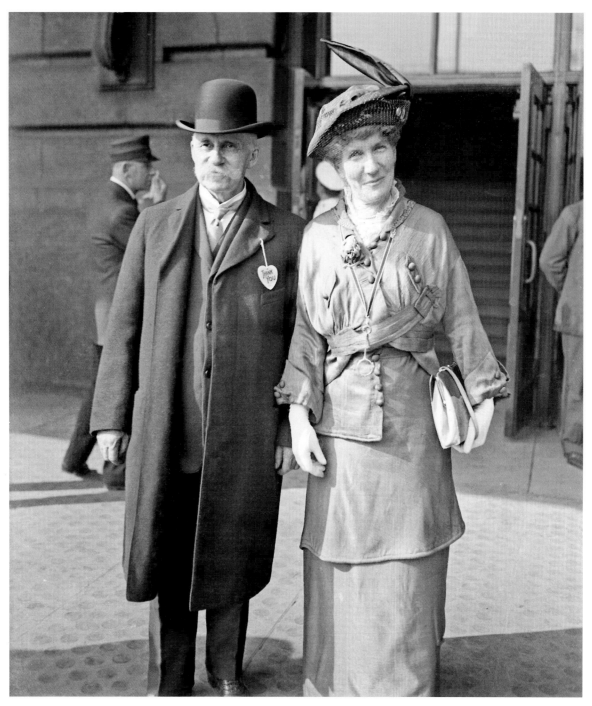

Harry Pratt Judson joins his wife Rebecca Ann Gilbert Judson in Chicago in October of 1914. Judson was with the University of Chicago from 1892 until 1923, serving at its second president from 1907 to 1923. Earlier in 1914, Judson had traveled to China on behalf of the Rockefeller Foundation, acting as director of the China Medical Commission, investigating the country's medical and public health conditions.

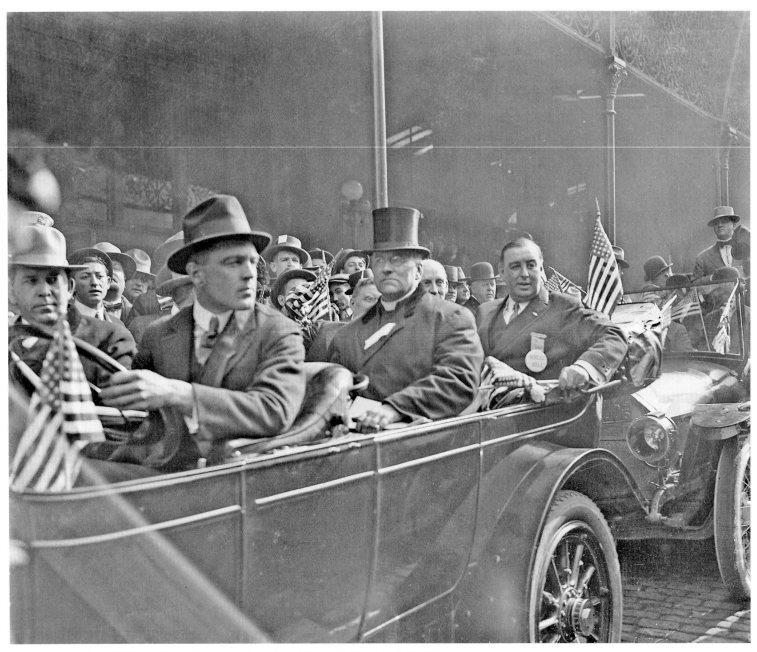

Crowds greet Mayor William Hale Thompson along Canal Street in October 1915. Mayor
Thompson began his first term as mayor that year. He ran again successfully in 1919, but
declined to run for reelection in 1923, amid charges of corruption. Thompson regained the
office for one more term in 1927. He was the last Republican to be mayor of Chicago.

Residents of the Dunning Mental Institute (later the Chicago State Hospital) sit on the lawn after a fire in 1915. Dunning, located on Irving Park Road and Narragansett Avenue, was established in 1851 as a poorhouse and mental asylum; it later served as a tuberculosis sanitarium as well.

Rescuers and survivors stand on the hull of the overturned *Eastland* steamer on July 24, 1915. At 7:28 that morning, the excursion steamer rolled over in the Chicago River while still moored to her dock between LaSalle and Clark Streets. On board were approximately 2,500 Western Electric employees and family members, on their way to the company picnic in Michigan City, Indiana. Of these, 844 persons perished, the largest death toll in any Chicago disaster.

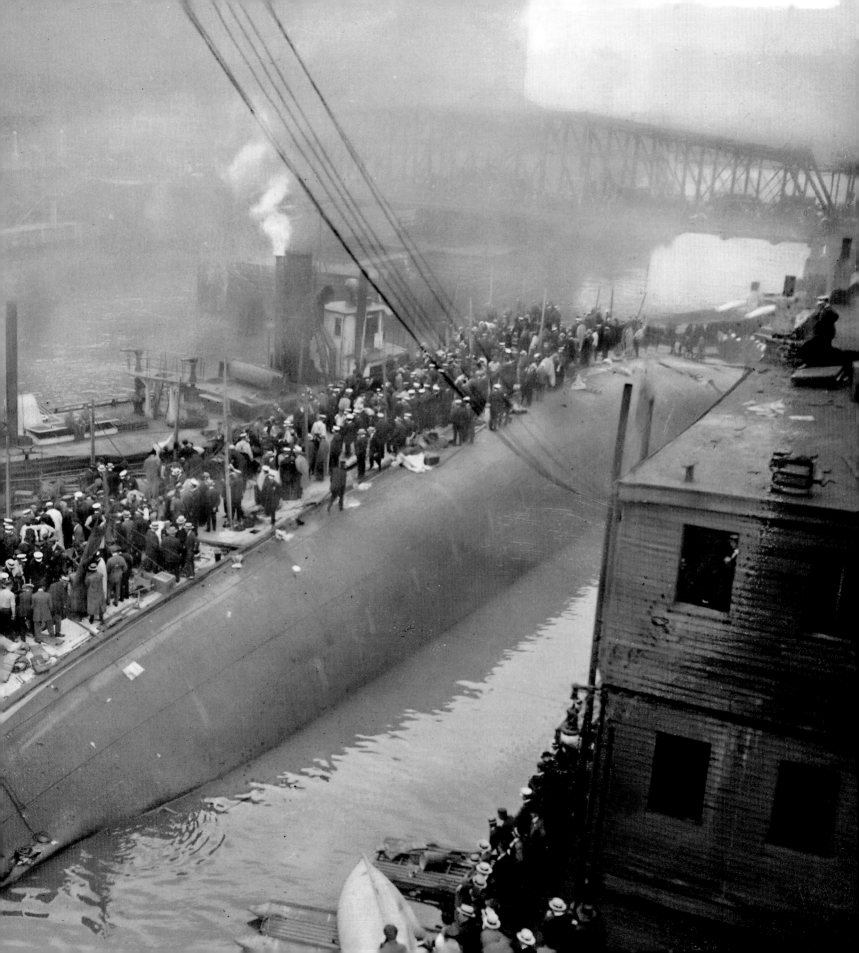

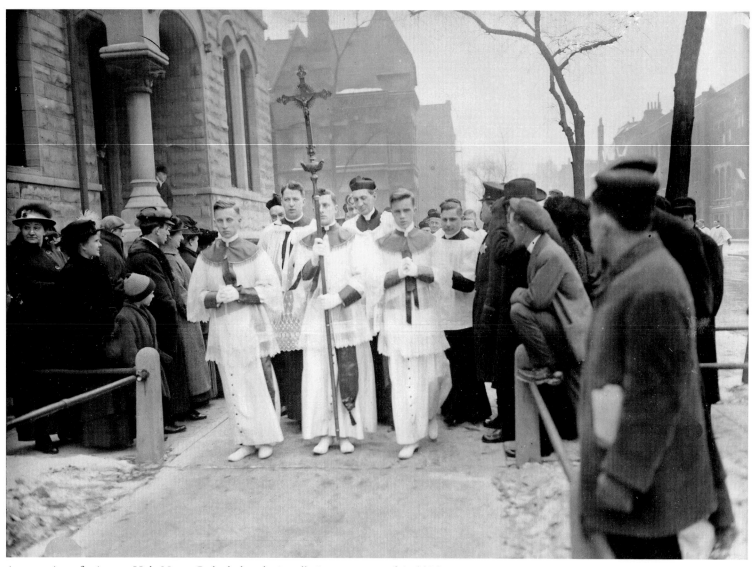

A procession of priests at Holy Name Cathedral at the installation ceremony of Archbishop George Mundelein in February 1916. Previously auxiliary bishop of Brooklyn, he succeeded Archbishop James Edward Quigley. In 1924, Archbishop Mundelein was elevated to Cardinal, the first in the history of the Chicago diocese. He served as Cardinal until his death in 1939.

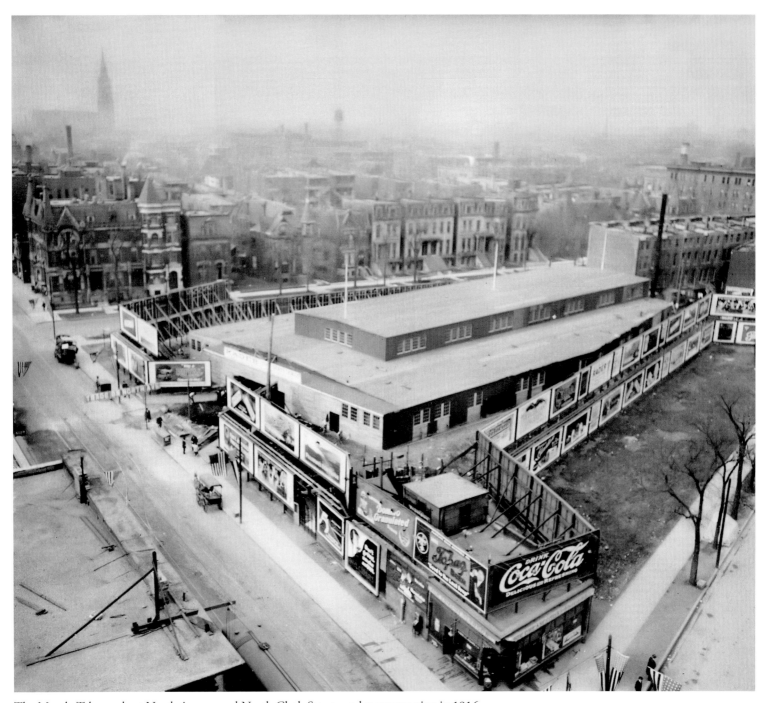

The Moody Tabernacle at North Avenue and North Clark Street, under construction in 1916, held 5,000 worshipers. It replaced the Moody Church on North LaSalle Street, founded by Dwight Moody in 1864 as the Illinois Street Church.

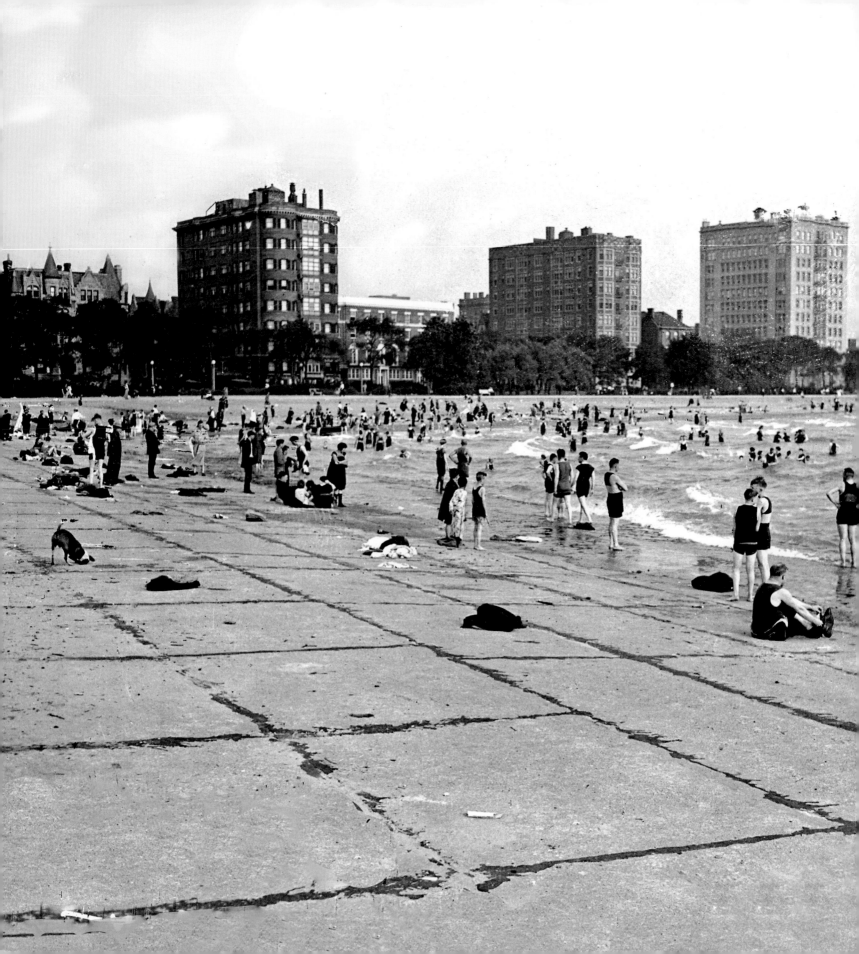

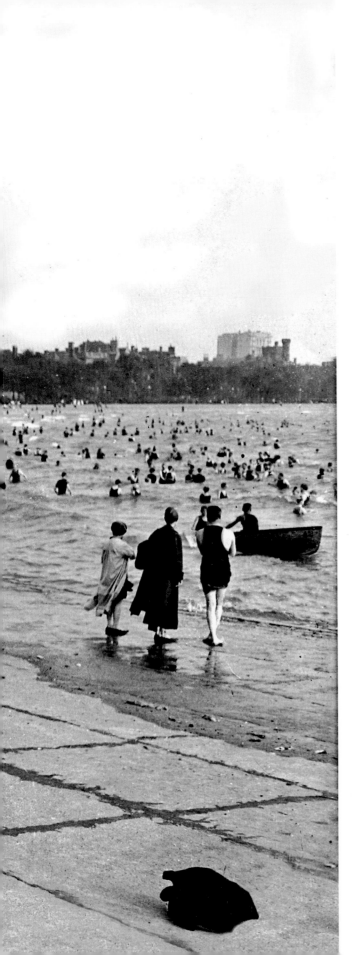

Swimmers enjoy the day at Oak Street Beach in August 1916. The neighborhood around the beach is known as Streeterville after George Streeter, who claimed squatter's rights to the sandbar after running his boat aground there. His claims to the land finally resulted in a court battle, ending in 1918, when his claims were ruled invalid.

A view looking south on Michigan Avenue from Grant Park in 1916 shows the Chicago Public Library on the right with the Montgomery Ward Tower in the background. A portion of the peristyle, recently recreated in Millennium Park, can be seen on the left.

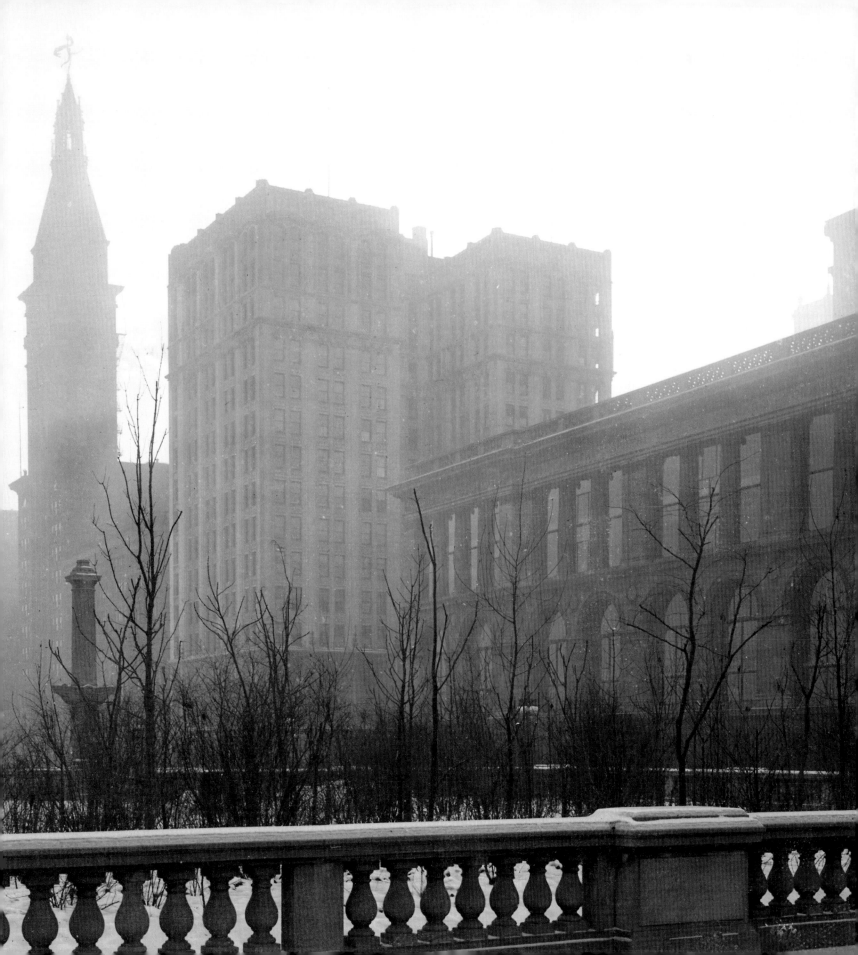

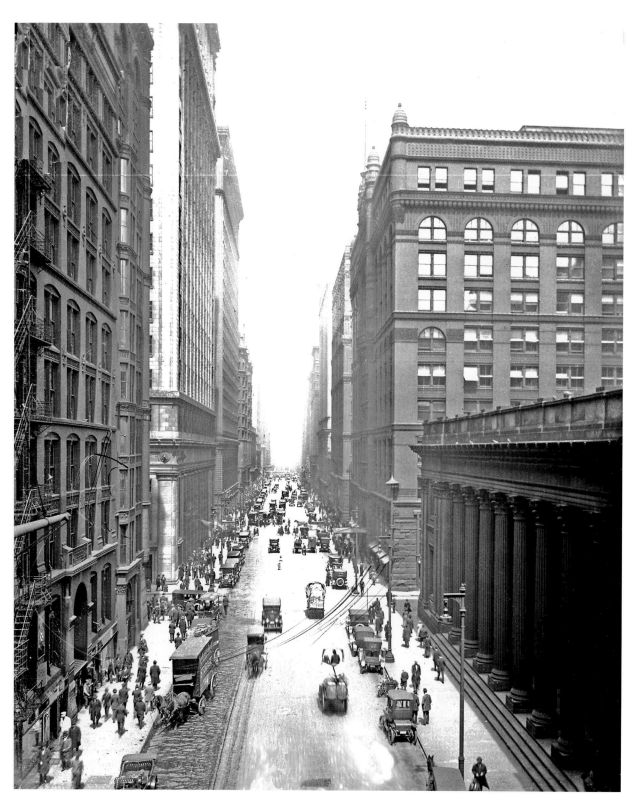

This view of LaSalle Street looking north from the Board of Trade in 1916 shows several important buildings of that era. On the left is the Gaff Building at the corner of Quincy and LaSalle: the Illinois Trust and Savings Bank is on the right, next to the Rookery Building.

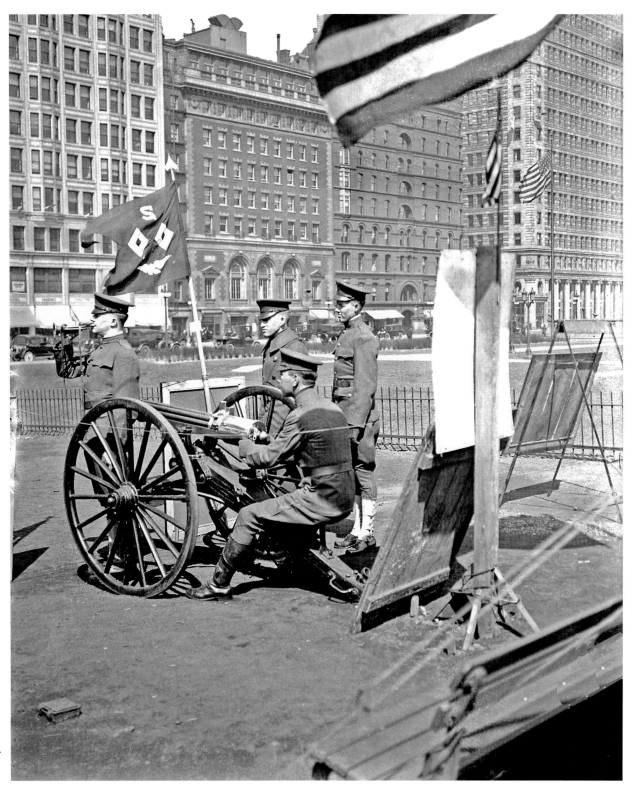

Army recruiters set up
in Grant Park in 1917.

A crowd attends an open-air meeting at Grant Park in 1917. The buildings seen on South Michigan Avenue are, from left to right, the Auditorium, the Studebaker Theater, the Chicago Club Building, and the Chicago Exchange.

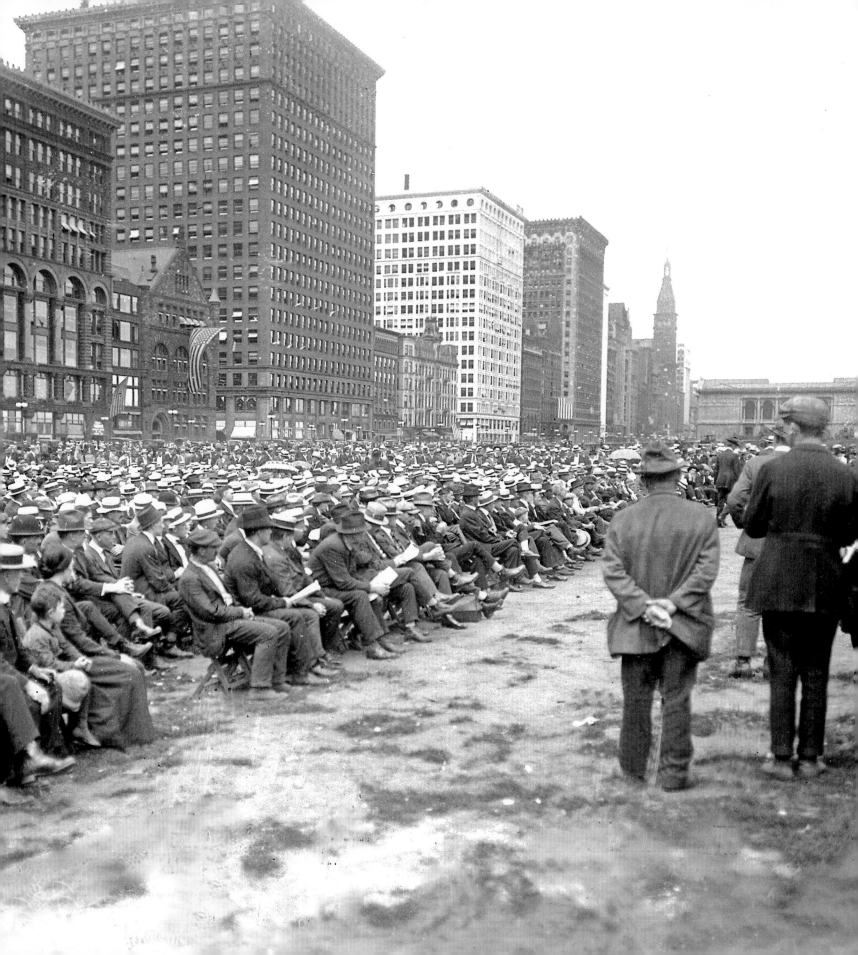

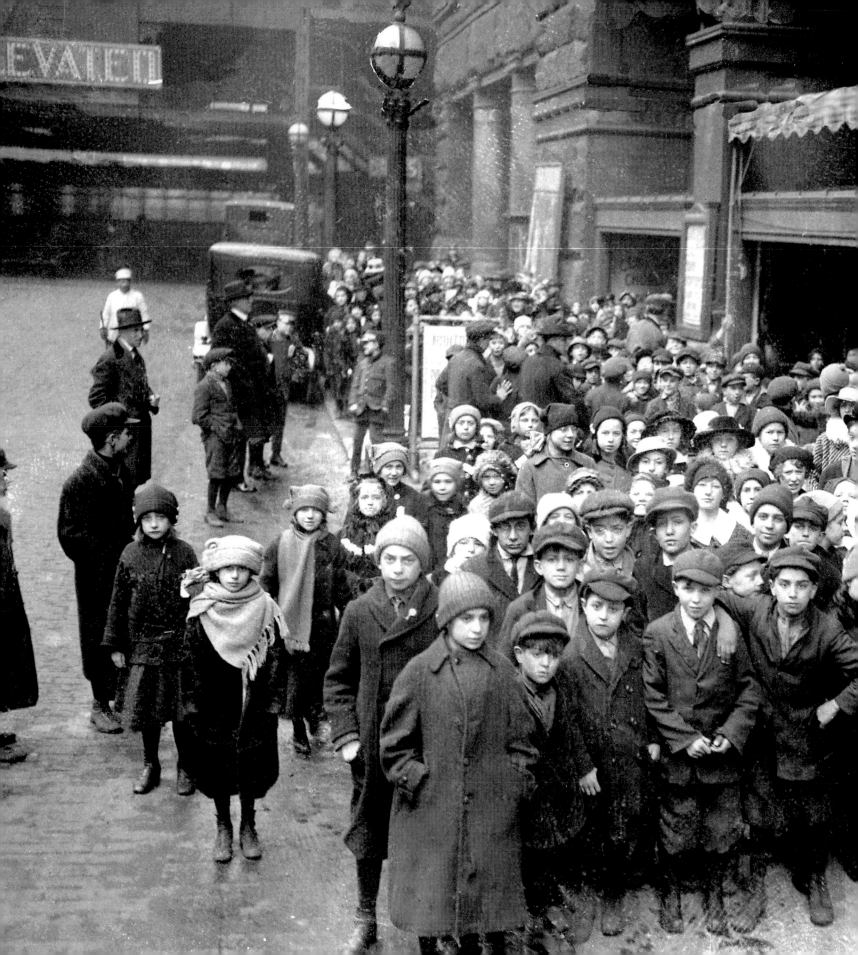

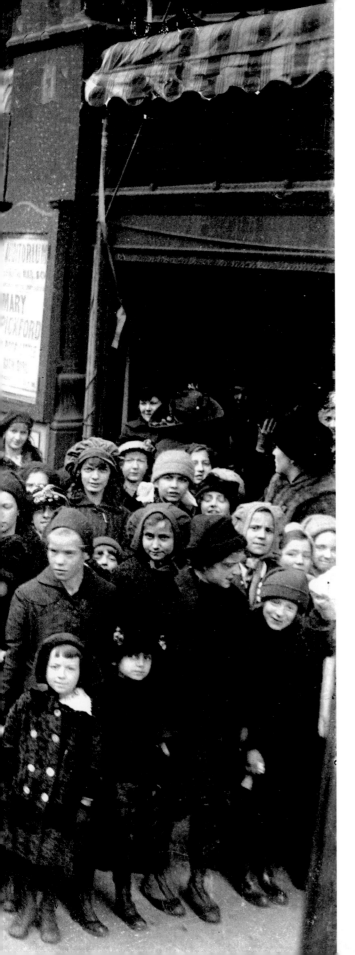

On March 23, 1917, children crowded outside the Auditorium Theater on South Michigan, where *Poor Little Rich Girl*, starring Mary Pickford, was playing.

Billy Sunday shakes hands with Mrs. Harriet Sanger Pullman, wife of industrialist George M. Pullman, in 1917. Earlier in his life, Sunday played professional baseball with the Chicago White Stockings. After his conversion at Pacific Garden Mission, he became one of the country's most well known evangelists.

Girls from Wendell Phillips High School exercise before a track meet at the athletic field at
Marshall Field (renamed Stagg Field in 1913) at East 57th Street and South Ellis Avenue on
the University of Chicago campus.

A family feeds ducks swimming in the lagoon at Lincoln Park. The park was built on 120 acres of swamp land, with a ten-mile ditch dug to drain the lowlands and create the lagoon. At first called Lake Park, the development was renamed Lincoln Park after the assassination of President Lincoln in 1865. The park and surrounding neighborhood were modeled after New York's Central Park as well as Haussman's Park and Boulevard system in Paris.

VIOLENCE AND THE DEPRESSION
MARK THE END OF THE FIRST CENTURY

1918–1940

The year 1919 was tumultuous for Chicago. In July Chicago's South Side exploded in racial violence, when whites stoned to death an African American boy who had crossed the color line on a Lake Michigan beach. Tensions over the boy's death and the growing tide of Southern blacks into the city erupted in beatings, shootings, and arson that resulted in the deaths of 38 and injury of 537 black and white Chicagoans. Despite overt racism, African Americans built a community numbering 109,894 by 1920, and Bronzeville, the South Side neighborhood, became both a cultural and business mecca for black Chicagoans.

The onset of Prohibition in 1919 brought a new level of crime and a new reputation for Chicago. Arriving from Brooklyn about 1919, Alphonse Capone rose to leadership of an effective crime syndicate in Chicago through his organizational skills and his penchant for violent retribution. Aided by legions of corrupt public officials and police, Capone won control of bootleg alcohol in the city through the beer wars of 1924-30. The bloody 1929 St. Valentine's Day Massacre engineered by Al Capone reinforced the national image of Chicago as a violent, crime-ridden city.

The Great Depression hit Chicago hard. Soup kitchens, strikes, and homelessness were common sights throughout the city. Chicagoans elected democratic mayor Anton Cermak to get the city back on its feet. After Cermak was tragically assassinated in 1933, Mayor Edward Kelly continued to strengthen Chicago's democratic political machine, and President Roosevelt brought badly needed New Deal funds to the city. But the 1937 Memorial Day Massacre, where 10 Republican Steel strikers and supporters were killed and 90 wounded, was a stark reminder of the precarious economic conditions in Chicago and the city's labor tensions.

For 39 million Americans, Chicago's 1933 Century of Progress International Exposition provided entertainment and distraction from the grind of the depression years. Sited on Chicago's lakefront, the world's fair promoted the benefits of science for everyday life and featured pavilions and buildings representing the latest in modern architectural materials and design. Buoyed by the fair's popularity, President Roosevelt secured additional funds to keep the fair open through 1934.

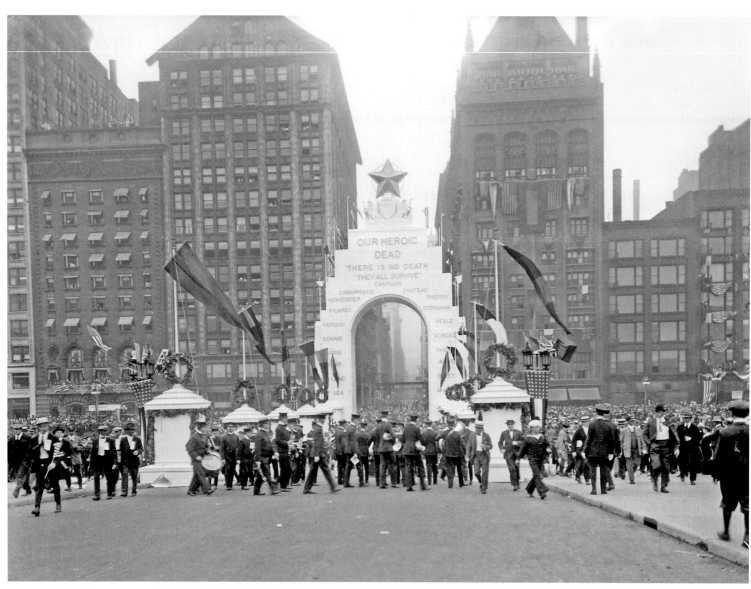

Participants in the 1918 Labor Day Parade gather at an arch-shaped monument at
East Monroe Street and South Michigan Avenue.

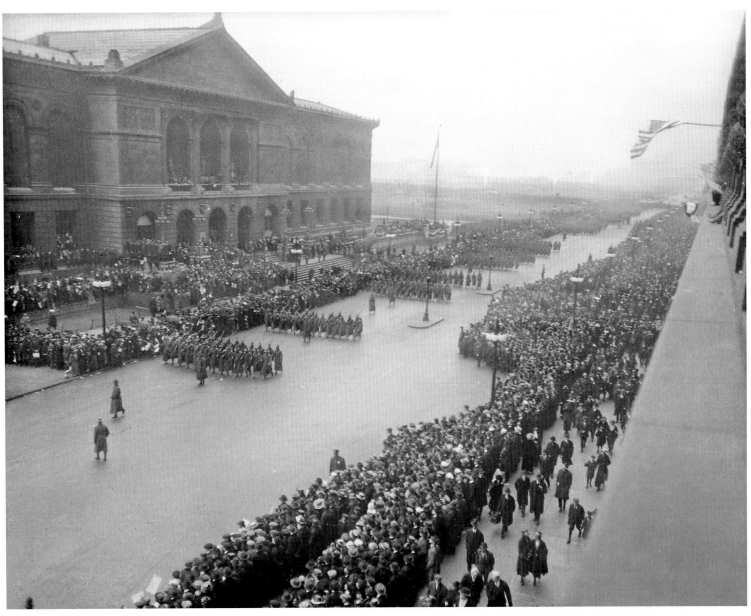

The Third Liberty Loan parade was held in Chicago in 1918 to raise money for the war. Despite the flu epidemic spreading throughout the country, the Chicago health department gave the okay for this huge public gathering. Parade goers were instructed to strip, rub their bodies dry, and take a laxative after returning home to prevent contracting the disease.

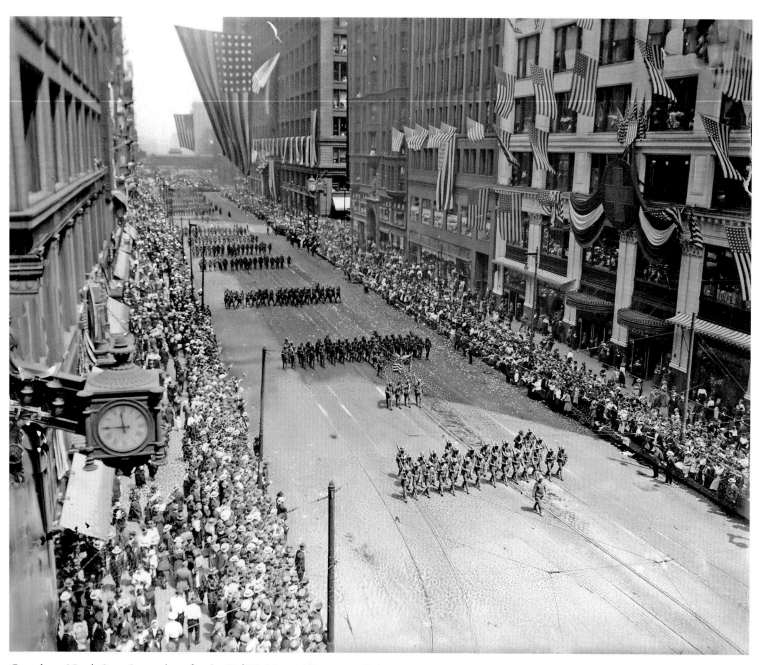

Crowds on North State Street cheer for the 33rd Division soldiers upon their return home after World War I.

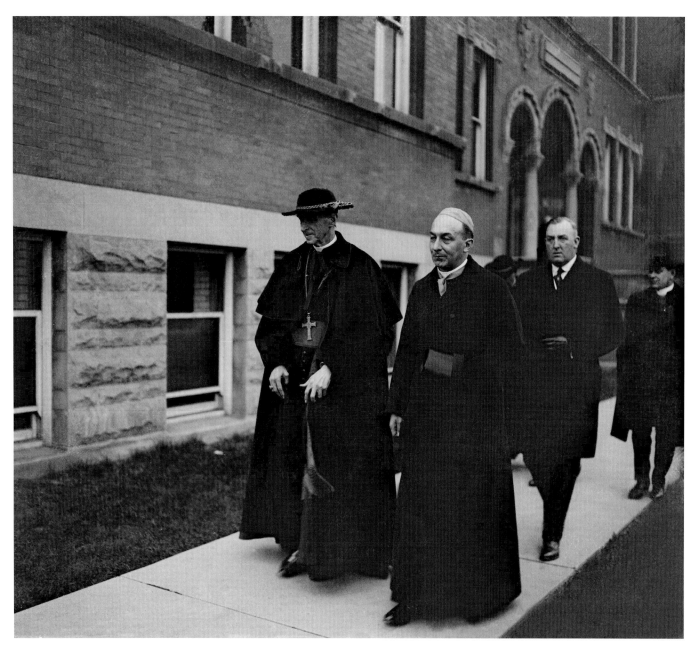

Belgian Cardinal Désiré Joseph Mercier (on left) met with Archbishop George W. Mundelein on a trip to Chicago in 1919. Cardinal Mercier, who was briefly held under house arrest during World War I for his opposition to German occupation, was raising money to rebuild postwar Belgium.

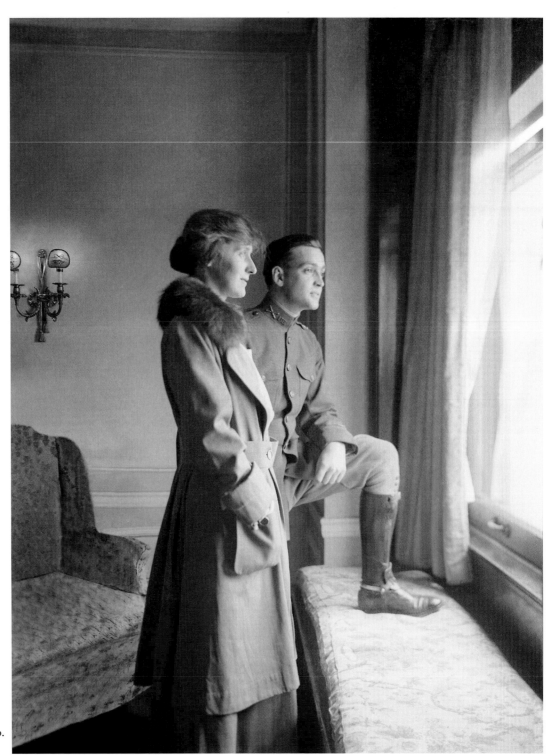

Department store heir Marshall Field III poses with his wife, Ruth, in 1919. Seen here in uniform, Field enlisted with the 1st Illinois Cavalry (later the 122nd Field Artillery) in World War I. His distinguished service earned him a promotion to captain. In 1941, he founded the *Chicago Sun*, later buying the *Chicago Times* and merging the two.

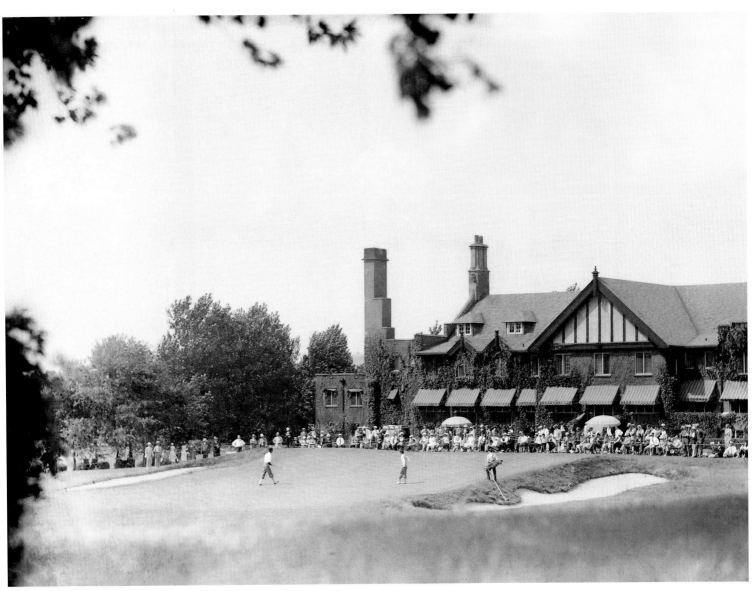

Members at Beverly Country Club, 8700 South Western Ave., look out over the golf course in
1919. In 1918, Scottish-born course designer Donald Ross was retained to redesign the course.
Its eighteen holes stretch from 86th to 91st Street along Western Avenue.

Sergeant John Edmondson, of the Illinois 8th Regiment, with his wife and daughters in 1919. The only regiment to be entirely commanded by African Americans, the Fighting 8th served with distinction in France during World War I, suffering many casualties.

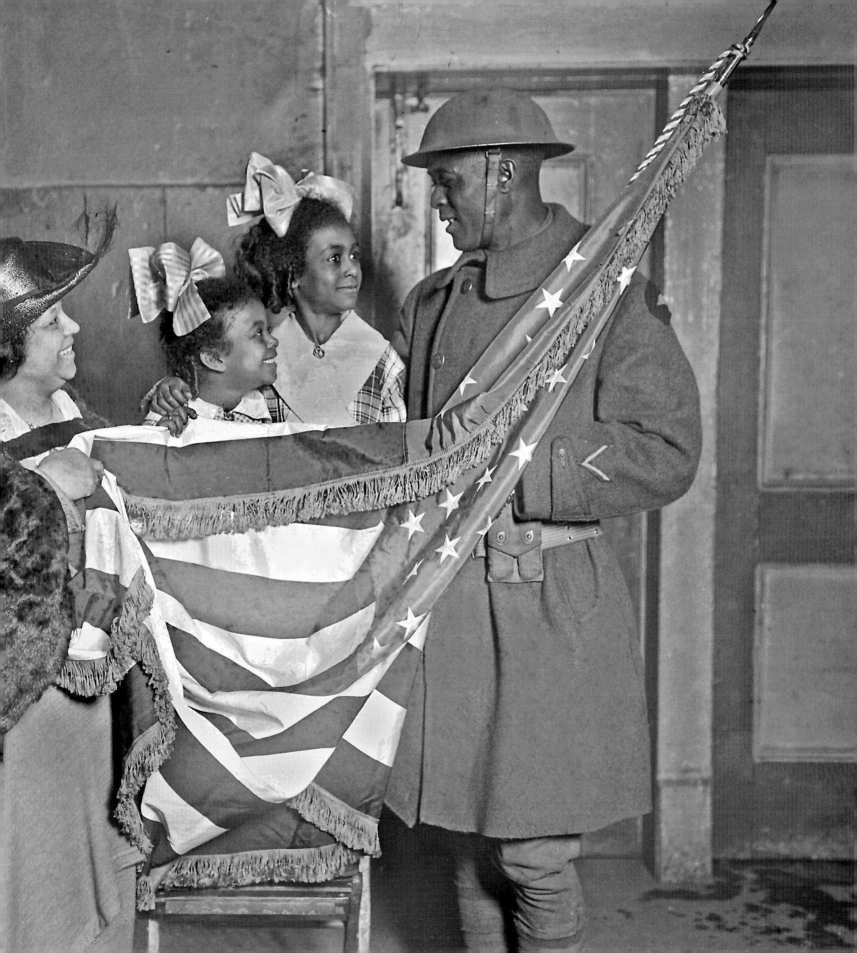

Major A. V. Dalrymple, on the left, sorts through
a pile of confiscated material found in a search
during prohibition.

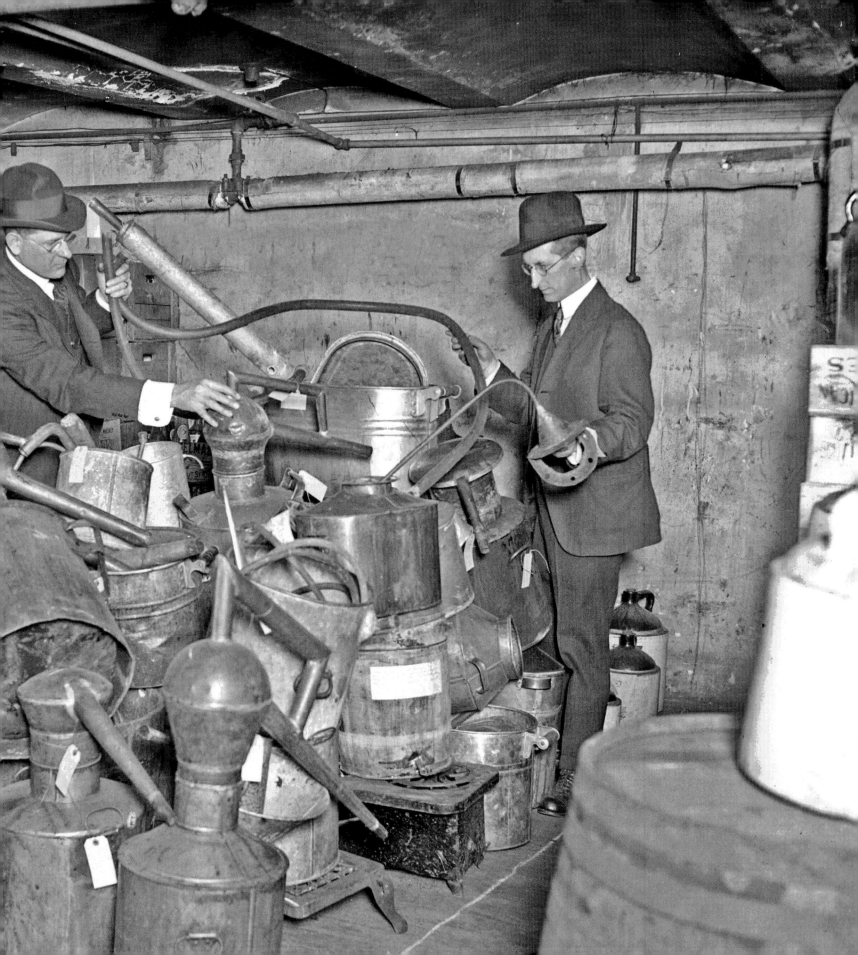

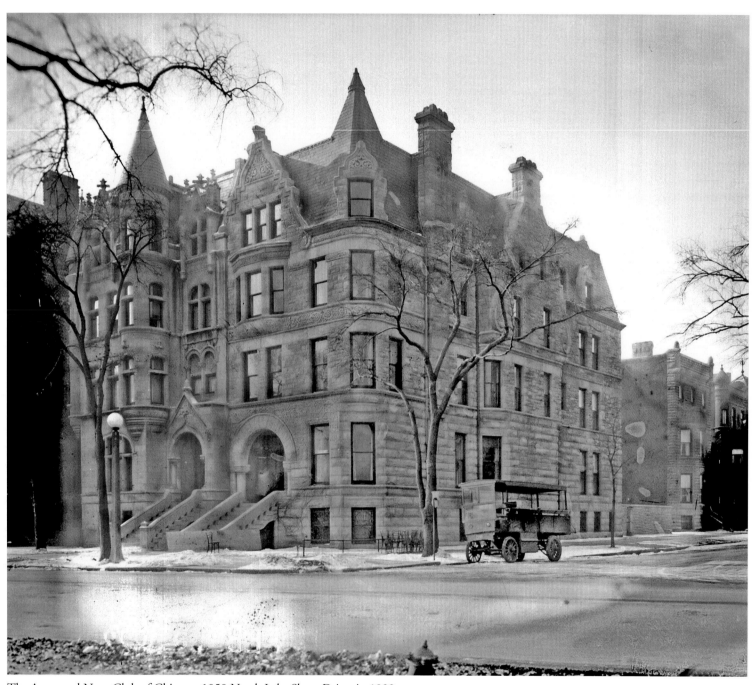

The Army and Navy Club of Chicago, 1050 North Lake Shore Drive, in 1922.

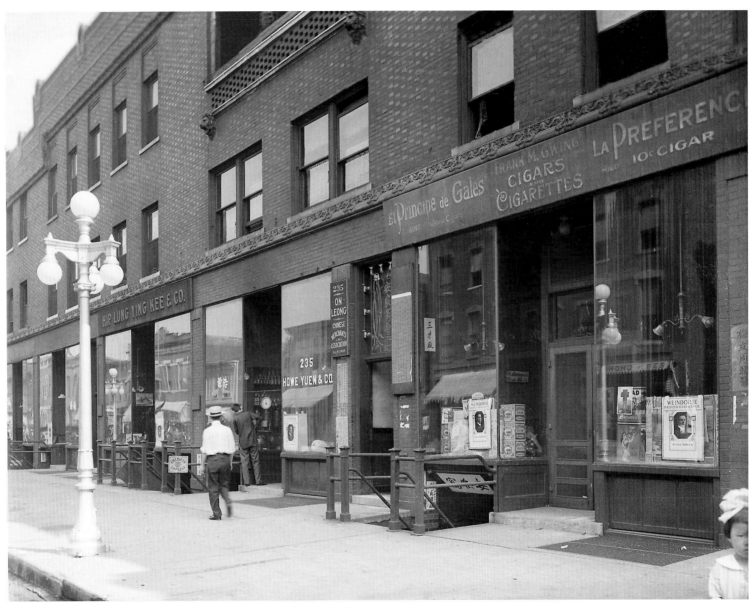

A view of 22nd Street in Chinatown in 1928. Chicago's Chinese
community was originally centered in the Loop, but moved to
this area in Armour Square around 1912.

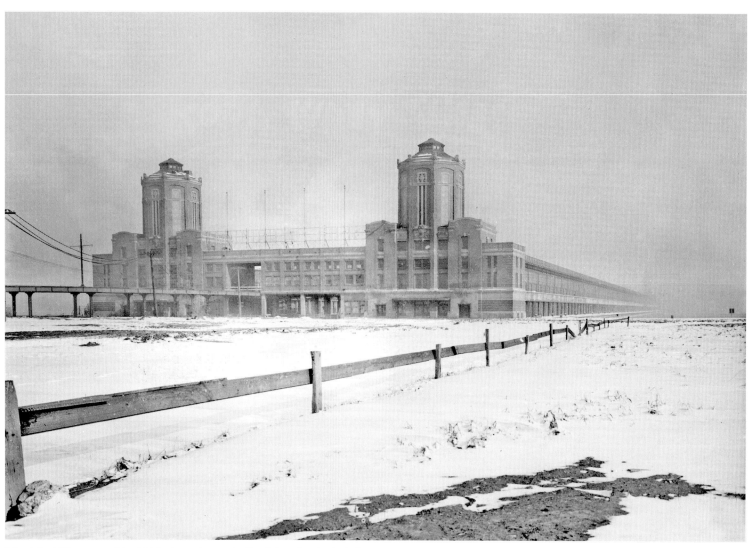

Municipal Pier opened in 1916, the only one built of the piers included
in Daniel Burnham's plan for harbor development. When opened, it was
the world's largest freight and recreational pier at 292 feet wide and 3,000
feet long. In 1927, it was renamed Navy Pier in honor of World War I
veterans.

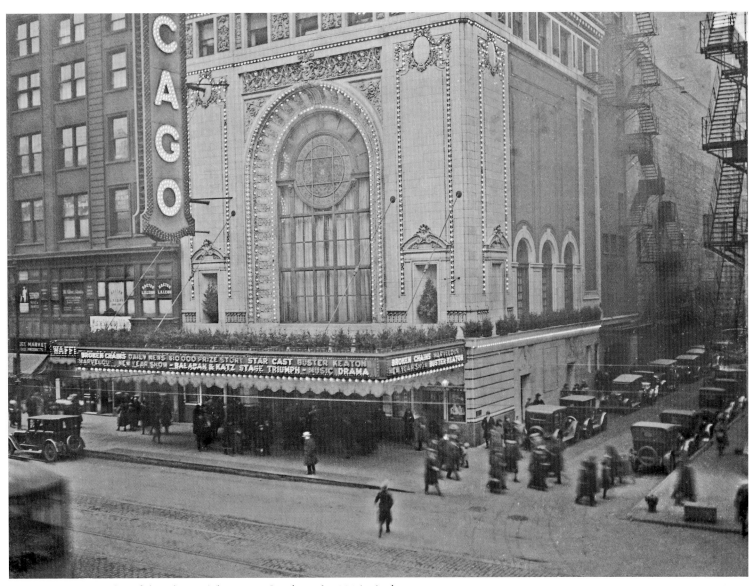

Ads for the opening day of the Chicago Theatre on October 26, 1921 invited patrons to view its "indescribable splendor." In its early years, the theater featured both film and live performances, including "Broken Chains," seen here on the marquee in 1923. The Chicago Theatre, with its 3,800 seats, was the flagship of the Balaban and Katz theatre chain. Its six-story "C-H-I-C-A-G-O," sign is a landmark.

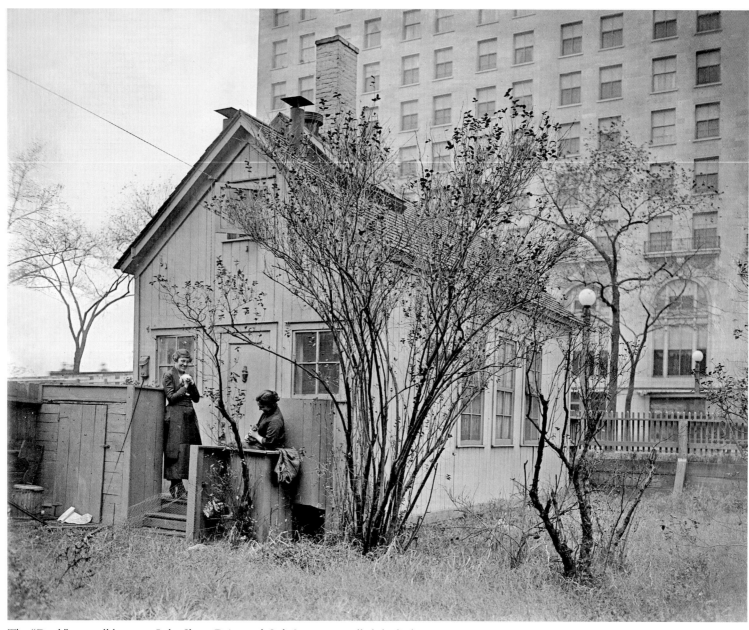

The "Duck", a small house at Lake Shore Drive and Oak Street, was called the little sister to the Drake Hotel in 1921. The elegant Drake is visible in the background.

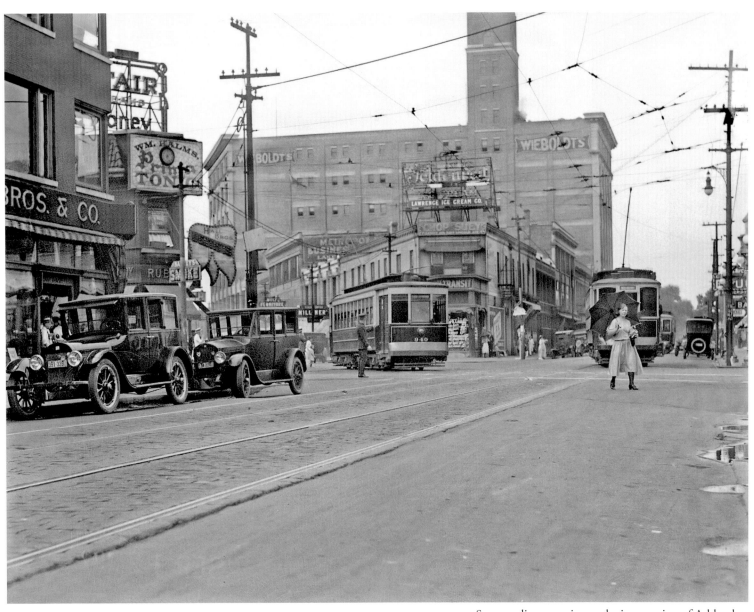

Streetcar lines meeting at the intersection of Ashland,
Lincoln, and Belmont Avenues 1922.

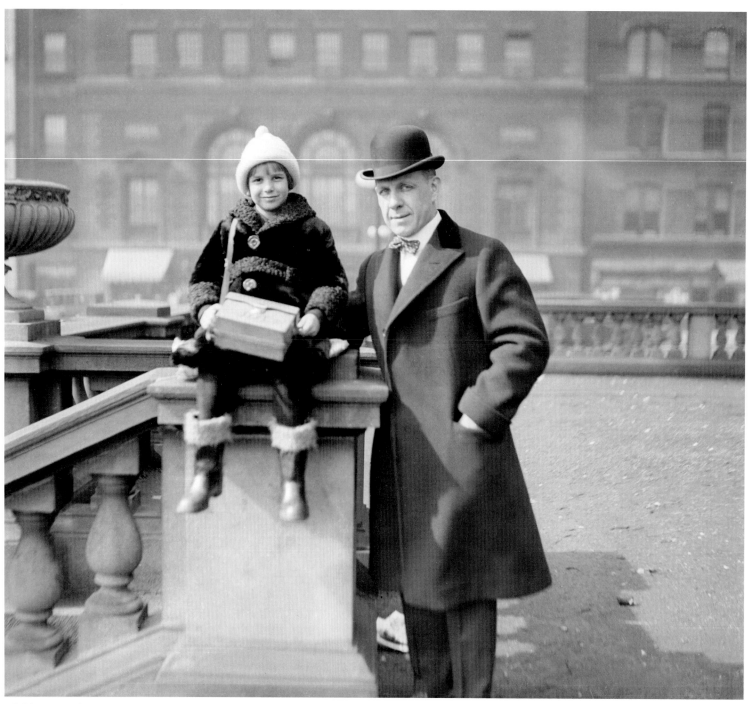

Child actor Jackie Coogan is seated next to Frank Behring, manager of the Hotel Sherman, outside the Art Institute in 1923.

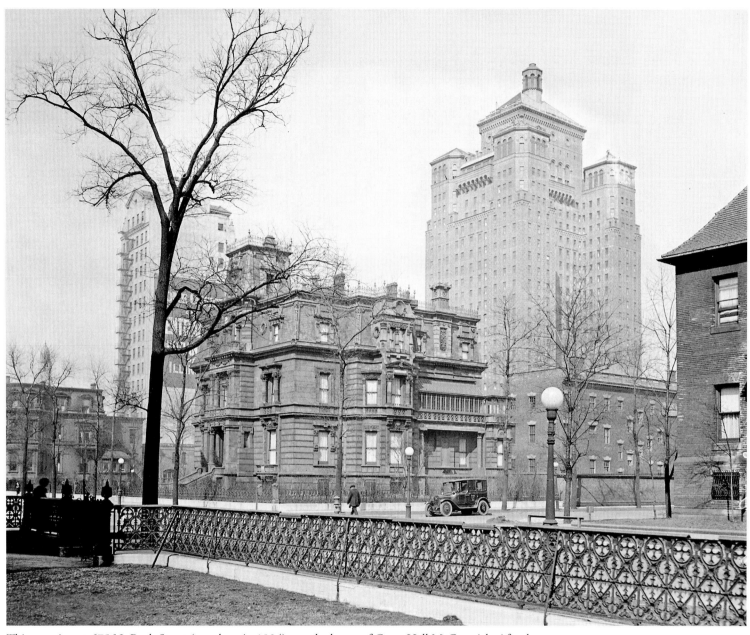

This mansion at 675 N. Rush Street (seen here in 1924) was the home of Cyrus Hall McCormick. After he died in 1884, other members of the McCormick family occupied the house until 1941.

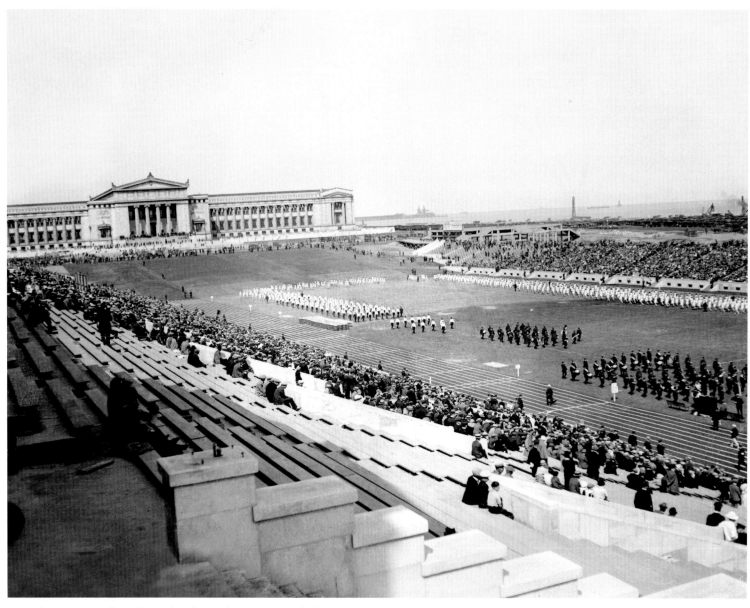

Crowds at Grant Park Field watch police in formation at a field meet in 1924. The stadium had its official opening on October 9, 1924, the 53rd anniversary of the Chicago Fire. It was renamed Soldier Field shortly after.

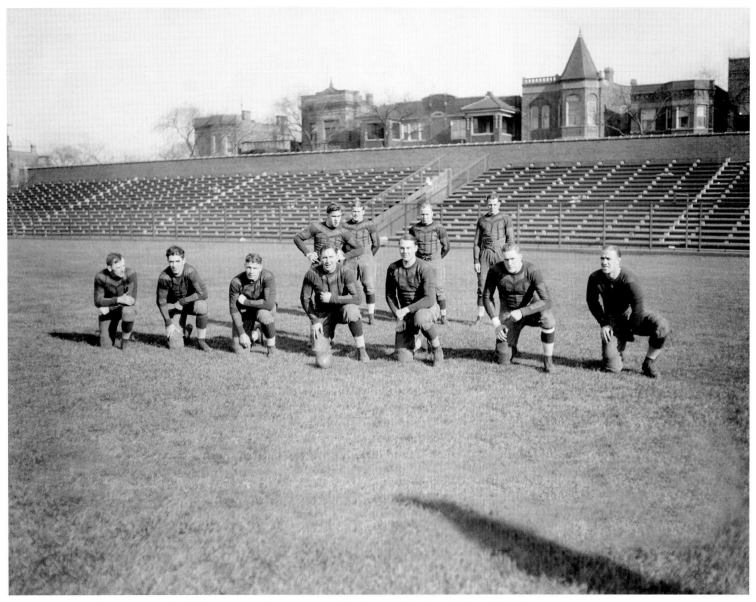

Members of the Chicago Bears football team pose for a picture at Weeghman Park (later Wrigley Field) in 1925. Included are Bill Fleckenstein, Harold "Red" Grange, George Halas, Frank Hanny, Ed Healy, Jim McMillen, Richard Murray, Joe Sternman, George Trafton, and Laurie Walquist. The Bears, whose name was a reflection of the baseball Cubs, played here until 1970 when they moved to Soldier Field.

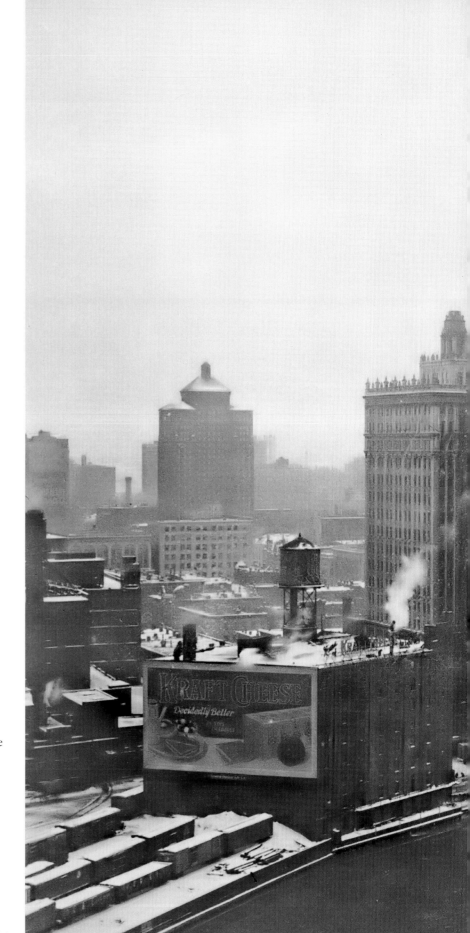

Wacker Drive in 1926 shows a view of three great landmarks: the
Tribune Tower, the Wrigley Building, and the Jewelers Building
(now known as the 35 East Wacker Drive Building). All three
buildings still stand.

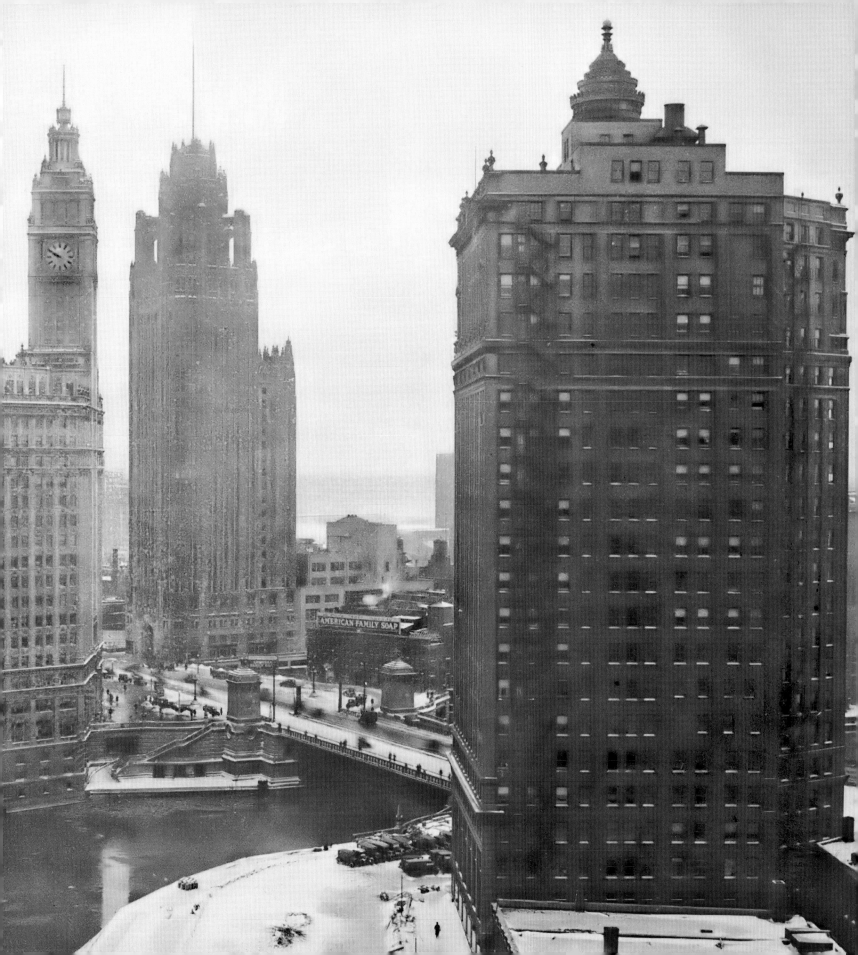

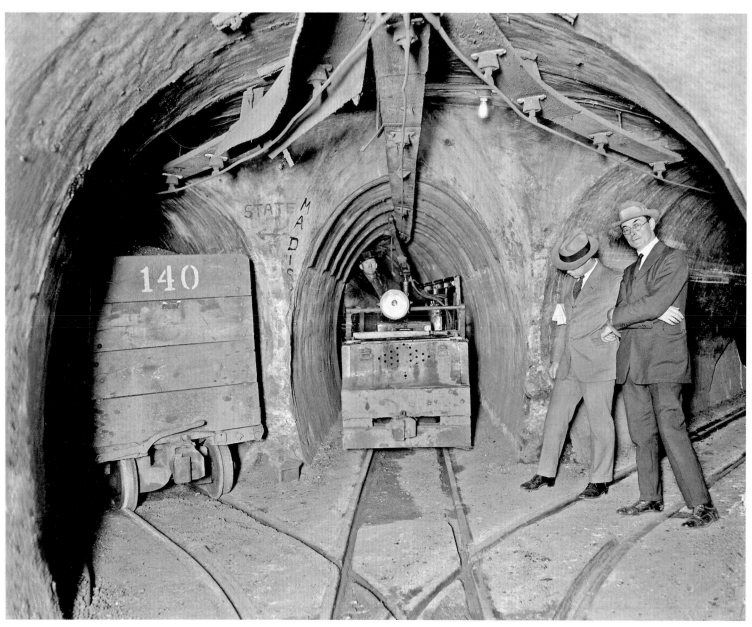

Three tunnels intersect in the Chicago Tunnel Company's underground network in 1926. The tunnel system was planned in 1899 to house telephone cables, but the tunnels were large enough to include two-foot gauge railroad tracks. By 1906, freight cars were in service, delivering merchandise and coal to freight stations, warehouses, office buildings, and stores.

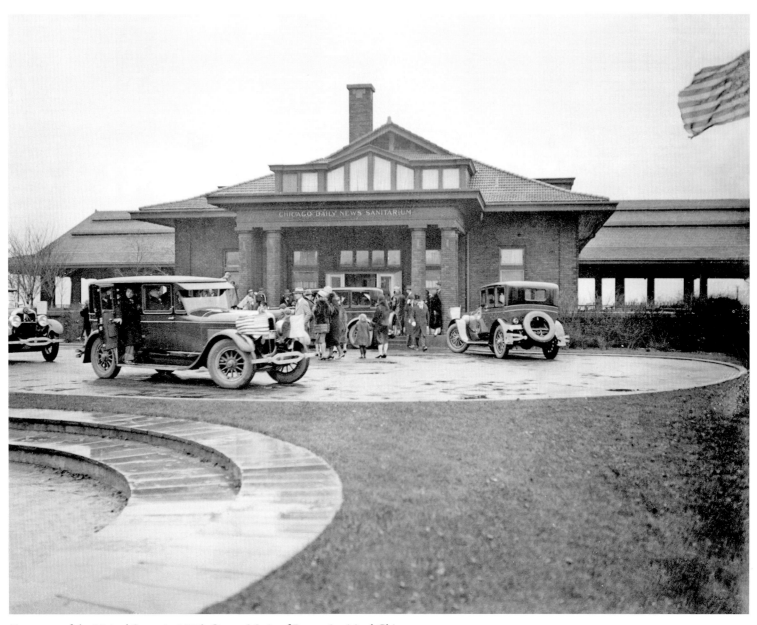

On a tour of the United States in 1926, Queen Marie of Romania visited Chicago.
One of her stops was the Daily News Fresh Air Sanitarium at Fullerton and the Lake.
The former sanitarium building is now home to the Theater on the Lake.

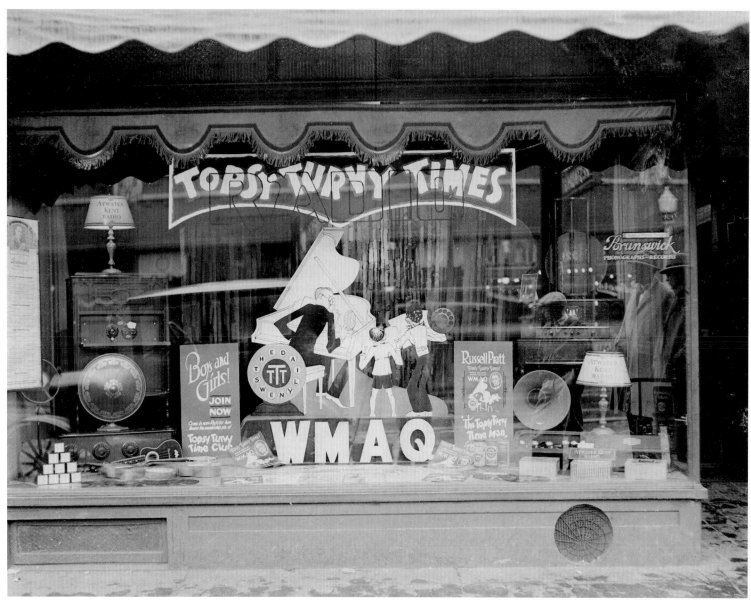

A window display promotes popular shows from WMAQ Radio in 1926. The station began as a joint effort between the Chicago Daily News and the Fair Department Store, although the Fair's involvement was short-lived. The first broadcast under the WMAQ call letters was on October 2, 1922.

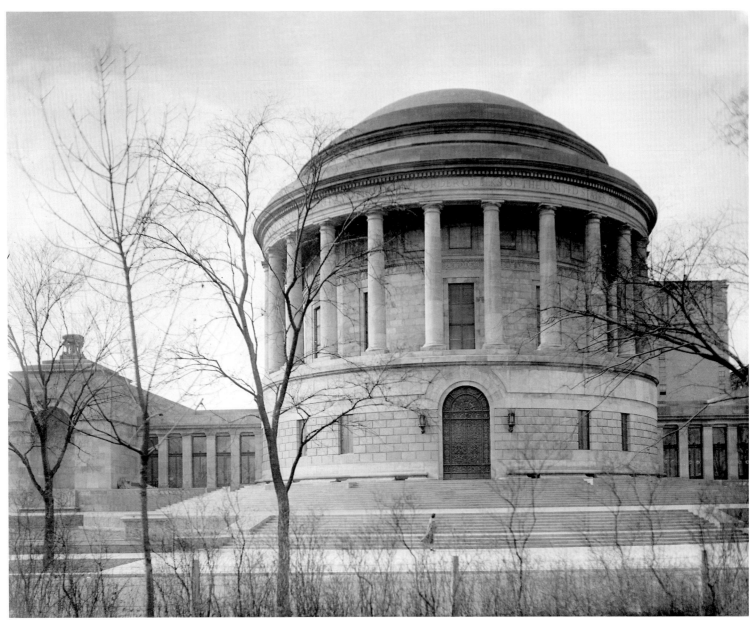

The Elks National Memorial Building, 2750 North Lakeview Avenue, was
erected in 1926 to honor those Elks who lost their lives in World War I.

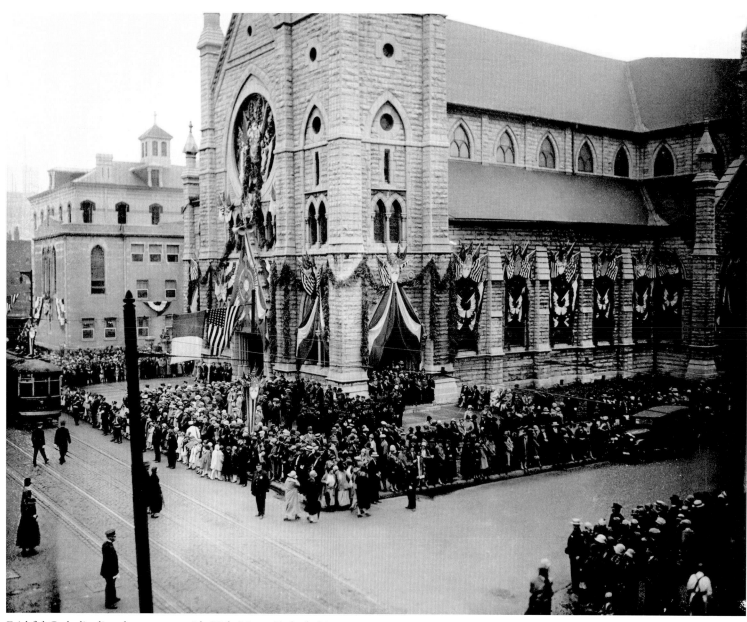

Faithful Catholics line the streets outside Holy Name Cathedral in
1926 at the 28th International Eucharistic Congress. This congress
was the first held in the United States.

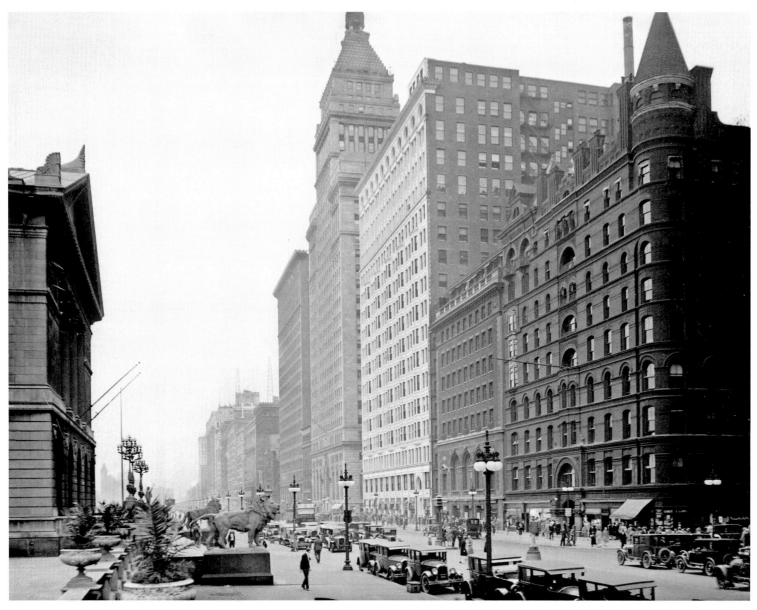

Looking south from Adams Street down Michigan Avenue in 1927,
the Pullman Building, Orchestra Hall, and the Railway Exchange
are on the right. The north face of the Art Institute is on the left.

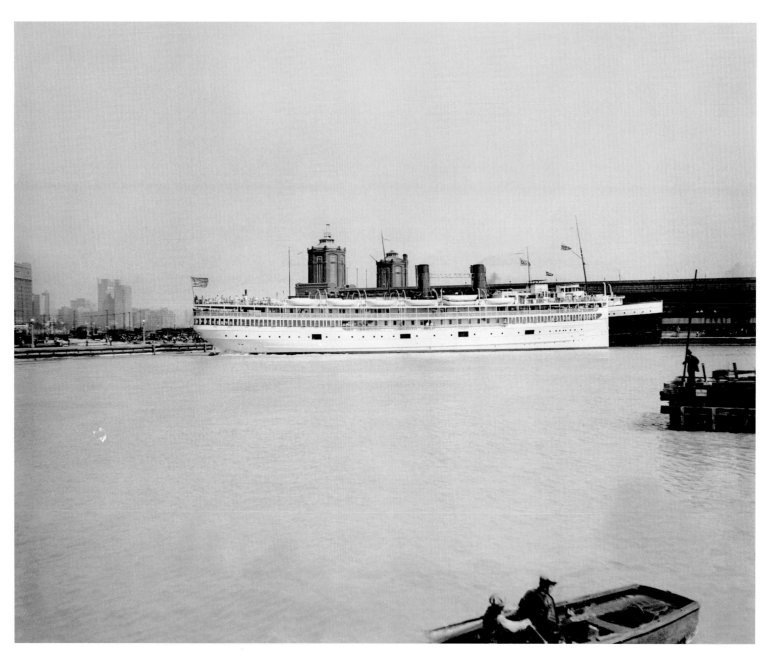

The steamer *Theodore Roosevelt* on Lake Michigan in 1927. Navy Pier is visible in the background.

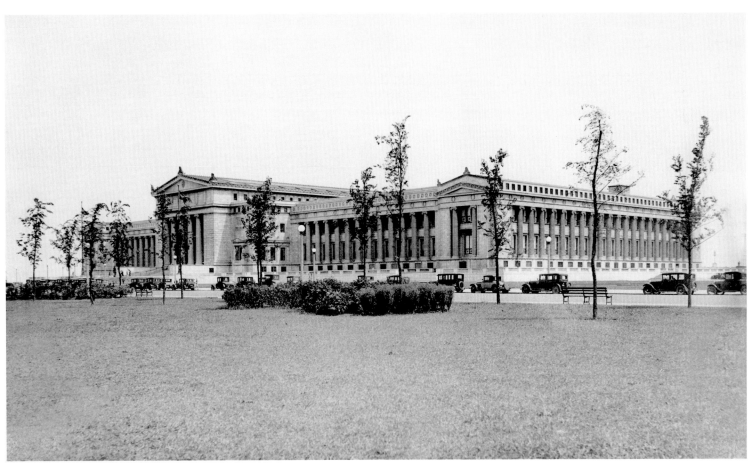

The Field Museum of Natural History, as viewed from Grant Park in 1928. By 1930 both the Shedd Aquarium and Adler Planetarium would join this museum at the south end of the park. The museums were included in the design of the Century of Progress.

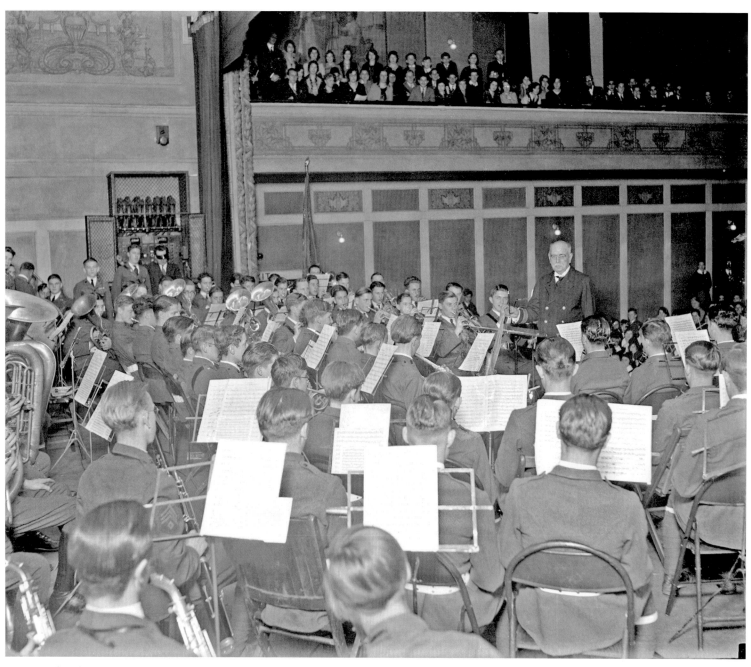

American bandmaster and composer John Philip Sousa conducted a performance at
Austin High School, 5417 West Fulton Street, in 1928.

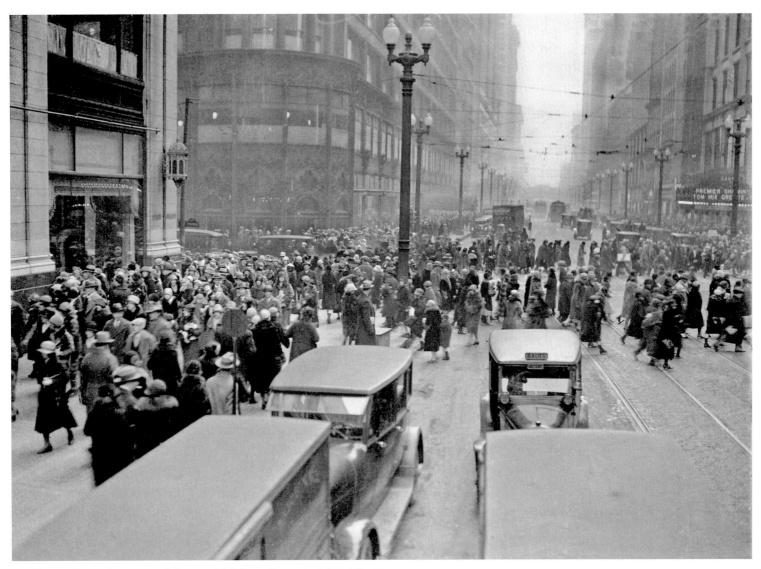

Bustling traffic on the corner of State and Madison Streets in 1927. The Carson Pirie Scott department store is in the background on the left. This landmark structure, the first part of which was built in 1899 as the Schlesinger and Mayer store, is one of architect Louis Sullivan's masterworks.

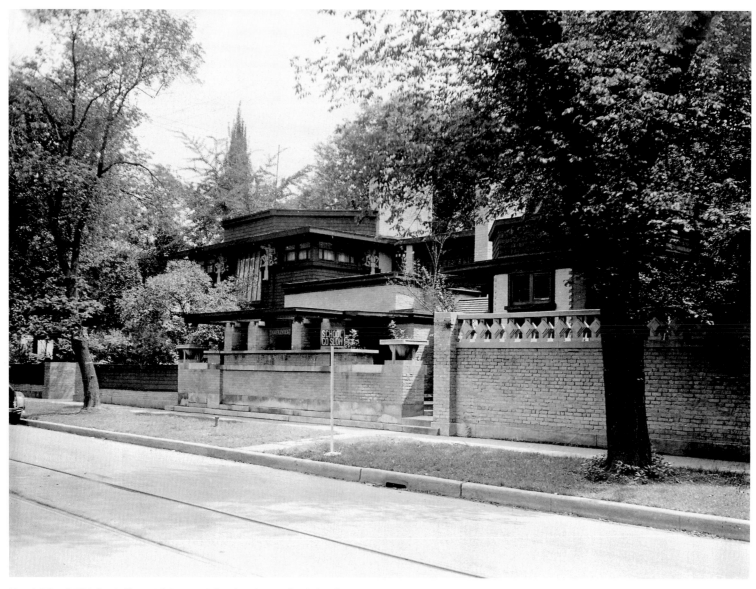

Frank Lloyd Wright, influential Prairie School architect, built his first studio in Oak Park, pictured here 1926. In Chicago, Wright worked first as a draftsman for Joseph Lyman Silsbee, and, starting in 1887, for the noted architectural firm Adler & Sullivan. He became chief draftsman before he left in 1893 to begin his own practice.

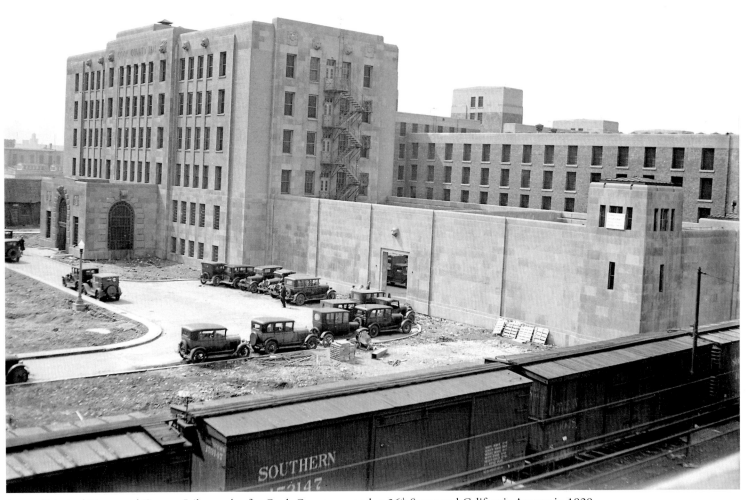

A new Criminal Court and County Jail complex for Cook County opened at 26th Street and California Avenue in 1929.

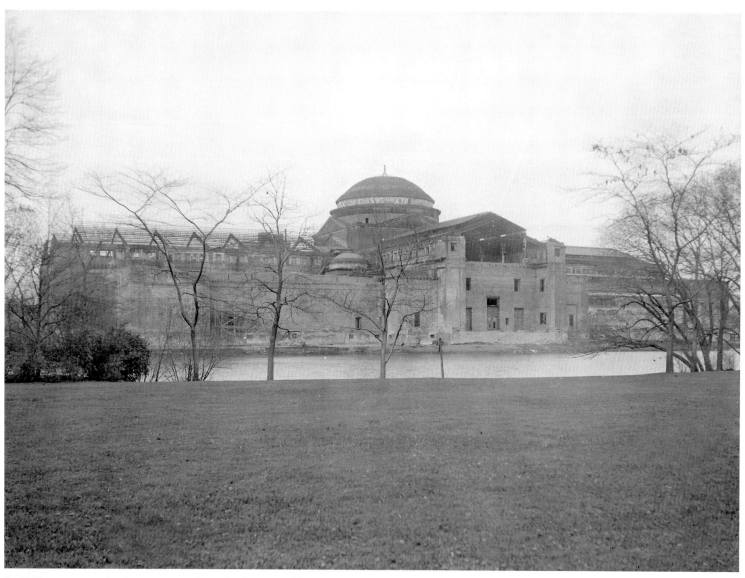

In 1929, reconstruction began to transform the former Field Museum into the Museum of Science and Industry. The exterior was kept as an exact copy of the original Beaux-Arts from when it was the Palace of Fine Arts for the Columbian Exposition. The interior was remodeled in the Art Moderne style, under the direction of architect Alfred Shaw.

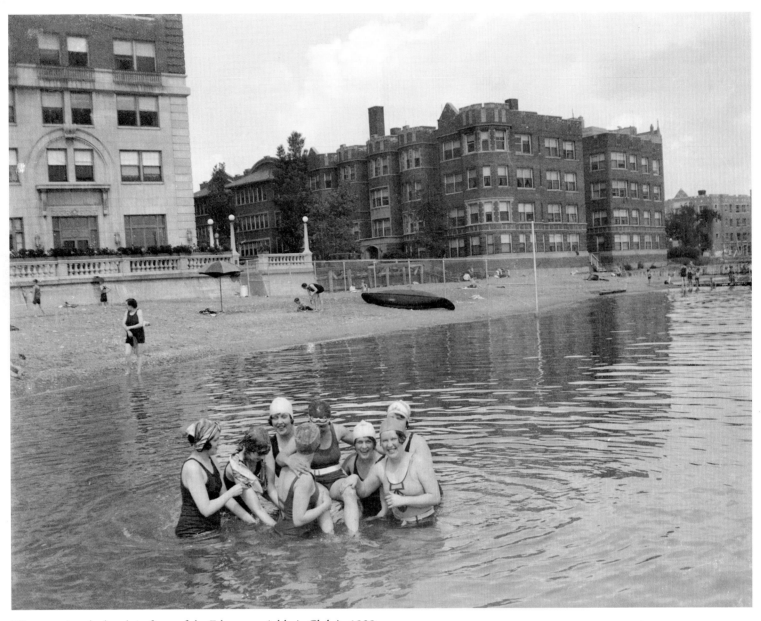

Women enjoy the beach in front of the Edgewater Athletic Club in 1929.

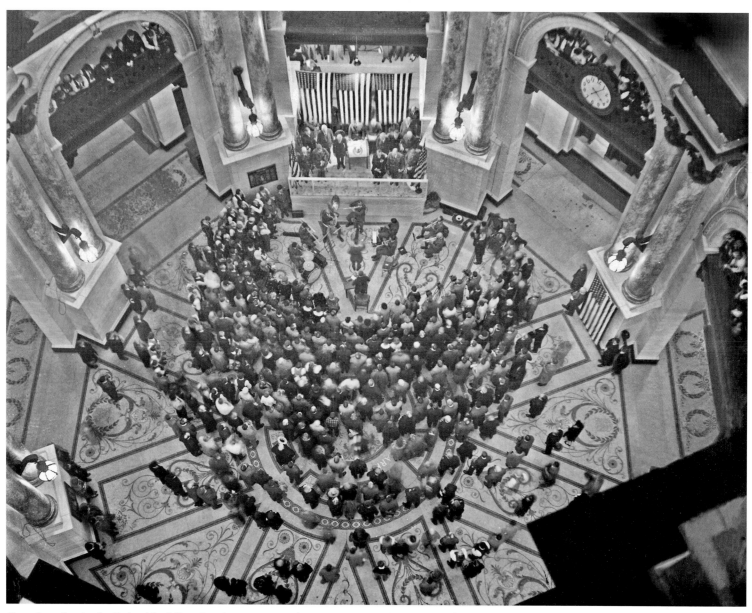

Crowds gather in the Federal building October 11, 1929, during services marking the 150th anniversary of the death of Polish nobleman and Revolutionary War hero Casimir Pulaski.

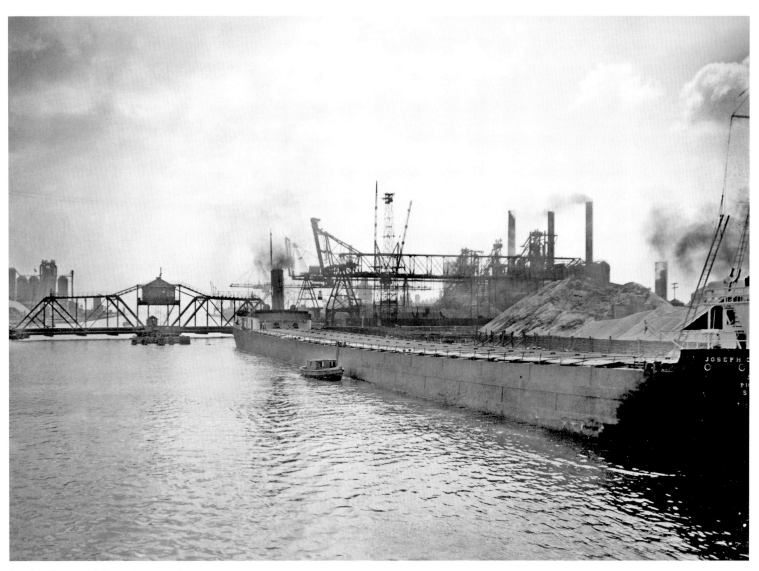

Steel mills viewed from the water in 1929.

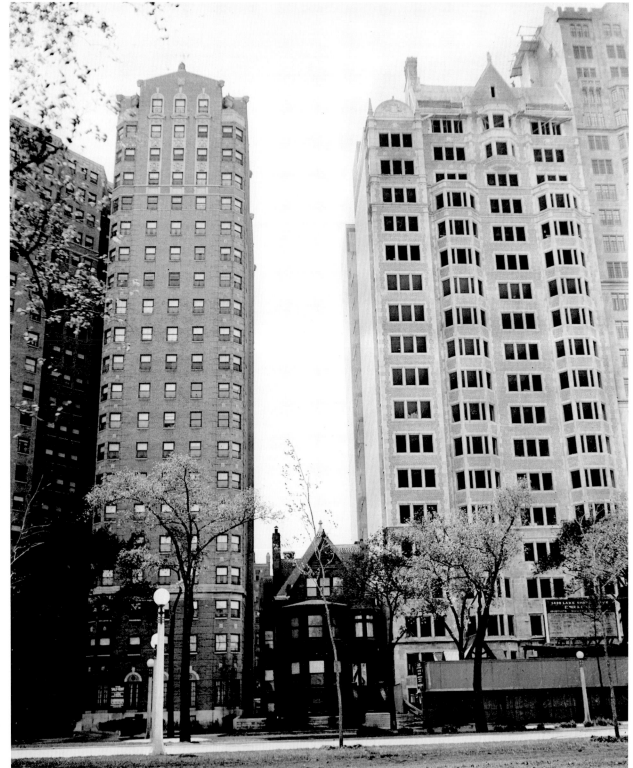

By 1929, skyscrapers had started to line the streets of the Near North Side. The building at 1418 North Lake Shore Drive was sandwiched in between two skyscrapers.

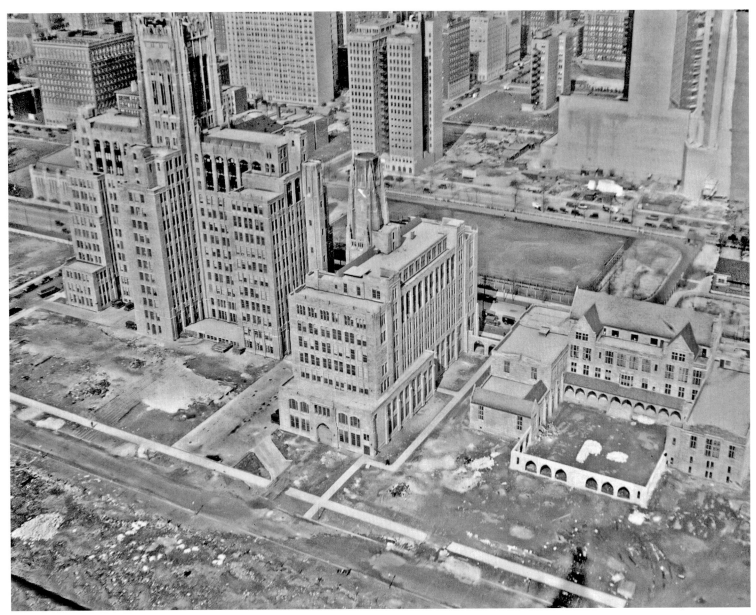

A view of the Chicago skyline from the top of the Furniture Mart at 666 North Lake Shore Drive in 1927. In the 1920's, the four states bordering Lake Michigan had the largest concentration of furniture manufacturers in the country. The American Furniture Mart housed the nation's most important furniture shows. After the building was converted to condominiums in the 1980s, the address was changed to 680 North Lake Shore Drive.

Jane Addams, President of Hull House, Ruth H. McCormick, U.S. Representative-at-large, Governor Louis L. Emmerson, and Mrs. Bertha Baur met in Chicago in 1929.

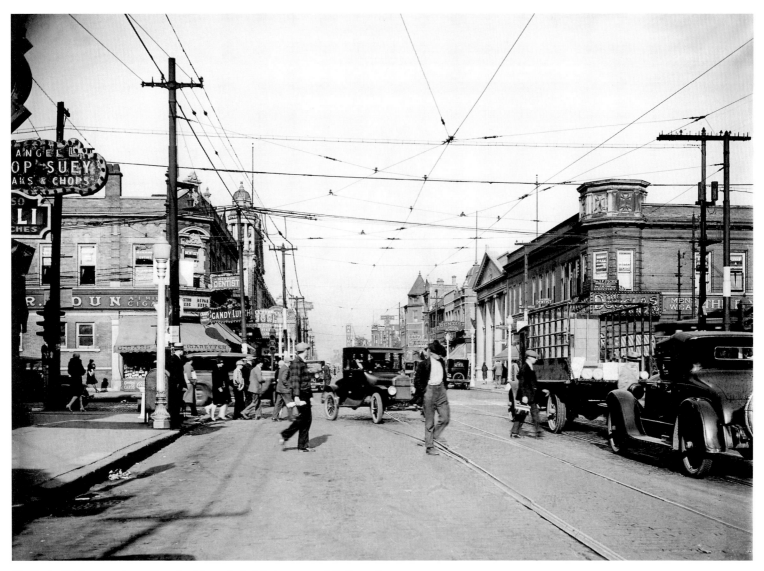

Traffic in Bridgeport along Crawford (now Pulaski) Avenue at 26th Street in 1929. Bridgeport was settled in the mid 1800's, primarily by Irish immigrants who worked on the Illinois and Michigan Canal. Bridgeport has been the home of five Chicago mayors: Edward Kelly, Martin Kennelly, Richard J. Daley, Michael Bilandic, and Richard M. Daley.

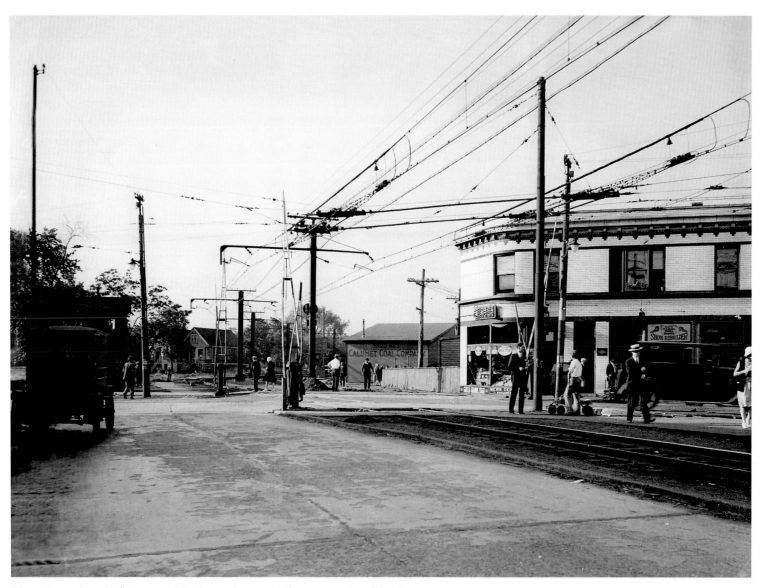

The train tracks at 79th Street and Exchange Avenue in the community of South Chicago in 1929. Following the Chicago Fire, much industry migrated south to this area. South Chicago was annexed to Chicago in 1889. The steel industry attracted many workers, who settled in ethnic pockets in the community.

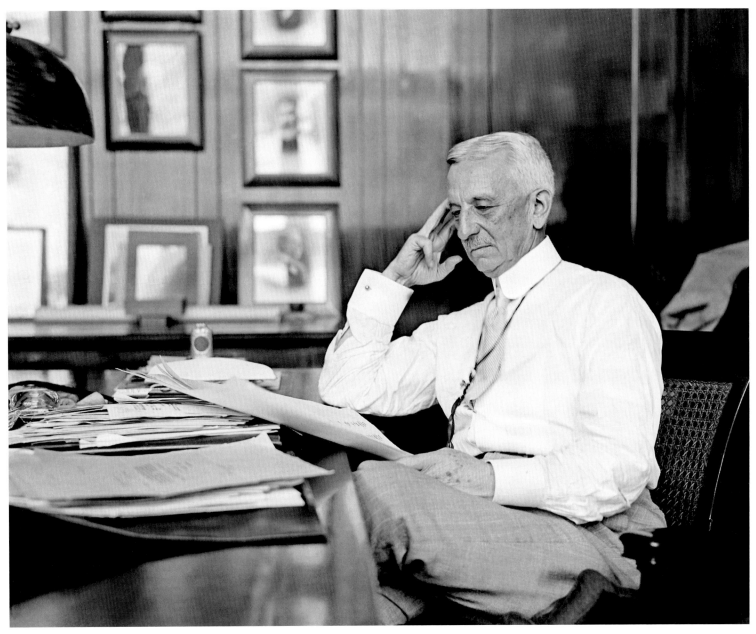

John G. Shedd took over as president of Marshall Field & Company upon the death of its founder in 1906. He had started as a stock clerk with the company in 1871. Shedd donated $3 million to start the aquarium that bears his name.

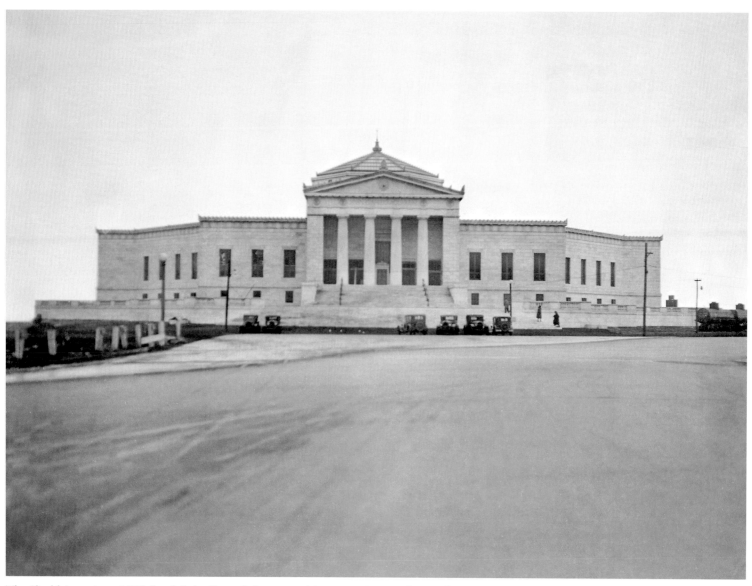

The Shedd Aquarium, 1200 South Lake Shore Drive, opened in 1929. A team of researchers traveled the world for ten months investigating the design and operations used in other aquariums before finalizing plans for the Shedd.

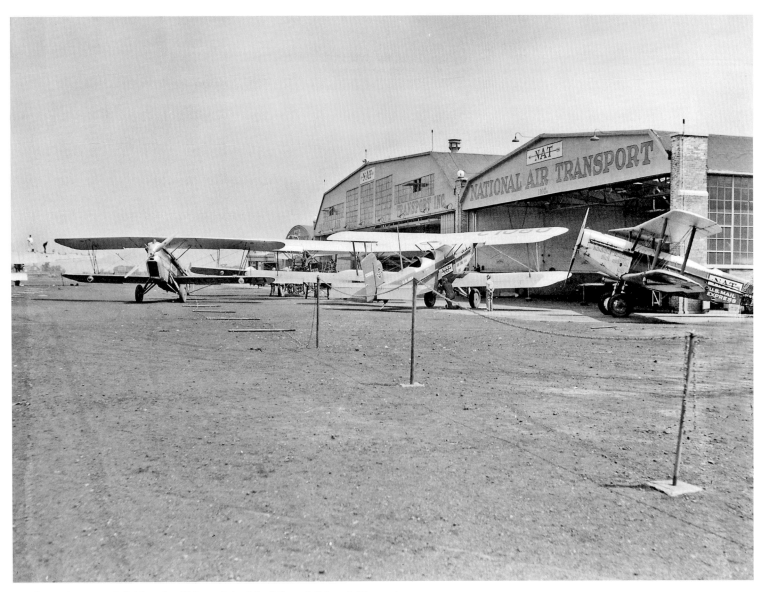

Airplanes sit on an airfield at the Chicago Municipal (later Midway) Airport in 1929. Originally built in 1922 as the Chicago Air Park, primarily for airmail contractors, it was dedicated in 1927. It was the "World's Busiest Airport" from 1932 until 1962 when O'Hare Airport took that title.

Members of the 1933 Chicago Blackhawks practice at the Chicago Stadium. Pictured here (from left to right) are: Paul Thompson, Chuck Gardiner, and Johnny Gottselig. In the 1933-34 season, the Blackhawks captured the Stanley Cup, winning the final game against Detroit in overtime, with all-star goal tender Gardiner earning a shutout. Two months after the victory, Gardiner died of a brain hemorrhage.

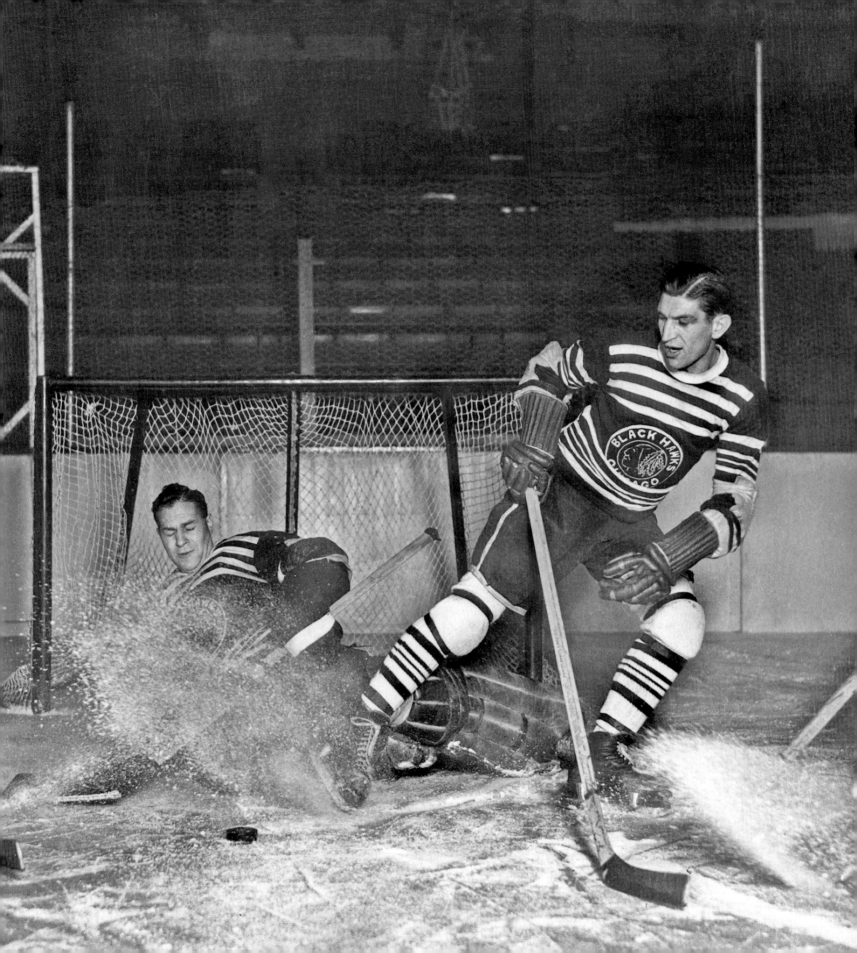

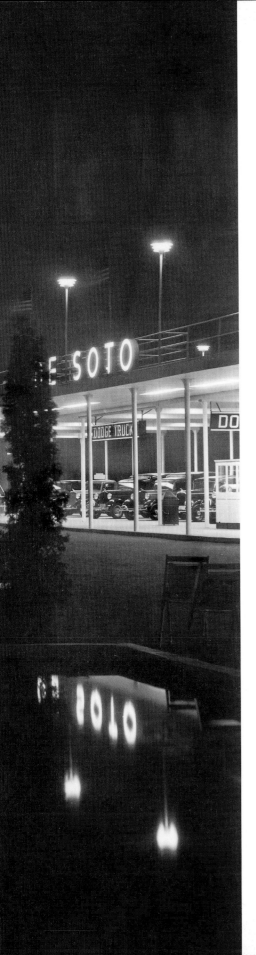

Linear Art Deco design was a trademark of the Century of Progress held in Chicago in the summers of 1933 and 1934. Here, the Chrysler Pavilion is mirrored in the water of the pool at its entrance.

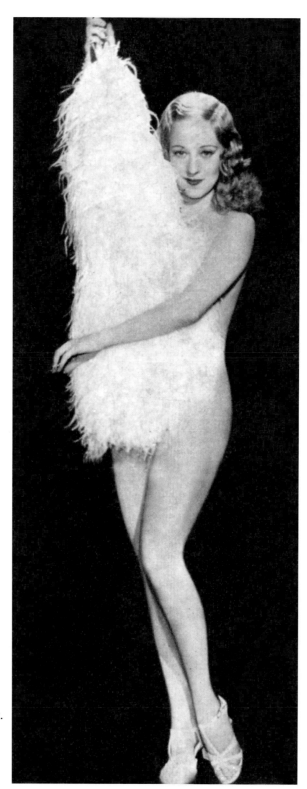

Sally Rand catapulted to fame during
the Century of Progress when she was
arrested for the "obscene" striptease fan
dance that would become her trademark.
Formerly a nightclub cigarette girl and
dancer, she performed in the Streets of
Paris concession on the fair's midway.

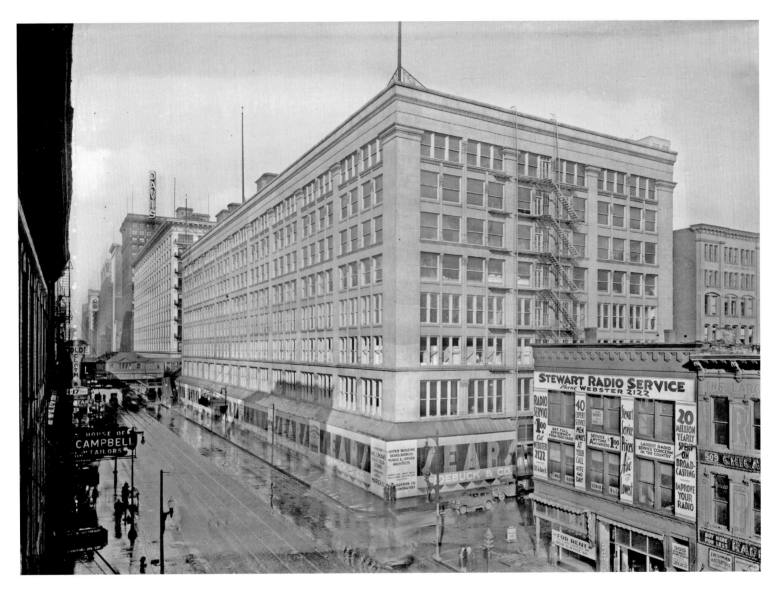

At the end of 1932, Sears opened its first downtown department store in Chicago on the corner of Van Buren, State, and Congress streets, spending over a million dollars to remodel the former Siegel, Cooper & Co. department store. On opening day, more than 150,000 shoppers visited the store. The new store brought 1,000 much-needed jobs to the city in the midst of the Great Depression.

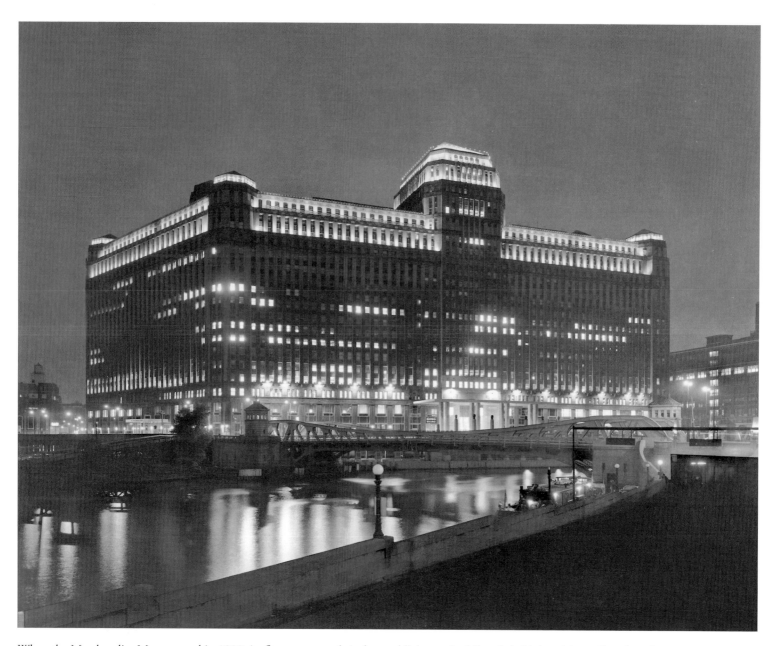

When the Merchandise Mart opened in 1930, its floor space made it the world's largest building. It held that title until 1943, when it was overtaken in size by the newly-opened Pentagon. Originally built by Marshall Field and Company to consolidate Field's wholesale activities, the Mart was built in the airspace above the Chicago and Northwestern Railroad tracks. Joseph P. Kennedy purchased the building in the 1940's.

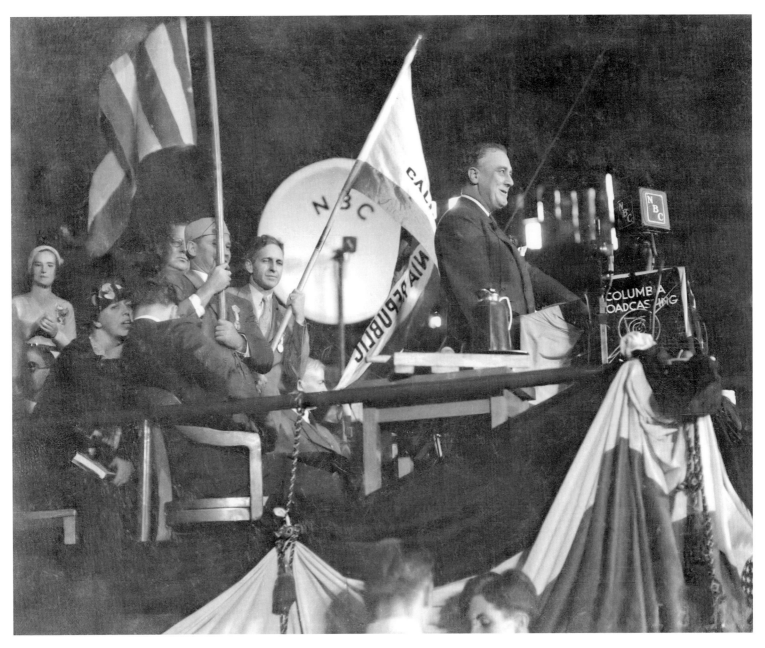

In 1932, Franklin Delano Roosevelt accepted the presidential nomination of the Democratic Party at the Chicago Stadium. President Roosevelt would return to Chicago in 1940 and 1944 to accept his party's nomination for his third and fourth terms in the same building.

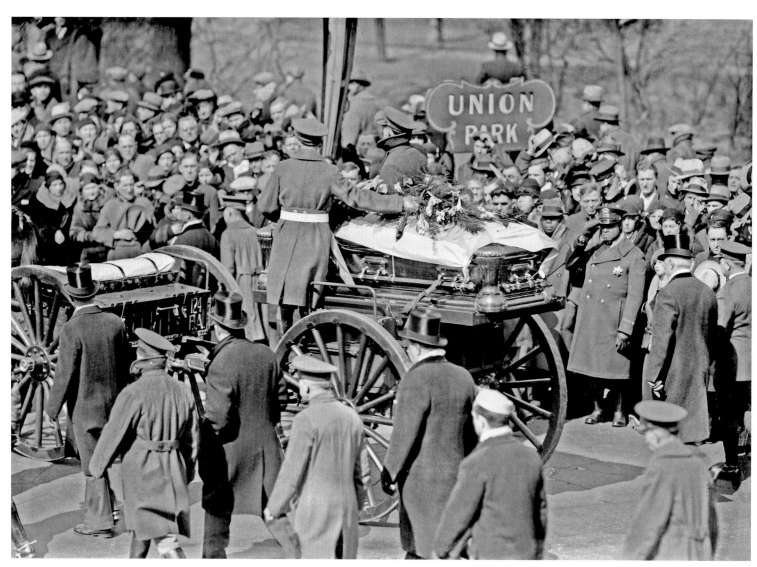

A horse-drawn wagon carried the body of Mayor Anton J. Cermak through the streets of Chicago on March 10, 1933. Mayor Cermak, known as the father of Chicago's Democratic machine, beat incumbent William Hale Thompson in 1931. Mayor Cermak was shot in Miami Beach, Florida, on February 15, 1933, in an assassination attempt on President-elect Franklin Delano Roosevelt.

The Modern Chicago

1940–1970

During World War II, Chicago's diverse manufacturing sector converted to war industry. The city was a research center as well. In December 1942, physicist Enrico Fermi oversaw the first sustained chain nuclear reaction on the campus of the University of Chicago. Thousands of service men and women came to Chicago for training, and others flooded the city en route by train to their final destinations.

The development of an extensive interstate highway system in the 1950s and 1960s and the opening of O'Hare Airport in 1961 added two more layers to the city's existing rail and water transportation network. Chicago's industries remained strong in the 1950s, and steel was a mainstay of the city's economy until the industry collapsed in the 1970s. As scores of companies shifted their headquarters and operations to suburban areas, depleting the city of jobs, middle-class whites followed in record numbers to take advantage of new homes and jobs and to escape the integration of city neighborhoods.

Elected mayor in 1955, Richard J. Daley centralized power in the mayor's office through an efficient system of patronage. A political reformer, he steered federal urban renewal programs to Chicago to replace South Side black slums with high-rise low-income housing, resulting in the highest concentration of public housing in the world. But Daley's tenure was also marred by racial tension and political turmoil. An effort in 1966 by Martin Luther King to end racial discrimination in Chicago housing laid bare the deep racial divisions within the city, which erupted in rioting in April 1968 in the aftermath of King's murder. Later that summer, protesters squared off with Chicago police during the Democratic National Convention, and Daley was forever cast as a political villain.

In the late 1940s and early 1950s, local television productions such as "Kukla Fran and Ollie" and "Garroway at Large" revolutionized the new medium, and African Americans transformed traditional Mississippi Delta blues into a gritty new Chicago sound using electric guitars. Promoted by Chess Records, which was founded in 1950, Chicago electric blues has had a lasting impact on rock and roll, country, and gospel music.

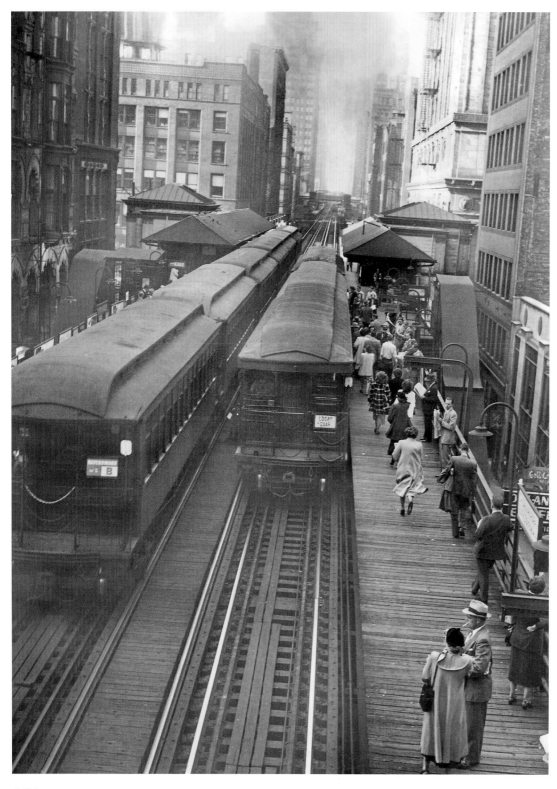

The Quincy Outer Loop station house, pictured here in 1949, was completely restored in the 1980's. It is the only one of the historic stations to be restored. A.M. Hedley designed the Palladian-styled station in 1896 for the Union Elevated Railroad. The station house is built of painted sheet metal, with Corinthian pilasters, Baroque-styled windows, and cartouches along the roof. The interior has wooden floors and tongue-in-groove wooden wall paneling.

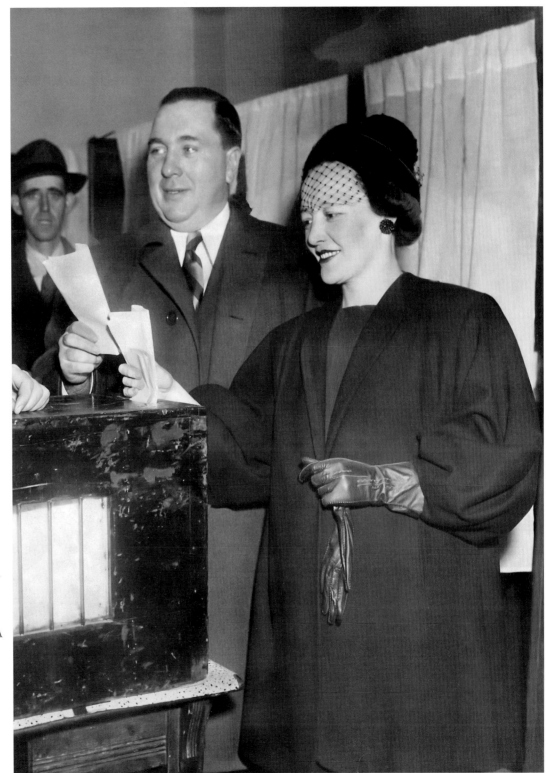

Richard J. Daley and Eleanor "Sis" Daley vote in the 1946 election. Daley suffered the only electoral defeat of his career in that race, in which he ran for the office of Sheriff of Cook County. A lifelong Democrat, Daley won his first election on the Republican ticket in 1936, filling a vacant seat in the state legislature. Soon after that election, Daley returned to the Democratic Party. Daley was mayor of Chicago from 1955 until his death in 1976.

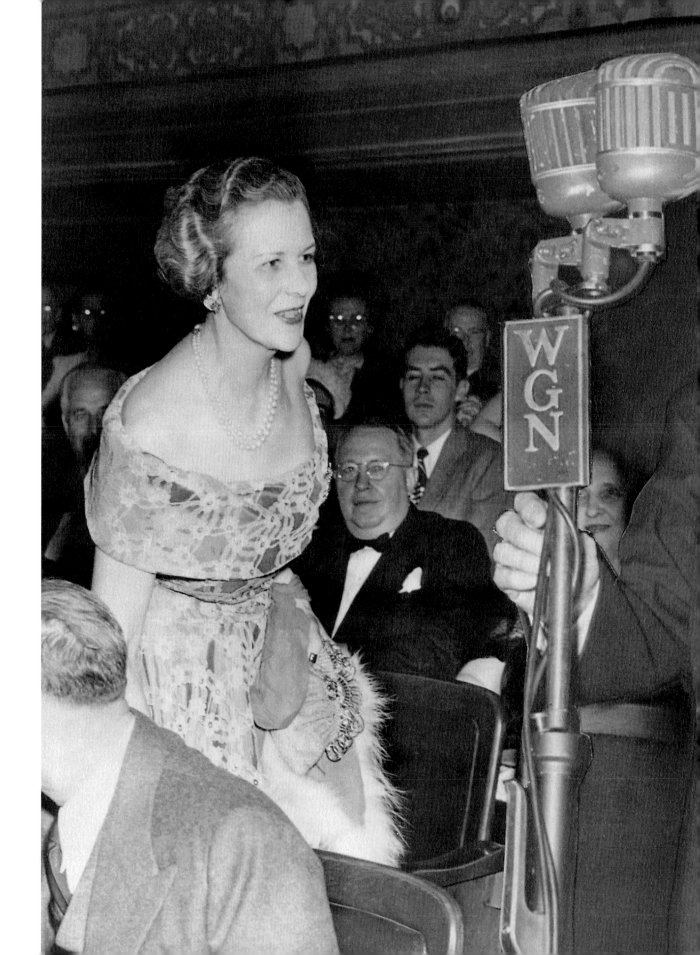

"Colonel" Robert McCormick founded the WGN
("World's Greatest Newspaper") radio station.

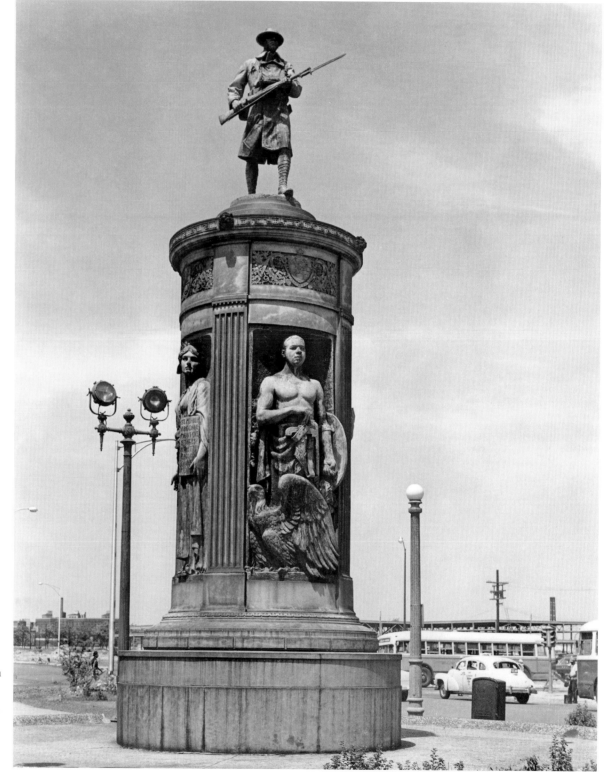

Located at 35th Street and King Drive, the Victory Monument was erected to honor the Eighth Regiment of the Illinois National Guard. The "Fighting Eighth," an African-American unit, served in France during World War I as the 370th U.S. Infantry of the 93rd Division. The monument was dedicated on Armistice Day, November 11, 1928. The figure on top was added in 1936.

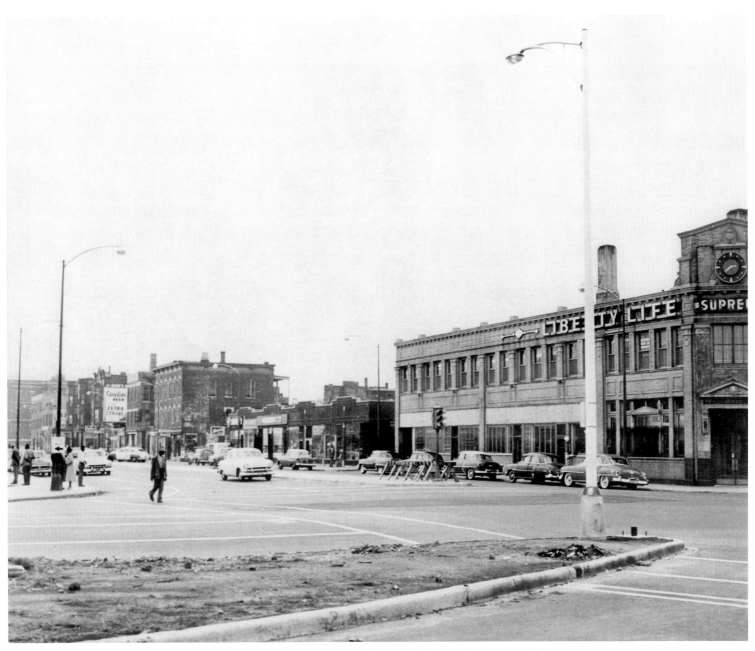

The headquarters of Supreme Life, 3501 South King Drive, is an icon of one of the first and most successful insurance businesses owned by an African-American. Businessman Frank L. Gillespie founded the company in 1919 as the Liberty Life Insurance Company. Supreme Life, formed from the merger of Liberty and two-out-of state firms, was one of the few businesses of the "Black Metropolis" to survive the Great Depression.

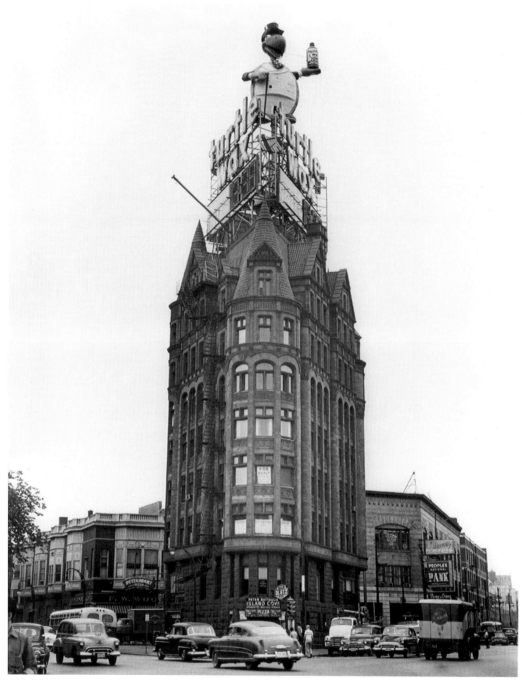

The Turtle Wax storefront on Madison, Ashland, and Ogden. Ben Hirsch started the company with his wife, Marie, initially mixing the car polish in a bathtub. One of his methods was to polish the bumper of a parked car, wait for the owner to come, and sell him a bottle of the polish. The company still has its headquarters in Chicago.

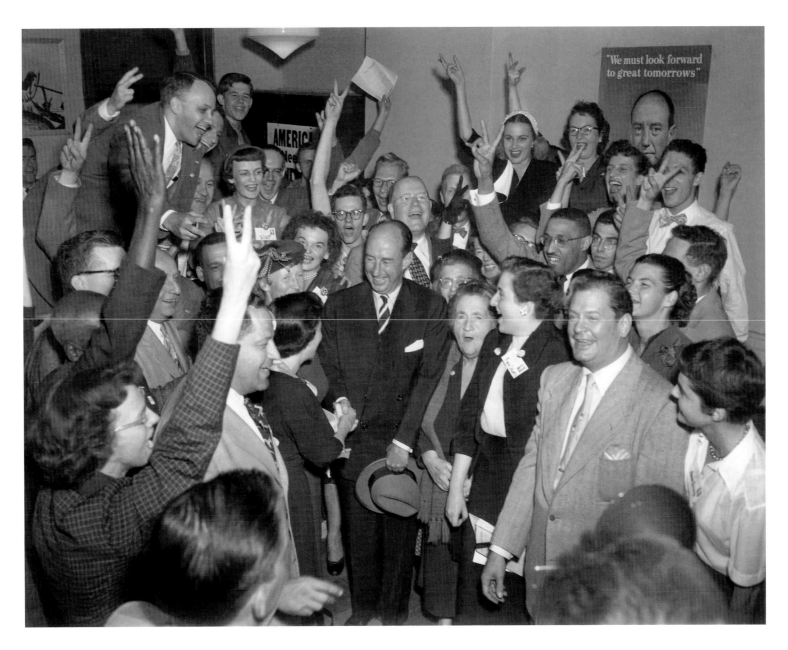

In 1952, Democrats gathered in Chicago for the national convention and nominated Illinoisan Adlai Stevenson II. A few weeks earlier, Republicans had nominated Dwight Eisenhower in the same venue. These were the first conventions nationally broadcast on television.

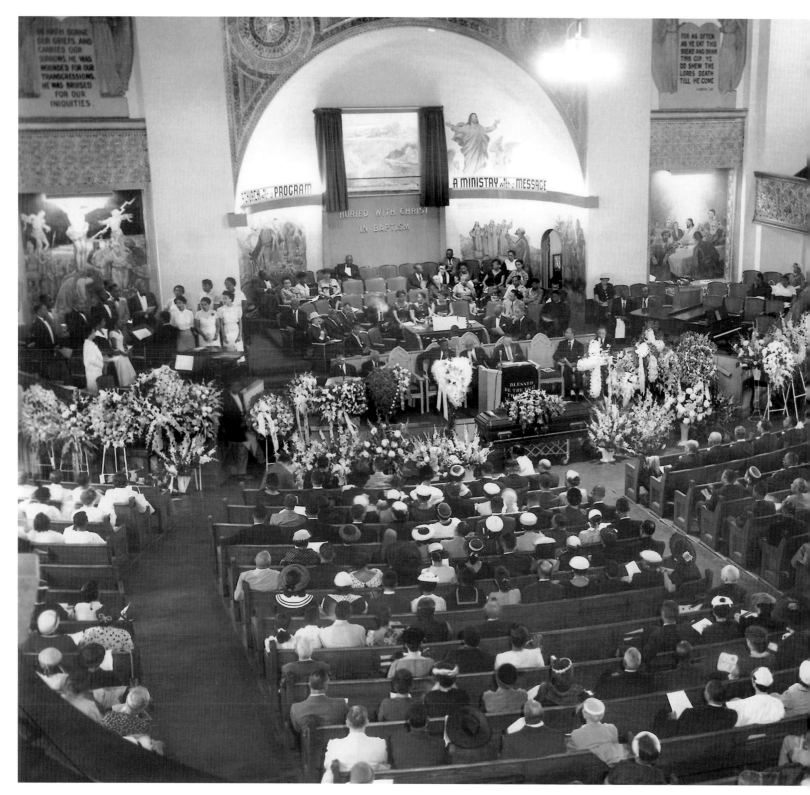

Originally built as Kehilath Anshe Ma'ariv synagogue in 1890, this structure at 3301 South Indiana Avenue was designed by Adler & Sullivan. It has housed Pilgrim Baptist Church since 1922. One of the church's first music directors, Thomas A. Dorsey, became known as the "Father of Gospel." It is shown here during the 1956 funeral of Robert Alexander Cole, one of the city's wealthiest African-Americans of that era. In January 2006, a fire sparked by roofing work gutted the building.

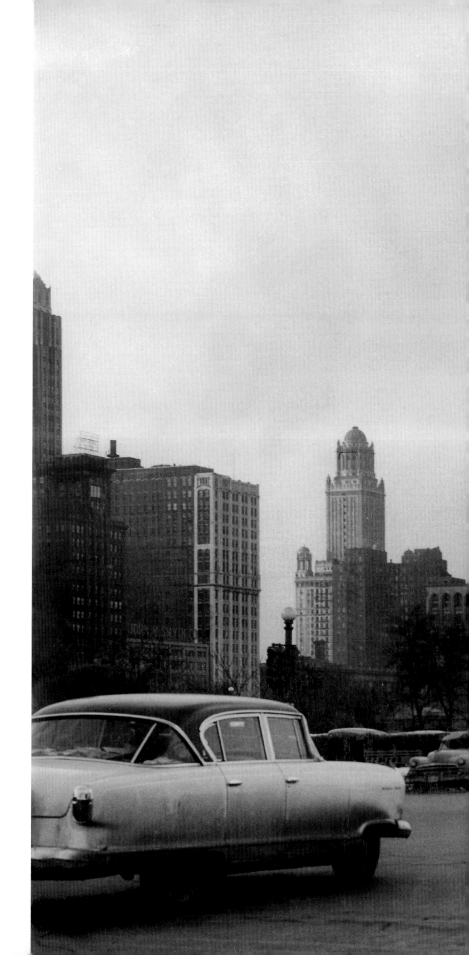

The windows of the Prudential Building reflect the sunlight in this sklyline photo taken in 1956.

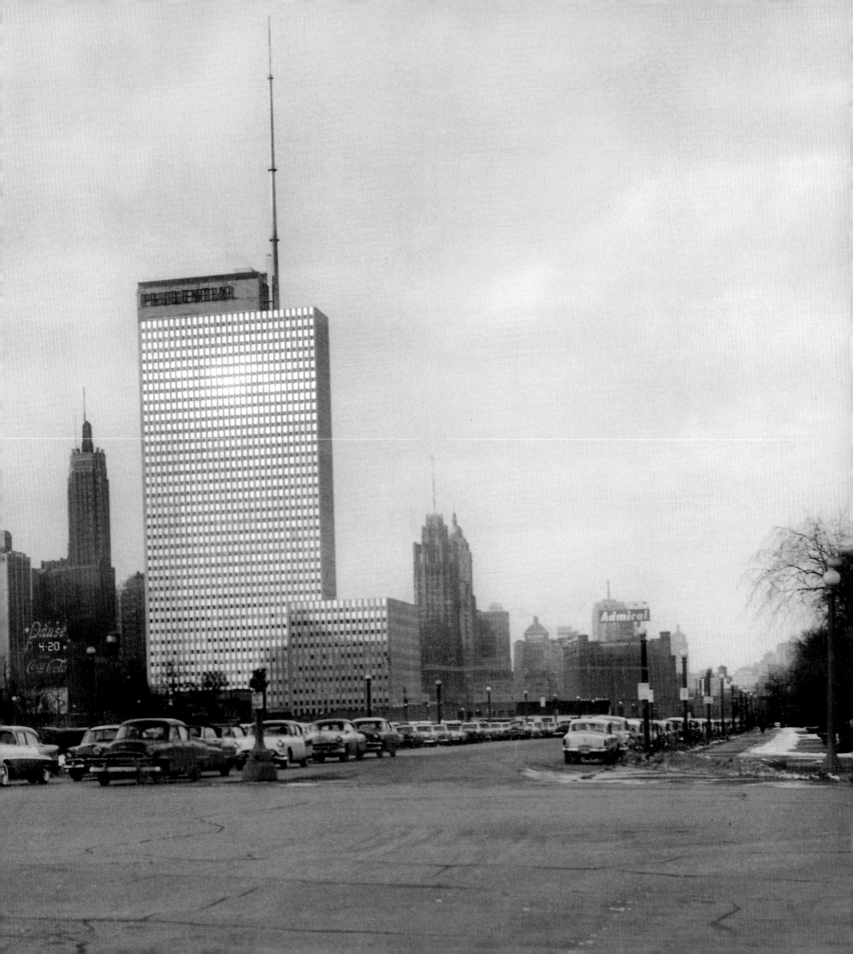

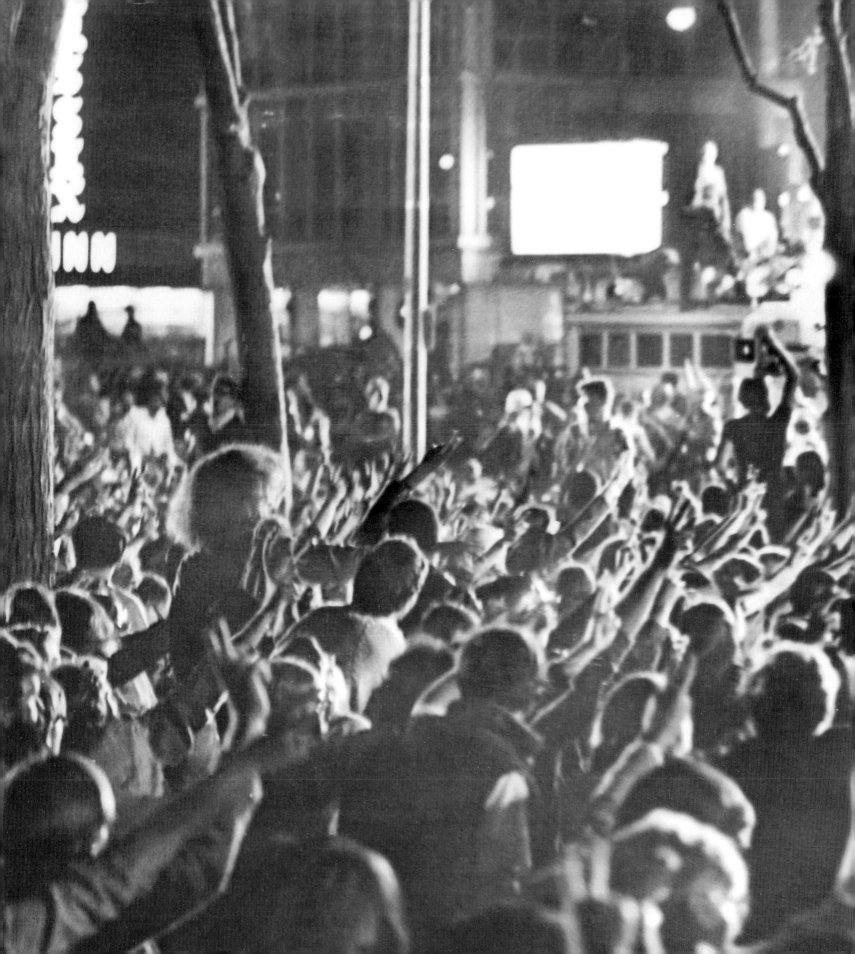

Protesters crowded the streets during the 1968 Democratic convention. The political unrest brought about by the Vietnam War, the civil rights struggle, and the assassinations of Martin Luther King, Jr. and Robert Kennedy came to a head in the streets of Chicago that summer.

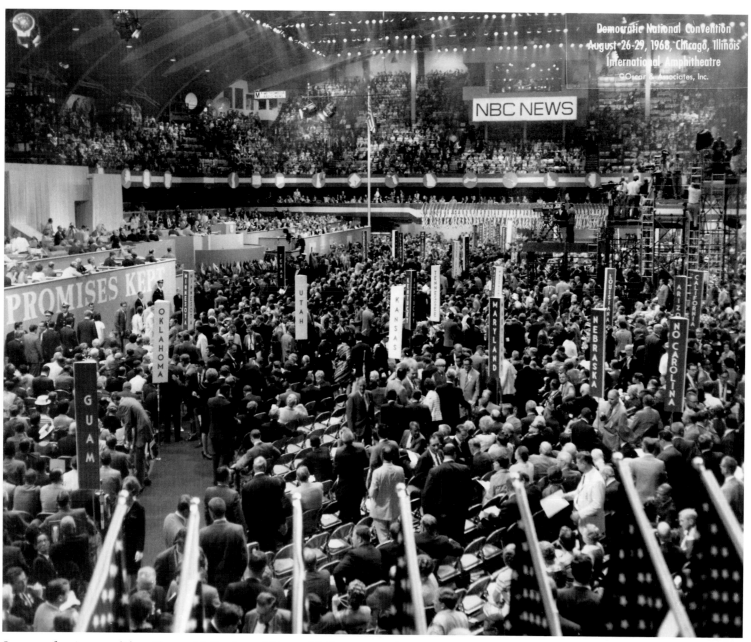

Support of antiwar candidates Eugene McCarthy and George McGovern created tension at the 1968 Democratic Convention. In the end, delegates inside the International Amphitheater nominated Hubert Humphrey and, for vice-president, Edmund Muskie.

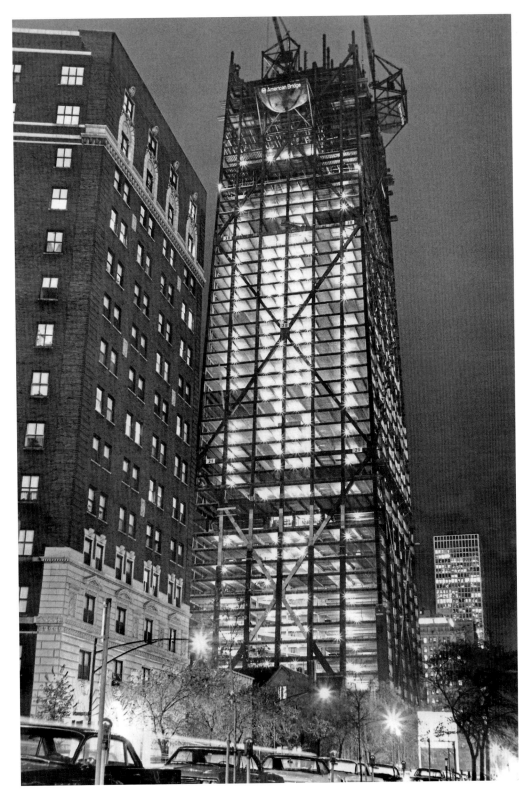

The John Hancock Center lit up like a Christmas tree while under construction in December 1967. When "Big John" opened in 1969, its 100 stories stood at 1,127 feet tall, making it second only to the Empire State Building in height. It is currently the fourth tallest skyscraper in the United States. The Hancock Center's opening was the beginning of the development of Michigan Avenue's Magnificent Mile.

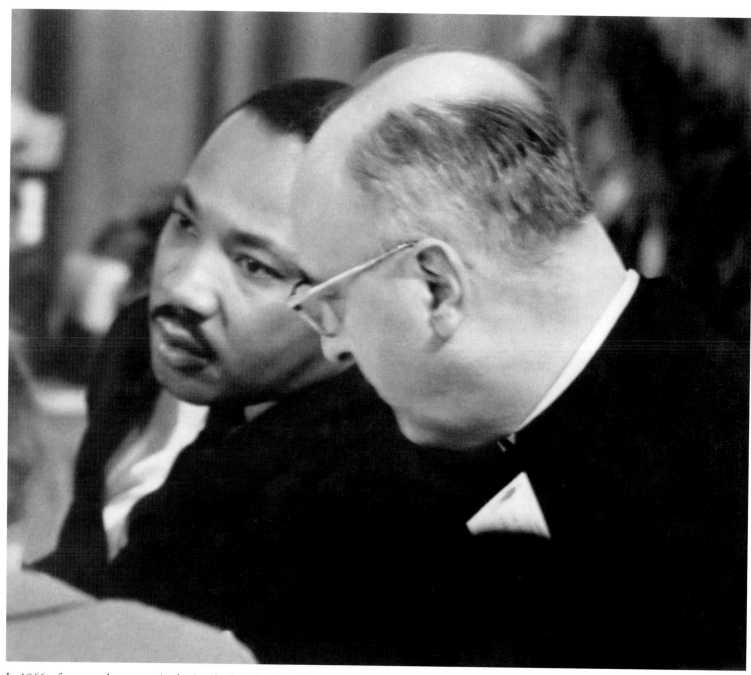

In 1966, after several successes in the South, Dr. Martin Luther King, Jr. moved his efforts north.
He is shown here at an Illinois Rally for Rights. In an effort to bring attention to the living
conditions of Chicago's poor African-Americans, Dr. King and his family moved into the city's slums
while working in Chicago.

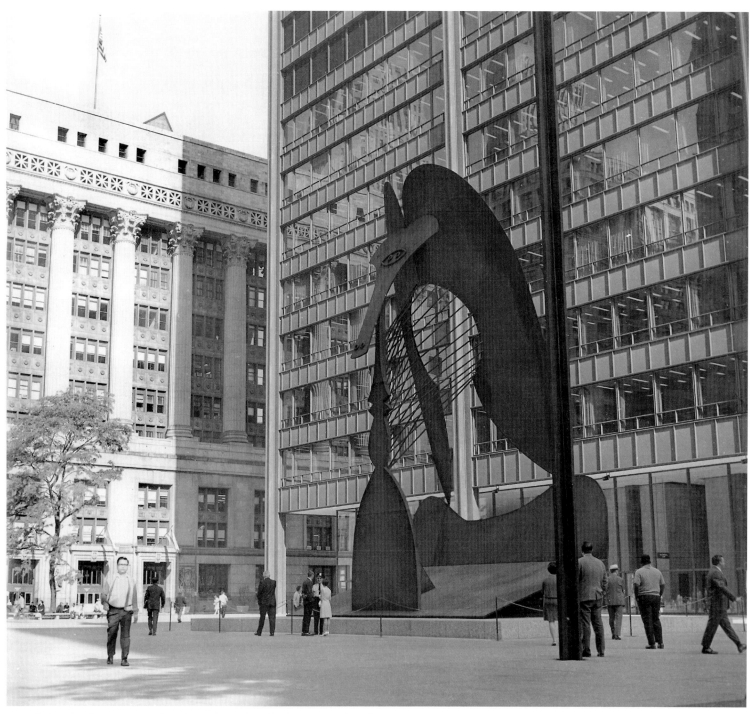

Unveiled at the Civic Center Plaza (now the Daley Plaza) in 1967, the Chicago Picasso is an unpainted, three-dimensional, cubist sculpture standing 50 feet tall and weighing 162 tons. U.S. Steel's nearby Gary Works fabricated the sculpture from the same Cor-Ten steel used to build the Daley Center building.

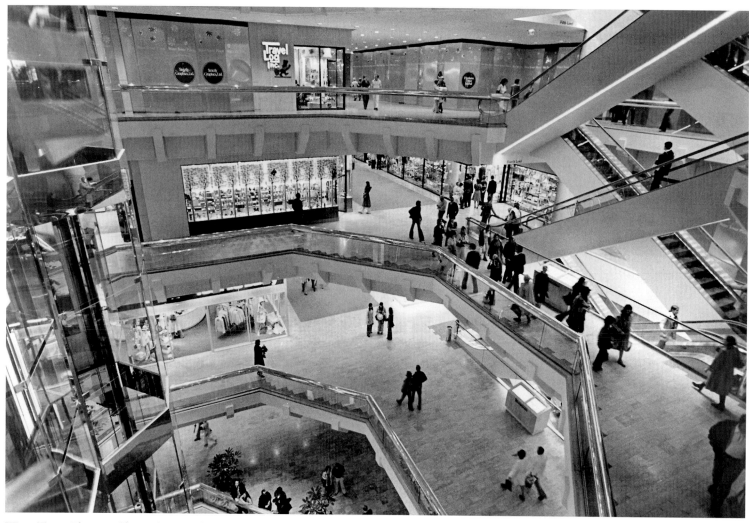

Water Tower Place on Chicago's Magnificent Mile opened in 1976. The 859-
foot tall building hosts a shopping mall that is centered on an 8-floor atrium and
features the city's most famous elevator, encased in three vertical glass tubes.

Notes on the Photographs

These notes, listed by page number, attempt to include all aspects known of the photographs. Each of the photographs is identified by the page number, photograph's title or description, photographer and collection, archive, and call or box number when applicable. Although every attempt was made to collect all available data, in some cases complete data was unavailable due to the age and condition of some of the photographs and records.

125 **THIRD LIBERTY LOAN PARADE**
DN-0070063
The Daily News Collection
Chicago History Museum

126 **33RD DIVISION ON PARADE**
DN-0071277
The Daily News Collection
Chicago History Museum

127 **ARCHBISHOP GEORGE W. MUNDELEIN**
DN-0070156
The Daily News Collection
Chicago History Museum

128 **MR. AND MRS. MARSHALL FIELD III**
DN-0070896
The Daily News Collection
Chicago History Museum

129 **BEVERLY COUNTRY CLUB**
DN-0071574
The Daily News Collection
Chicago History Museum

130 **8TH REGIMENT SOLDIER**
DN-0070089
The Daily News Collection
Chicago History Museum

132 **PROHIBITION RAID**
DN-0072348
The Daily News Collection
Chicago History Museum

134 **ARMY AND NAVY CLUB**
DN-00073951
The Daily News Collection
Chicago History Museum

135 **CHINATOWN**
DN-0070262
The Daily News Collection
Chicago History Museum

136 **MUNICIPAL PIER**
DN-0065714
The Daily News Collection
Chicago History Museum

137 **CHICAGO THEATRE**
DN-0075429
The Daily News Collection
Chicago History Museum

138 **THE DUCK**
DN-0073576
The Daily News Collection
Chicago History Museum

139 **ASHLAND, LINCOLN AND BELMONT**
DN-0074901
The Daily News Collection
Chicago History Museum

140 **JACKIE COOGAN**
DN-0075790
The Daily News Collection
Chicago History Museum

141 **CYRUS HALL MCCORMICK MANSION**
DN-0076818
The Daily News Collection
Chicago History Museum

142 **GRANT PARK FIELD**
DN-0077577
The Daily News Collection
Chicago History Museum

143 **CHICAGO BEARS**
SDN-065678
The Daily News Collection
Chicago History Museum

144 **WACKER DRIVE**
DN-0082241
The Daily News Collection
Chicago History Museum

146 **CHICAGO TUNNEL COMPANY**
DN-0077911
The Daily News Collection
Chicago History Museum

147 **DAILY NEWS FRESH AIR SANITARIUM**
DN-0082508
The Daily News Collection
Chicago History Museum

148 **WMAQ DISPLAY**
DN-0082123
The Daily News Collection
Chicago History Museum

149 **ELKS NATIONAL MEMORIAL BUILDING**
DN-0080197
The Daily News Collection
Chicago History Museum

150 **INTERNATIONAL EUCHARISTIC CONGRESS**
DN-0081730
The Daily News Collection
Chicago History Museum

151 **VIEW DOWN MICHIGAN AVE.**
DN-0068616
The Daily News Collection
Chicago History Museum

152 **STEAMER THEODORE ROOSEVELT**
DN-0083571
The Daily News Collection
Chicago History Museum

153 **FIELD MUSEUM**
DN-0085872
The Daily News Collection
Chicago History Museum

154 **JOHN PHILIP SOUSA**
DB-0087099
The Daily News Collection
Chicago History Museum

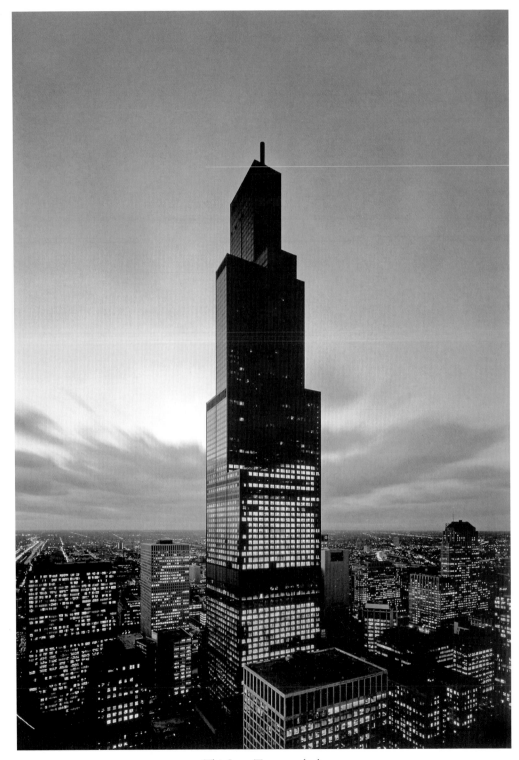

The Sears Tower at dusk